Advice to
Young Artists

in a Postmodern Era

Advice to
Young Artists

in a Postmodern Era

William V. Dunning

with Ben Mahmoud

Syracuse University Press

All Rights Reserved
First Paperback Edition 2000
00 01 02 03 04 05 6 5 4 3 2 1

The paper used in this publication meets the minimum requirements of
American National Standard for Information Sciences—
Permanence of Paper for Printed Library Materials,
ANSI Z39.48–1984 ∞

Library of Congress Cataloging-in-Publication Data
Dunning, William V., 1933–
Advice to young artists in a postmodern era / William V. Dunning
with Ben Mahmoud.—1st ed.
p. cm.
Includes bibliographical references and index.
ISBN 0-8156-0526-9 (cloth : alk. paper) / ISBN 0-8156-0630-3 (pbk. alk.)
1. Art—Vocational guidance. 2. Art—Study and teaching
I. Mahmoud, Ben. II. Title.
N8350.D86 1998
702'.3—dc21
97-46913

Manufactured in the United States of America

Contents

Preface vii

Acknowledgments xiii

1 Talent, Intelligence, and Art 1

2 Reading—and Reading Right 18

3 Artists and Teachers 38

4 Tradition and the New in Current Art 56

5 Artist and Artist's Image 72

6 The Color Monster 92

7 Galleries, Portfolios, and Web Pages 100

8 Jobs for Young Artists 125

9 Working Spaces 138

10 Records and Taxes, Ben Mahmoud 148

11 Blind Dancers 155

Bibliography 181

Illustrations

 1. Mark Rothko, *Green and Tangerine on Red* 167

 2. El Greco, *The Assumption of the Virgin* 168

William V. Dunning is a professor of fine arts at Central Washington University. He is the author of *Roots of Postmodernism* and *Changing Images of Pictorial Space: A History of Spatial Illusion in Painting* (Syracuse University Press) and of numerous articles on art and aesthetics. Dunning has had one-person shows of his painting and sculpture and has had numerous exhibits in West Coast galleries.

Preface

LEARNING IS AN ART. Few students master it even at the doctoral level. Most grind through their degrees one after another, but they take little joy in learning and once properly degreed, they abort the learning process. I believe good teachers should teach more than just subject matter. They should also teach students how to be good students, how to learn efficiently, how to become life-long seekers after knowledge and understanding, and, above all, how to enjoy the process. Such a recommendation is certainly nothing new, but this book will explain that which is too often merely recommended.

Each college usually hosts a few instructors who have learned to search well. They have learned to be eternal students. Ideas afford them pleasure, and some of them can pass this knowledge and excitement along to their students. Perhaps watching what so many of their students do wrong teaches them to understand the art of learning. I myself did not understand how to be a good student until I had first taught for a while and then returned as a student.

College teachers often discuss among themselves the differences between good students and poor ones, and they generally agree. But the ideas they share so easily among themselves are rarely passed on to those who desperately need them—the students. In this book I will discuss many of the same beliefs and suggestions that the best instructors agree on among themselves.

Though I seldom see it done, such advice could be offered during classes. I would like to see colleges and universities initiate a one-credit course on how to learn, how to be a good student. And this class should be required of all new students, both the swift and the halt, to avoid the stigma of being classified as a remedial class. Such a class would help students understand what is expected of them, why instructors teach what they do, as they do. But too many of those very instructors who understand the learning process are afraid to usurp precious time from the subject matter itself to offer advice on learning in general. I hope this book will help fill this gap.

I will demonstrate how to have success as a student of any field and how to achieve excellence in any area. But this book is primarily aimed at young artists because I know that field well, from the perspective of a studio artist as well as from that of a writer, and I have enjoyed helping many young artists for more than thirty-five years.

Most people can achieve a high degree of excellence in most subjects—if they know how to do so. Extensive experience leads me to believe that most can learn to be quite good at what they do, if they work hard and if they have competent advice and guidance along the way. But beginners in every field tend to have the wrong idea about how to pursue excellence. They often believe that people are either good at something or they are not, as if we were all born one way or the other—talented or not talented, smart or not smart. They do not realize that people who are exceedingly good at something have spent much time doing that thing. I am constantly surprised by the number of students I meet who fervently believe they will become great artists by dint of talent or instinct; they believe their talent alone will lead them to paint well, like cats born with an instinct to hunt.

We have two cats in our household. A farmer gave us Jabba the Hut. He was born a field cat, raised till he was eight weeks old by a mother who hunted the fields; and, like all cat mothers who hunt well, she taught her son to hunt. Jabba is a short-coupled, very fat, slow moving cat who could not jump high enough to get on the bed if he did not have claws to scratch and scramble his way up. He would seem to have little of the equipment that it takes to be a good hunter. Cool, on the other hand, was born in an apartment. He is a lithe, quick, strong, young cat who jumps like a basketball star. Physically, Cool is far better equipped to hunt than is Jabba. But he was never taught.

Cool loves hunting. He spends far more time hunting than Jabba does. He shakes and chatters violently when he watches birds—imagining, I suppose, that he will somehow catch one someday. Then he suddenly charges in impatient desperation and leaps futilely into the tree after them. Consequently, Cool brings home a few butterflies, grasshoppers, and moths, while Jabba the Hut brings home far too many field mice, gophers, moles, and birds—even one crow that he managed to jump high enough to knock out of the air as it swooped two feet above the ground. (My wife was quick enough to save the

crow.) Yes: cats are born with an instinct to hunt, but they are not born with an instinct to hunt well.

They must be taught.

· When you see a child in Little League who plays baseball well, you see a child whose parent has hit a lot of grounders and pitched a lot of balls to swing a bat at. The best players are often the children of coaches, who teach them the correct form. Good form and disciplined practice make up for a lot of talent.

Similarly, many humans are born with the instinct to make art; but they are not born with the instinct to do it exceedingly well. Many can, however, become good at what they do constantly. If they obsess, they will excel. Literary testimonies describing surges of inspiration abound. We have all read passages like Thomas Wolfe's description of the process that generated his book *Of Time and the River*:

> I cannot really say the book was written. It was something that took hold of me and possessed me. . . . It was exactly as if this great black storm cloud I have spoken of had opened up and, mid flashes of lightning, was pouring from its depth a torrential and ungovernable flood. Upon that flood everything was swept and borne along as by a great river. And I was borne along with it. (Wolfe 1961, 187)

What a rousing description of pure inspiration! But what can those young artists who have yet to experience such an "ungovernable flood" learn from this? Very little. If they learn anything from such a description, they learn to feel grossly intimidated, convinced that they have no such talent, and that, furthermore, they are probably wasting their dreary untalented time in the arts. Or they may assume that their mission is to wile away time as they passively await the advent of their own ungovernable flood. Most will assume that Wolfe's "flood" was there from the start, that it came to him free and easy—an unearned gift. What young artists need to learn is, not how such miraculous inspiration can sweep an artist away in its ungovernable flood, but how to seek and eventually generate such floods.

If young artists do not learn how to pursue inspiration, they are destined to

impotently await its improbable arrival. This book is intended to equip students to court the Muse actively, rather than idly awaiting its capricious entrance. I will quote the inspired only when they tell us how to entice that flood of revelation, not when they describe what it feels like once they have it.

Few people in the arts harbor the unreasonable belief that a teacher can create Michelangelos or de Koonings, but a good teacher can let young artists know what they must do if they wish to excel in their field. Most major artists and most major athletes had at least one good teacher, coach, mentor, or sponsor who passed on the ideas that are necessary for success in the field, much the same way a runner in a relay race passes the baton to the next runner. That is what I hope to do in this book. I hope to pass on to the next generation an understanding of the process that tends to beget good students or good artists—or, for that matter, good scientists, philosophers, or mechanics.

Such a book seems to be sorely needed. I know two such books that were written for young scientists; I will quote from them at times and sometimes I will compare the training of artists with the training of scientists. There are more similarities in both the teaching and the learning of these two disciplines than the instructors or the students in either field are likely to understand. For instance, after extensive investigations for their book *Artists as Professors,* Morris Risenhoover and Robert Blackburn tell us that teachers in both science and art tend to teach as they themselves were taught; both model their teaching after the best teacher they ever had; both change the techniques that they perceive as minor flaws in their mentor's method; and only those who habitually experiment with new techniques on a trial and error basis manage to develop an entirely new style of teaching.

Neither art teachers nor science teachers collect objective evidence of the results of their teaching style; instead, they base their decisions on their empirical impressions of how students respond to their method. Both believe the primary ingredient of good teaching is the subject-matter expertise of the teacher, and both respect demonstrated truths. But both fervently believe they teach better than trained pedagogues, so neither is likely to read about teaching methodology nor make use of the university's instructional resources.

Teachers in both art and science worry about the quality of their teaching. They work hard at it, and they work to improve their teaching skills. Further-

more, instructors in both disciplines hold fast to the notion that the essence of genuine teaching is person-to-person instruction. If asked to choose between the importance of taking courses in their professional area versus courses leading toward a broad liberal education, they will both choose specialization. Finally, I will reiterate that teachers in both art and science believe that expertise in subject matter is the *essential* ingredient for success as a college or university teacher (Risenhoover and Blackburn 1976, 200–1).

Besides the two books offering advice to young scientists, two well-known books of published letters offer advice to young poets: Rainer Rilke's *Letters to a Young Poet* and Llewelyn Powys's *Advice to a Young Poet*.

The art field too offers little more than its obligatory two books: the best known, *The Art Spirit* by Robert Henri—who was one of the most charismatic, influential, and idolized painting teachers in modern history—offers only a few tidbits that are relevant to today's art; the best, I believe, is Hiram Williams's small book, *Notes for a Young Painter* (1963). It was an excellent book for young modernists. I bought a copy when first it appeared, and it has been a heavy influence and guide to me and my students over the years.

But Williams's book concentrated more on his own work, his own useful opinions, and some valuable personal insights into art criticism, while I will aim my book more toward a general strategy that I have seen work well for many young artists. And I will support this advice and strategy with the views of those who have achieved success in art, or with the results of studies that examine the process followed by those who have achieved success.

After attending three major art schools, and after more than three decades of working with graduate students—who had attended many other art schools across the nation—I have noticed that certain ideas, disciplines, and methods facilitate learning and often seem to be a prerequisite to success. I believe these ideas are of vital importance to young artists.

I will offer my view of several topics that young artists should be aware of. If some find my point of view inconsistent with their own, perhaps this book will, nevertheless, stimulate them to develop their own awareness and opinions about these important topics.

Discussion at its best offers few answers; it generates awareness. And awareness breeds learning. I can learn anything I am aware of, but I cannot

learn what I do not suspect. Perhaps I can help young artists eliminate some of the wheel spinning and blind alleys that sap their time and energy when they are left to their own devices. I hope to stimulate young artists to find their own answers to some of these important questions, or, more important, to find their own *questions*—the one indispensable ability that I will demonstrate is crucial to success in both art and science.

I believe that much of the advice that is offered to younger scientists, poets, and artists is too narrow or irrelevant. Such advice is often too specific to individuals or particular works or styles, or it wanders into peripheral areas as far afield as what foods to eat, morality, and even sex. I will avoid advice on food and sex because I am not aware of any practices related to these areas that have any bearing on the competence, the learning process, or the success of an artist. Moreover, I cannot (or will not) demonstrate that I have any special knowledge or expertise in either subject.

I will also avoid any discussion of morals because that also seems unrelated to artistic abilities; artists through history have run the gamut from wantons to moralists, from aggressive to meek, from the self-centered to the selfless. Furthermore, I have noticed that many of the moral principles instilled in me in my youth were based more on the prejudices of the period, the geographic locale, or the ethnic point of view in which they originated than on any universal truth. The most high-blown principles, it seems, can be whitewashed prejudices.

But, when I discover that a successful artist, poet, scientist, or teacher has offered advice that I believe is pertinent to the training of young artists in this era, I will pass along that baton to those who follow.

Many artists with extensive experience will disagree with, or find alternatives to, certain parts of this book. I would hope that instructors who assign this book to their students would use it as a departure point for discussion and for the airing of those parts they may disagree with. ⌐

Acknowledgments

TO THOSE WHO WISH TO TAKE IDEAS APART and play with them, like a child with a broken watch, it is imperative to have a peer group to immediately share any exciting discoveries with.

In writing my previous books I received invaluable help from my peer group on the local university campus where I teach; but in writing this book, the peer group I turned to was the group of recent friends I have met on the Internet, primarily in discussion groups. I have had the privilege of sharing most of the ideas I present here with people from all over the world and I have benefited from their advice and candid corrections.

I particularly exploited the opinions of the people that I felt had demonstrated to me their expertise in some relevant area of art. Such Internet friends as Thomas Kitts and David Newman helped keep me in touch with accuracy and reason when I strayed too far. But I especially value the help that Ric Dragon, a painter from New York, offered when he read the entire manuscript and made many helpful suggestions, while rigorously challenging some of my assumptions.

The friend who helped the most was Ben Mahmound, a respected and successful painter who has taught at Northern Illinois University and exhibited at Sonia Zaks Gallery in Chicago for decades. I used several of Ben's suggestions throughout the book, and he wrote the section on taxes for the artist in one of the later chapters. ✌

Advice to
Young Artists

in a Postmodern Era

Talent, Intelligence, and Art

INTELLIGENCE IS NOT GASOLINE. Our society tends to harbor the idea that intelligence is a quantifiable single substance like gasoline. We tend to believe that both the quick and the slow have more or less of the same substance, but some simply have more of it. We think that some people have a full tank while others are running near empty. This model of intelligence is not useful for young artists—nor any other student for that matter.

Intelligence is not a simple one-dimensional substance that can be measured the same in both the swift and the halt. The difference between those we *think of* as intelligent and those we *think of* as slow is more a difference in kind than in degree.

A discussion of well-known theories of intelligence—such as Piaget's cognitive development, information-processing psychology (cognitive science), or the symbol systems approach—will be of little value to creative people. First, these theories are too complex to offer a useful model or analogy to artists. Second, these theories tend to concentrate on problem-*solving* behaviors, but I will demonstrate that the most important ability for those in creative areas is problem *finding*. I would like to offer a more useful model for this discussion. I will offer a heuristic explanation (a lie that helps us understand a more complex reality) of the workings of the intellect.[1]

For most young artists, intelligence might be profitably perceived as a complex combination of abilities, habits, priorities, interests, and activities that can either impede or facilitate learning and creativity. So-called normal people (those without demonstrable learning disabilities) whom we

1. My construct might be perceived as somewhat closer to the "useful fictions" that Howard Gardener outlines and documents thoroughly (Gardener 1983). But Gardener too focuses on problem-solving abilities and tends to treat these abilities as more separate, autonomous, inborn, and immutable than I feel comfortable doing.

consider slow have often formed habits and priorities that make it difficult for them to learn. Furthermore, normal people who have difficulty learning often lack interest and curiosity about subjects that we tend to associate with persons of intelligence.

Our society tends to *perceive* as intelligent those who occupy their time with so-called intelligent pursuits. Compare two people of the same native ability and intelligence: one may watch television and drink beer all day when he is not out on his snowmobile; the other may spend time reading and discussing philosophy and history. Most of us will think of the first as normal or slow, while we will probably think of the second as bright, perhaps even brilliant. We tend to perceive as intelligent those who have spent their time pursuing and mastering subjects that we consider "intelligent" subjects. And what we consider intelligent subjects are disciplines that are traditionally learned in school, and learned through reading: philosophy, the arts, science, literature, history, etc.

There is no more certain indicator of intelligence than an insatiable curiosity. I have never met a child who was exceedingly curious and seriously interested in any subject that can be learned through reading who did not appear to be bright. The child who reads about dinosaurs, spouts their names, and discusses their habits will be perceived as bright. Even the child who quotes baseball statistics will be perceived as bright, while the child who hits the home runs that the other studies may be perceived as slow in class. In short, those who spend their time pursuing what we consider the realm of the intellect will generally be considered bright.

Consequently, intelligence might profitably be thought of as an activity rather than a stable gift delivered to us at birth. There are, of course, those who are genetically incapable of learning at any higher level. And there are impediments to learning, such as the array of learning disabilities, dyslexias, and dysgraphias; but these can often be overcome by determined and consistent practice (which professionals in learning disabilities delight in calling "remediation").

I have known three bright well-read college teachers who started school with dyslexia. Several years ago one of my better freshman students told me he was seriously dyslexic. He was an unusually disciplined and determined

hard worker, but he was barely passing his academic classes. I told him he could greatly improve his reading ability if he would establish a consistent pattern of reading.

I explained that he should schedule at least four days a week when his commitments would allow him to read, if only for thirty minutes, then he should read for that thirty minutes *every* day he had scheduled. He should read longer than thirty minutes only if he was enjoying it and wanted to do so. Being determined, he did more than I suggested. Four years later, when he took my seminar class as a senior, I was delighted to discover that he had become the best reader (though still somewhat slower than some of the others) in that class of graduating seniors. He demonstrated a deeper understanding of the assigned material than anyone else in class. He had also become one of the best painters in that department. I firmly believe the two things are often related.

Doing well in college depends on several tricks, or learned behaviors. In thirty-five years of teaching I believe I have encountered only five students who lacked the intelligence to do college work, and do it reasonably well. The most successful students do most, or all, of the following: they go to class consistently; they take good notes, then reorganize and rewrite those notes before the next class; they study and share their notes with a group; some of them even do extra work or reading for classes; and if they have a learning disability, they seek help, which is available to them at most colleges and universities. Furthermore, those who are generous enough to help slower students learn even faster yet. No one learns faster than new teachers.

Students who flunk out rarely do any of these things. Some are too young and have failed to develop a serious interest in their major. Though many younger students may pass their classes easily, I find only a few students under the age of twenty-five who have the discipline and determination to excel. Younger students usually do not know how to study, or they lack discipline, or interest, or all of the above.

A few students freeze during tests and thus may perform significantly below their ability. Almost no problem can be solved as simply and easily for many students as freezing on tests: Chew gum while taking tests.

Let me state an empirical fact that should be, but surprisingly is not,

Talent, Intelligence, and Art

familiar to everyone: Learning to do a thing well requires an immense, even a painful, amount of effort, whether that thing is athletics, academics, or art. The first thing athletes learn is: "no pain, no gain." Marathon runners know they will not excel by running only on those days they happen to be in the mood. They know they must run every day they are scheduled to run. They know they cannot quit when they feel pleasantly tired. They must run till they are very tired, then they must run till it becomes so painful they cannot run anymore; then they must run some more. Furthermore, they must do this consistently—day after day. It is not enough to finally, on the day of competition, work up a serious determination to win, as so many movies about athletes mislead us to believe. The determination must be there through the years of training.

This determined and sustained effort is accomplished either through love of or obsession with that activity or through self-discipline—ideally through both. The kind of self-discipline that prompts a young artist to steady work may substitute for a while for the obsessive need to do art. Often the discipline of steady work may even help develop the kind of interest and love of the subject that compels artists to work constantly; and it also develops habits that will serve such an obsession well. I find it tiresome to hear "I'm working my butt off. I don't seem to have enough time in the day to get all my work done." Conversely, I know that a young artist has potential when I hear "What a great week! I had a lot of time to do nothing but what I wanted. I painted (or photographed or metalsmithed) all day every day."

Learning any subject is frustrating at first, and art demands as much pain tolerance as any athletic endeavor, but it demands a tolerance for emotional frustration, failure, and rejection rather than physical pain. Art is exceedingly frustrating for beginners during the first two to five years. Nothing they do goes the way they intend. Everything they do seems worthless, inept. Much of my time in studio classes is spent telling students "Yes, I know that particular drawing (or painting or sculpture) is not as good as you hoped it would be. I know you don't have any idea what you are doing yet. I know it hurts. It always does. It's supposed to."

If young artists drop out of art school for a year or two and still continue to work regularly during that time when they have no outside encouragement or access to studios and equipment, they probably have a strong potential in art. Those who are not serious will find excuses to avoid work as soon as they leave the hothouse atmosphere of the university. And they will do the minimum required while in the university. But those who are serious will find a way to work, even if they have to sit at their kitchen table and do miniatures.

Furthermore, there are many routes to learning, and a serious student will use them all. The best learning situation uses a balanced combination of the empirical (practice) and the conceptual (theory). Without steady practice, guided by concept, no one learns to swim or play tennis well: they cannot learn from books and coaches alone. But neither do they learn to do these things at a competitive level by unsupervised practice alone. To learn anything well it must be studied from all possible angles. Books offer conceptual insights and understandings that cannot be gleaned from practice alone.

Furthermore, few athletes reach the big leagues without the help of an excellent coach somewhere along the way. The same is true of most artists, politicians, and actors. Most of the successful people in any field have been lucky enough to find a sponsor—a competent coach, teacher, mentor, or helpful professional—early in their career. And they had the good sense to listen and to practice what they learned.[a]

Art students hear anecdotal accounts of artists who claim to be self-taught or they hear about successful artists who decided they knew more than their teachers and dropped out of art school to become famous. What they do not hear is that most of the "self-taught" did have the advantage of excellent teaching at some point: the baton of competency was passed from Donatello to Verrocchio (Donatello's student) to da Vinci (Verrocchio's student). Successful artists who quit art school usually did so after several years, when they had already come to understand that they *finally* knew more about *their own direction* than their teachers did. All good artists must reach this stage. But it is self-defeating to *think* they know more in the beginning. Timing and an objective view of one's self are critical.

Gauguin, for instance, did not attend art school, but after years of unpro-

ductive painting, he quit his job and began to run around with helpful friends such as Pissarro, Cézanne, and Emile Bernard. These well-trained professionals taught Gauguin everything he knew about painting. In a letter to Maurice Denis in June 1899, Gauguin admitted: "I have really 'stolen' so much from Emile Bernard, my master [in] painting and sculpture, that (he himself has said it in print) he has nothing left" (Gauguin 1978, 178). Gauguin had the good fortune to study under the best and the most advanced and up-to-date artists of his generation. Art school is a mere substitute for such an ideal learning situation. Young artists who have access to the kind of expertise that Gauguin did, and who are willing to listen, need not go to art school (unless they want a degree that enables them to teach).

Most artists who claim to be self-taught did attend art school before they knew enough to claim they knew more than their teachers. Most young artists cannot fully understand why they do not need art school until they have developed the ideas and awarenesses that they develop in those very art schools, which they then do not need.

With various different routes to knowledge at their disposal—books, practice, teachers, museums, studying the works of other artists—why should young artists purposely cripple their development by rejecting one or more of these valuable resources? The typical reason young artists refuse to accept suggestions is because they labor under the obsolete romantic misapprehension that one must be a "genius" to produce good art. And genius, they believe, needs no teacher. In fact, some seem to think that accepting a teacher proves the lack of genius. "Genius," however, is an old-fashioned modernist concept that first budded with Leonardo and Michelangelo and burst into full bloom only with the advent of the romantics in the late eighteenth century.

Postmodernists do not accept the idea of genius. They believe art is a collective product of the society in which the artist exists. In short, they believe the culture paints the painting, carves the sculpture, or throws the pot. The artist is simply the tool through which society organizes and expresses the ideas that run rampant though it. Society was saturated with the kinds of ideas that Monet and Freud each organized into a cohesive whole. If these two had not come along when they did, postmodernists reason, someone

very much like them would have taken their place in history to fill the demand for such images and ideas.

Classicists such as Sir Joshua Reynolds and Ingres believed art could be taught. They fervently believed that art demanded certain competencies: composition, control of pictorial space, sensitivity to proportion, value control with a knowledge of color, as well as the necessary craft to fabricate the material work.

Romanticists such as Gainsborough and Delacroix, on the other hand, believed that true art was produced only through the efforts of genius. These two different beliefs create two different results: the worst of the well-trained classicists are, in my opinion, not nearly as bad as the worst of the romanticists, and the best of the romanticists may arguably be a little better than the best of the classicists.

Still, I find it interesting that the work of the best of the romantic "geniuses"—Delacroix, for instance—demonstrates strong classical competencies. Somewhere during their development the best romantics seem to have acquired the kind of structures that classicists prize so highly: composition in dark and light, spatial composition, sensitivity to proportion, value control, etc. Romantics, however, seem to toss these competencies off with more abandon and less coaxing, picking, teasing, and meticulous control than their more careful classic counterparts.

I find myself mostly in agreement with the postmodern repudiation of the idea of genius, but I have to admit that a few outstanding historical figures make this thesis hard to defend in its entirety: Michelangelo and Einstein, for instance. It is hard to argue that those two did not demonstrate genius. Perhaps the concept of genius is open to interpretation and may have no permanent answer, but I will caution that if the idea of genius is to be embraced, the label must be awarded far less often than some do. And if there is such a thing as genius it is not measurable by tests. Genius is not the same as intelligence. Those who register an IQ test score of 150 or above have no claim to genius—none whatsoever. The score simply indicates that they are blessed with a facility for learning easily.

The title of genius is not awarded for potential.

Genius is measured and awarded only on the basis of accomplishment. A

person who has accomplished something astounding of worldwide importance to the century they live in—an accomplishment that generates profound effects on disciplines other than their own—might be awarded that label, but it is misleading to apply the label of genius to every bright author, movie director, professor, student, and wine taster.

Furthermore, because so-called geniuses are obsessed with their subject, they tend to produce great quantities of work. The nineteenth-century Welsh poet Llewelyn Powys wrote many letters of advice to a young poet named Kenneth Hopkins, who later achieved his own success and taught at an American university. When a student asked if there were genius in the poetry he had written for Hopkins's class, Hopkins answered: "Well, I won't say whether you are a genius or not, since genius implies both quantity as well as quality"(Powys 1969, 125 n).

Perhaps the most limiting misapprehension that a young artist can harbor is the belief that art is a natural talent. Psychologists are quick to note that abilities in math and math-related activities such as chess and music are true talents. Art, however, is primarily a discipline. There is a demonstrable difference between a talent and a discipline: talent is demonstrated in fields where the very young have been known to perform at professional levels, but ability in a discipline is manifest much later in life. A true talent may show up as early as six or twelve, or even earlier. It is well known that Mozart was performing at a professional level at three (though not, of course, at the level he accomplished as an adult). Many child prodigies have been hailed as genius at six or twelve because they demonstrate a professional mastery of math, chess, or music.

This never happens in art. Never.

Traditionally, artists have rarely made any lasting contribution before the age of thirty-five (except, of course, Masaccio, who died at twenty-seven). Picasso bragged that he was an accomplished academic painter at fourteen. He labored under the worst part of the modernist illusion that his genius was outside the bounds of society, and he often claimed that he knew at fourteen what other artists were still trying to learn at twenty-five. But his work does not demonstrate the truth of this claim. His work at that age,

owing to the training his artist father gave him, looks a little like the work a facile but uninspired senior in a traditional academic art school might have produced at the end of the nineteenth century. The work demonstrates that Picasso still had a lot to learn academically, and it shows nothing unusual or imaginative in direction or concept.

Among my students, over a period of thirty years, several have become successful and now show what many would label strong talent, but I do not remember a single one of them that I thought demonstrated such talent during the first year or two (though some of them demonstrated an unusual focus and determination). Now and then I came across a freshman that I thought was the best freshman I had ever seen. Generally, when I thought I perceived this early talent in a student I was swayed—despite my better judgment—by rendering technique and a somewhat unpredictable, personal, and consistent image quality. Only one of these students ever improved much. As seniors they still looked like the best freshmen I had ever seen.

In every case their work looked good at first because they had been drawing for years and had already developed a skill and consistency that may pass for a while as talent or potential—a skill that was far in advance of their classmates. But each of them also labored under the handicap of premature craftsmanship: because they could render well, because they could draw photographically, they had already developed their own lay support group. They had friends outside the art world telling them they were talented and genius, and warning them, "Don't let those art teachers mess you up."

A well-known Zen koan tells of a famous scholar who decided he could profit from learning Zen technique. He arranged an interview with a Zen master, and during the interview he related all his accomplishments and explained to the master what he wanted to learn and why. He explained how Zen pertained to his expertise and how he would apply the principles to his field. As he spoke, the master lifted a teapot and began to pour tea into the scholar's cup, while he looked attentively at the speaking scholar. When the tea filled the cup he seemed not to notice and continued to pour. The tea spilled onto the table.

"Stop!" exclaimed the scholar.

Talent, Intelligence, and Art

"What's wrong?" asked the master.

"My cup is full. It won't hold any more."

"Yes," replied the master. "That is how you come to me. Your cup is so full there is no room for more. You must first empty your cup."

The more time students have previously invested in the practice and skill it took to fill their cups, the more difficult they find it is to discard those hard-won skills when they are introduced to new ideas. For instance, students who have invested years of practice developing their rendering skills are rarely enthusiastic about discarding those skills to explore other directions. Consequently, they often find themselves married to a direction before they have developed the conceptual ability to discriminate the profound from the cliché—marriage before puberty, so to speak. This is particularly true of new graduate students who may have spent years learning a direction and are suddenly asked to question that direction and perhaps try several new ideas to discover their natural abilities.

Many graduate schools seem to encourage this kind of premature marriage. They seek graduate students who have already developed a consistent direction; and they want them to continue that direction. I believe this encourages young artists to solidify their direction too soon. It encourages them to settle for "pretty good," when they should be searching for and demanding "damn good." Graduate school, for most young artists, should still be a fertile period of searching for new awarenesses, characterized by great ambition, risky and courageous assaults, and colossal failures. Remember: few artists find a meaningful direction, or even know if they have potential, before they are thirty-five. George Burns once said, "By the time I realized I didn't have any talent, I was too big a star to do anything else."

In my years of teaching I have met three kinds of young artists: the conformists, the anticonformists, and the nonconformists. Two of these are absolutely predictable and thus, I believe, handicapped. I know in advance that the conformists will do whatever they are told. They tend to be guided by *who* is doing the talking, instead of listening carefully and weighing *what* is being said.

I also know in advance that the anticonformists will take no suggestions.

They are afraid to be influenced (as if it were possible to live in this society and escape influences). They presume that learning anything from anyone demonstrates that they have none of that mysterious substance they call "talent"—as if they believe that those with real talent achieve their accomplishments without learning.

The nonconformists are unpredictable. They will listen with an open mind to what is said, then decide for themselves whether or not it interests them. Or they may recall and use the advice years later when they need it. Blessed with competent instructors, they improve consistently and ultimately find their direction. It is common knowledge that most successful artists are nonconformists, but students are prone to confuse nonconformist with anticonformist.

Anticonformists are knee-jerk thinkers. They tend to reject even traditions that are spectacularly successful. They insist on change for the sake of change. They often thoughtlessly insist on doing something another way just because it is different. A four-foot pile of manure in the middle of the living room may be different, but it is not likely to offer a successful viable alternative to the traditional method of furnishing a living room. Nonconformists, on the other hand, are reflective thinkers. They will learn anything that is relevant to their interest, but they do not perform past rituals mindlessly. They reevaluate everything. They continue traditions that they perceive as useful or relevant to their time and interests, but they do not hesitate to discard practices that no longer make sense if they can offer an alternative that is better than, or as good as, the traditional practices.

Some young artists may refuse to accept instruction because they harbor the fear that conscious analytical attention will kill their spontaneity. This often misunderstood but legitimate concern is best illustrated by Gustav Meyrink's, story "The Curse of the Toad". A graceful centipede once danced in the village square. His enemy, the toad, was jealous; so, when the centipede took a short rest the toad approached and admitted that, having no more than four feet, she was not nearly as graceful as the centipede. She claimed, however, that she was quite good at calculations. Yet, she said, she could never understand how the centipede coordinated all those legs at

once. How did he know which leg to move first, or which to move second, or third, or sixth? What is the forty-eighth leg doing when he moves the sixteenth? After considering these questions for a moment, the centipede discovered he could do nothing but twitch a few individual legs in a completely unorganized fashion. He never walked, much less danced, again (Arnheim 1989, 57–58).

I know a tennis player who psychs out her opponents in much the same manner. When she is losing a close match, she looks for that which her opponent is executing best—something she is doing automatically without thinking—and forces her to think about it. As they pass at the net between games she will say: "You've got a killer serve. It's ruining me. You're bringing your elbow up high next to your ear, dropping your racket behind your back till it almost touches your belt, reaching high as you swing, and breaking your wrist at the exact right moment. Your serve just whistles." Her opponent had practiced that serve so long she could do it automatically, without thinking; but she now finds herself thinking about it. Invariably that serve is gone for the day—and with it, the rest of her game.

This is the old Zen trick of focusing attention on something you do every day and, by doing so, making it impossible: Drink this glass of water and do not think of the word "alligator." The best psych-out I have heard in tennis is: "When you raise the racket to serve, do you breathe in or out?"

This stifling of spontaneity is a legitimate concern, but it is often misunderstood and feared beyond reality, and for the wrong reasons; furthermore, such misunderstanding and fear can seriously hamper a young artist's progress. It is important to understand that you cannot kill the spontaneity of newly acquired skills, because new skills have not yet become unthinking habit. Spontaneity can be killed only when a skill has been perfected to the point that it no longer demands conscious thought.

In *Thoughts on Art Education*, Rudolf Arnheim tells us that the beginner's fear of losing spontaneity is a recent attitude, and it exists in Western cultures only. He notes that when beginning actors and dancers are first asked to apply specific rules to actions that they have always done naturally and unconsciously (like standing, walking, or talking), they find their body, limbs, and voice suddenly stiffen and move woodenly (Arnheim 1989, 58).

Advice to Young Artists

This intermediary stage takes place in most learning. But the gains, Arnheim explains, are worth the temporary frustration. New techniques typically drop out of consciousness after serious practice and soon become second nature. He contends that only individuals with weak intuitive impulses and control, or those hampered by other influences, can afford no outside distraction. I would add that impatient students, with weak self-discipline and low tolerance for frustration, cannot seem to bear waiting through the frustration; they are tempted to pursue quick results that they can recognize immediately, and they cannot tolerate suggestions or criticism. Sir Joshua Reynolds put it well in the eighteenth century:

> The impetuosity of youth is disgusted at the slow approaches of a regular siege, and desires, from mere impatience of labour, to take the citadel by storm. They wish to find some shorter path to excellence. . . . They must, therefore, be told again and again, that labour is the only price of solid fame, and that, whatever their force of genius may be, there is no easy method of becoming a good Painter.
>
> When we read the lives of the most eminent painters, every page informs us, that no part of their time was spent in dissipation. Even an increase of fame served only to augment their industry. (Reynolds n.d., 11)

To excel in art, karate, medicine, philosophy, or golf, novices must first discard the awkward movements, methods, and thinking of the beginner and learn entirely new and more efficient methods. They must restructure their approach from the ground up.

Though there is considerable agreement among teachers as to the character traits they feel are linked with success in art, their "feelings" are difficult to substantiate objectively. However, Jacob Getzels and Mihaly Csikszentmihalyi substantiated some of these feelings in a solid and elaborate study of the personal characteristics that *tend* to facilitate artistic success. They focused on the sophomore and junior classes at Chicago Art Institute because that school has many art students, which they felt was necessary to validate the study; they also believed that students there tend to be

Talent, Intelligence, and Art

more serious and committed than undergraduate art majors at many other schools. For two years they studied students' backgrounds, both academic and family. They interviewed, observed, and tested these students for everything imaginable. They interviewed and observed these students and administered a multitude of tests, including tests for drawing, IQ, spatial relationships, and problem-solving and problem-finding abilities.

Five years after the tested groups graduated, Getzels and Csikszentmihalyi contacted them again to evaluate the success, or lack of success, of individuals and searched for any recorded abilities or behaviors that were held in common by either the successful or the unsuccessful group. This is the only major longitudinal-controlled study of characteristics that generate success in young artists that I am aware of.

They discovered several predictable and a few surprising correlations. Some of the relationships they observed are beyond the control of the individual artist; I will not report these because I see no value, and some possible harm, in knowing them. Such knowledge (which tends to note only general tendencies) could easily discourage and impede some individuals rather than help them. The original book is available to those who feel they would like to know such things as the *tendencies* for family situation and order of birth among successful artists.

The authors did observe several key discoveries that seriously affect a young artist's potential for success in the field, and these discoveries referred to behaviors that can be encouraged, practiced, and controlled.

Getzels and Csikszentmihalyi enlisted the aid of both a gallery director and an art critic to evaluate the thirty-one students of the fine arts who had completed the study and were available for follow-up seven years later. The gallery director was already acquainted with eight of the former students, the art critic knew seven and had written about some of them, and four of these were also known to the gallery director.

Nine of the thirty-one former students had established recognizable identities in the art world (Getzels and Csikszentmihalyi 1976, 163–64). One had achieved as much success in the five years after graduation as any artist could hope for: his work had been shown in the best galleries, he had been

the subject of critical articles in the most prestigious art journals, and one of his paintings was in the permanent collection of a "great" (whatever that means) museum of art (164).

None of the conventional cognitive tests they had administered, and none of the tests for personal value scales, were demonstrated to be significantly related to success in art (169). But one of the more uncommon tests was quite closely related to future success: students who demonstrated problem-*finding* behaviors produced more original works during art school than did those who demonstrated problem-*solving* abilities. Furthermore, the problem finders also enjoyed far more success in the real art world (is "real art world" an oxymoron?) five years after graduation. The authors of this seminal study concluded that the tap root of creativity is the "questioning, metaphorical, playful, and problem-finding components of thought" (171, 169).

Creativity is practically synonymous with problem *finding.*

Artistic activity seldom consists of the solving of preexisting problems (243). Furthermore, problem-finding ability is important to success in both science and art. Outstanding scientists have stated time and again that the discovery and formulation of exciting problems is more essential than the solving of them; and "it is a more imaginative act." Computers and machines solve preformulated problems quite efficiently, but "the fine artist, the inventive scientist, the creative scholar, the innovative statesman, the self-actualizing person" can generate previously unformulated problems (248, 250).

The drawing tests that Getzels and Csikszentmihalyi administered demonstrated another important characteristic that seems to have a direct bearing on success in art: the tendency to delay or prolong the development of a recognizable image. This tendency has nothing to do with how long the student spent executing the drawing—nor was it related to the final degree of abstraction or realism. It refers to the period it takes to develop an image to the point that it can be named or recognized (this includes recognizable structural images such as linear perspective or dark-light compositions).

Five years after graduation, students who had a tendency to develop their images and structures early in the drawing process enjoyed far less success in the art world than those who experimented more and kept their drawings in

flux longer (176–77). None of the ten students with the highest scores in the delay of closure in drawing had dropped out of art six years later, but eight of the eleven students with the lowest delay scores had dropped out (181).

Getzels and Csikszentmihalyi believe their findings demonstrate that those who look "at problematic situations with an open mind, ready to let the issues reveal themselves instead of forcing them into a preconceived mold" increase their "chances of discovering original responses" (159).

After considering that their book was published in 1976, my first response to this observation was that it might be nothing more than a biased and predictable response from teachers and critics who had been shaped by modern attitudes, specifically by the attitudes of abstract expressionists who valued a "loose" technique. Keeping an idea in flux longer creates more changes of direction and image during the development of a work and would naturally tend to lead an artist toward a "looser" technique that focused more on process than on product—a hallmark of abstract expressionism.

But after some reflection I think that perhaps this tendency to delay discovery might well be a lasting and fundamental trait of many (but not all) successful artists as well as scientists. Even Picasso, whose work often appears to be hard-edged, preconceived, and "tight," as marked by clearly defined and assertive silhouettes, explained his process in these words: "The picture is not thought out and determined beforehand, rather while it is being made it follows the mobility of thought" (Zervos 1961, 57). And Gertrude Stein advised young John Preston: "You will write [well], if you will write without thinking of the result in terms of a result, but think of the writing in terms of discovery, which is to say that creation must take place between the pen and the paper, not before in a thought or afterwards in a recasting" (Preston 1961, 159).

Artists and scientists who know before they start an experiment what results they will find are less likely to find anything new; they are more likely to find what they expect to find rather than what happens. They are less likely to notice unpredictable effects or to make exciting discoveries. History has forgotten the multitudes of artists and scientists who have stumbled upon something exciting and simply overlooked it because they were looking for something else.

Advice to Young Artists

Related to this attitude was the following observation by Getzels and Csikszentmihalyi: when asked, "Could any of the elements in your drawing be eliminated or altered without destroying its character?" eleven out of the fifteen students who later dropped out of art answered no, and ten of the sixteen who remained in art and had some success answered yes. Those who were unsuccessful had a tendency to believe they had found the only acceptable solution, but those who later succeeded understood that they had discovered only one of many possible solutions. Getzels and Csikszentmihalyi presume that this is the attitude that has traditionally prompted great artists to experiment with the same theme again and again; such artists often find certain subjects to be inexhaustible, knowing all along that each solution merely introduces yet another problem (Getzels and Csikszentmihalyi 1976, 180).

Think of all the art history books, teachers, and critics who have argued that some work of art was demonstrably superior because nothing in it could be changed one iota without destroying the whole—as opposed to the best artists' belief that there are many alternative solutions to any problem. Many aesthetic problems generate endless iterations, or repetitions built upon preceding solutions. The problem, not the solution, is important. Those whose priorities lead them to concentrate on detail, accuracy, and being "right" might be better suited to engineering than to art.

As Gertrude Stein lay dying, she looked up at Alice B. Toklas and asked: "What are the answers, Alice?"

Alice, immobilized by her tears, shrugged helplessly.

"Okay, then, Alice," said Gertrude with a last shy sly smile, "what are the questions?" ⌐

2

Reading—and Reading Right

OUR SCHOOLS TEACH STUDENTS TO READ WRONG.
Reading is the primary key to learning everything. And all schools that I
have seen, or received students from—public and private, colleges and uni-
versities—condition students to read slowly and carefully for facts, not
quickly for ideas.

Schools habitually choose texts that concentrate on names, dates, and
locations—facts that are easily understood and easy to test for. Students are
then encouraged to fill their minds and memories with facts, most of which
can easily be looked up at any time in any reference book. These schools con-
vince students that education is an accumulation of facts—mostly useless.
Such memorization of facts takes too much time for any possible gain, and
it wastes the critical formative years of education.

Facts increase knowledge but not understanding.

Neither scientific nor artistic progress are achieved by adding more detail
or accumulating more knowledge within existing categories or paradigms:
"Progress," as Suzi Gablik tells us, "is made by leaps into new categories or
systems" (Gablik 1977, 159).

The Japanese have always made an important distinction between knowl-
edge and understanding. Some of the people I have met who know the most
facts have had little understanding. I would like to make a distinction
between knowledge and competency. I have had several students who were
so bright it was scary, but, as I came to know each of them, I discovered they
had all formed different habits than had students of apparently lesser abili-
ties. Bright students are interested in ideas.

Ideas = intelligence.

Those whom we consider bright have different habits, priorities, and
interests. Furthermore, those whom we consider bright approach reading in

an entirely different manner than do those whom we consider limited. Those with limited imagination and potential feel comfortable reading *only* material they can easily understand. Any material that they feel is beyond their comprehension tends to make them feel stupid. They feel like failures; consequently, they avoid it. Hence they usually read simple narratives, histories, biographies, and material full of easily understood facts.

They avoid speculation and concept.

They would insist that they avoid concept because it bores them, but perhaps they are bored in situations that make them feel uncomfortable. Most who steer clear of concept do not do so because the concepts are too difficult, but because books that emphasize concept often assume too much preliminary knowledge from readers, or because many of them are tortuously written and boring to struggle through. Academics are often bad writers; they want to state their ideas safely, hence they write too much in the passive voice: Tom was dispatched by Bill, rather than, Bill killed Tom. I believe any concept can be explained clearly to any normal person, if it is explained carefully and clearly. Concept becomes complex only when several simple ideas lock together to form a single cohesive construct.

Those whom we perceive as bright, on the other hand, tend to welcome challenges; hence they tend to read more difficult material. They are fascinated by new ideas. Let me assume without argument for a moment that the scores on IQ tests are meaningful.[1] If two people at the same IQ level (110 to

1. A letter in the *Wall Street Journal,* signed by fifty-two experts in intelligence and allied fields from most of the major universities in the United States, insists that "intelligence is a very general mental capability that, among other things, involves the ability to reason, plan, solve problems, think abstractly, comprehend complex ideas, learn quickly and learn from experience." Furthermore, they insist that "intelligence, so defined, can be measured, and intelligence tests measure it well. They are among the most accurate (in technical terms, reliable and valid) of all psychological tests and assessments. They do not measure creativity, character, personality, or other important differences among individuals, nor are they intended to do so." They also conclude that, "IQ is strongly related, probably more so than any other single measurable human trait, to many important educational, occupational, economic, and social outcomes. Its relation to the welfare and performance of individuals is very strong in some arenas in life (education, military training), moderate but robust in others (social competence), and modest but consistent in others (law-abidingness). Whatever IQ tests measure, it is of great practical and social importance.

These experts hold that this information is "regarded as mainstream among researchers on intelligence, in particular, on the nature, origins, and practical consequences of individual and group differences in intelligence"(Arvey et al.1994).

Reading—and Reading Right

pick an arbitrary number) read different kinds of material for long periods, they will not remain at the same level.

IQ, or learning potential, it was once believed, was a set quantity and changed little after the age of five, but we now know that it often changes considerably, even between the ages of twenty and forty: in professions that are encouraged to continue reading and learning substantive material after graduating from college, the measurable IQ may increase immensely.

Assume that subject A feels comfortable reading only material that she understands completely, while subject B, with the same IQ of 110, feels comfortable reading material she does not entirely understand. This may result in subject A reading at an IQ of about 90 (Mickey Spillane perhaps, or western novels), while B may be reading, though not entirely understanding, at an IQ of 130. Over ten years each moves toward the level of the material they read. Consequently, the cumulative difference in reading material creates two entirely different persons whose IQs are no longer similar.

Two experts in the psychology of reading, Henry Smith and Emerald Dechant, note that good readers have better vocabularies and higher intelligence than nonreaders (Smith and Dechant 353). And good readers usually gain that ability through practice: quite simply, they have spent more time reading. Consequently, if subject B now happens to reread something that she did not understand when she read it ten years earlier, she may think: Why did I think that material was difficult? It seems so simple now.

When we read texts that contain ideas we do not understand, the material that we do not understand is not simply discarded or ignored. It gets planted, like a small seed, somewhere in the back of the mind. Each time we read something that relates to that idea, the seed is nourished. Suddenly then, after months or even decades, we discover that the seeds of all those ideas we have planted and tended through reading have grown into mature trees.

Reading plants, nourishes, and grows ideas.

Consequently, after ten years of reading beyond her abilities, subject B has grown a forest of complex ideas, and many of them are beginning to mature. Furthermore, because B is now aware (even dimly) of more ideas and concepts than A, she is likely to understand far more of any difficult material she

encounters, while A's capability may even regress. Smith and Dechant tell us quite clearly: "The greater the number of concepts that the reader has fixed through words, the better tends to be his understanding of what he reads." They also tell us that good readers generally have better abilities in two areas that are important to artists: they can think in categories better and they handle abstractions better (38).

"Work beyond your understanding" is good advice to writers as well as artists. When his university students select a subject to write about, the excellent writer and essayist Roger Rosenblatt tells them: "Do not understand it." Consequently, readers, writers, artists, scientists should seldom attempt to furnish answers; their purpose should be entirely conjectural.

Conjecture is closely related to problem finding, and it is perhaps the heart of the learning attitude, it is also at the heart of the postmodern attitude. Conjecture is in direct opposition to the modern goal of determinism. Determinism is the belief that all events have clear-cut causes. The postmodern theorist or artist is suspect of any answer that purports to be the only correct answer.

Anselm Kiefer, perhaps the most respected postmodern artist, uses his work to explore his points of view and sentiments and their relationship to the collective sentiments of his entire society. He explained: "I wanted to evoke the question for myself, Am I a fascist?" He insists that "to say I'm one thing or another is too simple" (Madoff 1987, 129).

In short, creativity—in art, science, or writing—is the art of finding the right questions, not the right answers. And this is exactly what Getzels and Csikszentmihalyi mean when they conclude that creativity is problem finding, not problem solving.

Reading has been important to artists since at least the Middle Ages. The medieval artist was expected to be a Bible scholar. In *Van Eyck: The Ghent Altarpiece,* Elisabeth Dhanens insists that van Eyck's unique iconography must have been created by a scholar. This "scholar-poet" must have had a profound knowledge of medieval literature to arrange and interpret the complex texts, as well as compose new ones (Dhanens 1973, 16, 89). Later during the Renaissance Michelangelo insisted that he worked with his mind rather

than his hands, and the best artists of each succeeding generation have placed increasingly greater emphasis on the importance of the mind over the hand.[2] In the self-portrait that hangs in the Tate Gallery, William Hogarth, for instance, depicted himself with his palette resting on a pile of books by Shakespeare, Milton, and Swift, signifying that English eighteenth-century painting was more related to literature than to art. And Judith Adler notes that by the eighteenth century, artists took more pride in their knowledge of obscure mythological and historical themes than on their manual skill," until finally, in the 1960s, conceptual artists completely eliminated the art object and focused entirely on the conceptual and the philosophical (Adler 1979, 16). And Tom Wolfe published his book on modern art, *The Painted Word*.

In a book describing her life with Picasso, Françoise Gilot tells us that Picasso and his friends ridiculed Fernand Leger as shallow because he read so little and knew so little about art. Picasso insisted that any meaning in Leger's work would be recognized in the first two minutes of viewing. Particularly now, when art is more concerned with linguistics and signs than with illusion and retinal impact, reading is more important to artists than ever before.

In the twenty-second printing of *The Art Spirit*, I find Robert Henri stating it quite simply. He advised his students to read books: "Look them up. Get acquainted. There may be something you want to know" (Henri 1951, 38).

Roger Gilmore, the president of the Portland School of Art and recent past president of the National Association of Schools of Art and Design, insists that artists today need to be "literate, versed in the history and analytical techniques of the field, aware of the historic and social contexts, able to work with a diversity of cultural values, and capable of understanding global interrelationships" (Gilmore 1991, 36).

Some students, however, and even some faculty, may feel that today's art is so innovative and techniques and ideas change so rapidly that little of lasting value can be taught. They may feel that by the time faculty members finish school, establish themselves, and find a stable teaching position, everything they know has already become obsolete, but even those who worship innovation should recognize the value of knowing past art.

2. *Col cervello* (with mind) rather than *colla mano* (with hand).

Advice to Young Artists

22

Judith Adler explains that in this era when innovation is rewarded in an unprecedented manner, a familiarity with previously important ideas and concepts is more crucial than ever before. "The history of art," she argues, "must be known by the art student in the way a mine field must be known by a soldier who has to pick out a safe path." Knowing what has already been done is vitally important if an artist is to invent new ideas—even if that artist has to hire someone else to execute those ideas (Adler 1979, 139). Furthermore, a knowledge of art history demonstrates to young artists how important art is to society.

Studies of students from all fields consistently indicate that art students in general have read less than those in most other disciplines. But when *successful* people in all fields are compared to *successful* artists, the artists register as among the best and the broadest read of all the professionals. The implication for artists here is quite clear: don't read, don't succeed.

Gilmore also argues convincingly that "the higher the level of creative activity involved, the more compelling the need for a cohesion of studio practice, awareness of art history, and critical analysis, as well as [a] general education" (Gilmore 1991, 37).

Furthermore, those who read little can seldom discuss art intelligently, and an ability to discuss the ideas in your field is indispensable. Most of the best graduate schools expect students to discuss art in a knowledgeable manner. Even some accomplished young graduate students have found it difficult (though by no means impossible) to get into a good graduate school, or finish the program once there, if they cannot discuss issues of current interest to artists. And it is in the best of these graduate schools where young artists are likely to come in contact with a peer group that has something to teach them.

Even the best young artists may find it difficult to gain the confidence of their peer group if they cannot discuss art. This difficulty is significant in the light of the fact that many successful artists throughout history have been leaders within their peer groups. Their leadership was often established or facilitated by dint of argument. Howard Haas, in the newsletter *Bottom Line: Personal,* insists that one of the necessary qualities for leadership in any group is "the authority of knowledge." He says that just being a talker is not enough;

leaders must demonstrate that they are deeply involved in whatever they do (Haas 1994, 11). The lesson here is simple: If you do not read, you are unlikely to be able to discuss intelligently. If you cannot discuss, you are in danger of being ignored most of the time by almost everyone.

To master any area in art, artists must learn from several sources: a good teacher (coach, mentor, or sponsor, whatever you choose to call it), constant and steady work, discussion and interaction with a peer group, visits to museums and galleries, and reading about past and current concepts in art. Artists who deprive themselves of any of these sources may hinder their progress. The more sources they deprive themselves of, the more they are likely to hinder their potential.

But never allow what you read or what you know to blind you to your own vision, and never allow what you have read or heard shape what you see or experience. During my years in art school I read in several books, and I heard from several art history instructors, that the pointillists, especially Seurat, mixed their pigments additively. I was told that when Seurat and the pointillists wanted a green, they did not use green out of a tube; instead, they placed small dots of blue and small dots of yellow next to each other and let the color fuse additively in the eye to create a green that was livelier than any that could be mixed subtractively.

Josef Albers, the patron saint of color, wrote an inspired book, *Interaction of Color;* I believe this to be the best method ever devised to teach color empirically rather than theoretically. But on the mixing of green in pointillism, he made the same mistake everyone else was making. He tells us what he has read rather than what he has seen, and noting what he has seen is usually his strong point. About the impressionists (pointilists were originally called impressionists) he wrote: "Instead of using green paint mixed mechanically from yellow and blue, they applied yellow and blue unmixed in small dots, so that they became mixed only in our perception—as an impression" (Albers 1963, 39). Albers has just reiterated the classic misconception about retinal (actually partitive) color mixing.

When I was working on an M.F.A at the University of Illinois, I visited the museum at Chicago Art Institute. I specifically wanted to see Seurat's *La Grande Jatte,* the painting that is usually named as exemplary of the theoriz-

ing mentioned above. I stood in front of that painting and looked carefully for tiny intermingled dots of blue and yellow that would mix additively in the retina to make green.

There were none!

There was no place on that canvas that I read as green where I could find blue and yellow dots intermingling. Seurat had used dots of several different shades of green to depict the lawn and the foliage and those areas he wanted green (which generated a more vibrant green). Among these different shades and colors of green dots, he placed here and there a dot of red, which tends to make the green seem even brighter and more vibrant.

He chose red because the impressionists and the pointillists still used Brewster's by then outdated red, yellow, and blue primary colors to construct their color wheel; hence they believed red was the complement to green, and they had learned correctly from M. E. Chevreul's Laws of Simultaneous Contrast that adjacent complements create supersaturated color that is perceived as brighter (more saturate) than any pure color alone.

In the bright sunlit areas on the lawn, Seurat interspersed dots of yellow to make those areas yellower (lighter and warmer); and in areas of deep shadow he interspersed dots of blue, which made the shadows darker and cooler.

This came as a shock to me. I wondered if those writers and art historians had ever looked at pointillist paintings. Furthermore, I was moved to make further studies of color—the theory and the practice. What I found was that the books and the instructors that had explained these theories had not even come close to understanding color theory, and their misunderstanding of theory led them to see what they believed they were supposed to see.

Pigment cannot be mixed additively (except for fluorescent dry pigments under ultraviolet light). I will explain this further in the chapter on color. But it is not important that the books and instructors were wrong about something. Had I not read the wrong version first, I would never have recognized the mistake, and I would not have been so interested in the correct theory. Young artists should not read and listen just to find the answers: instead, they should read and listen to discover questions, sensitive areas to probe—problem finding, not problem solving.

In the words of the German lyric poet Rainer Rilke, who wrote letters of

Reading—and Reading Right

advice to a young poet friend: "Be patient toward all that is unsolved in your heart and try to love the *questions themselves*. . . . Do not now seek the answers, which cannot be given you" (Rilke 1954, 35). And Roger Gilmore notes that visual artists have a kind of intelligence that lends itself to "identifying and posing important and difficult questions." He notes further that studies of the relationship between creativity and asking questions show conclusively that "the higher the level of fine arts interest, the higher the level of creative problem-finding ability."[3]

I often meet students who are firmly convinced that art is a talent, and they believe they were either born to make art or they were not. Sometimes they seem afraid to learn what is offered, as if learning were somehow a threat to the idea of talent.

But neither intelligence nor learning threatens any ability.

However, too little learning might well *damage* ability. An adage states that "a *little* learning is a dangerous thing." It does not state that "*learning* is a dangerous thing," as so many misquote it. Artists find their downfall, not in knowing too much, but in knowing too little. Arthur D. Efland explains that our society passes on the belief that talent in art is unrelated to intelligence only because early studies that attempted to correlate intelligence with art talent measured talent only as the ability to draw representationally (which is *not* related to intelligence); therefore, these studies concluded that there was little correlation between intellectual ability and art ability. But as early as the 1930s, researchers, such as Norman C. Meier, conducted studies with *successful artists* and demonstrated that, contrary to previous opinion, general intelligence is directly related to success in art.[4] And much of our intelligence is acquired through learning.

Artists often think art is entirely intuitive, but intuition comes from the mind and operates only on the information fed into that mind. Furthermore, the mind, like a computer, obeys the well-known rule of computers: "garbage in, garbage out." I would add to this: "nothing in, nothing out." Intuition might be fruitfully understood at a simple level as the unconscious mind's ability to manipulate many ideas or facts at one time, without your being aware of it.

3. Gilmore, 36; *also see*: Getzels and Csikszentmihalyi 1976.
4. Efland 1990, 191; also E. Zimmerman 1985, 269–75.

In this ability the unconscious differs from the simplistic focused conscious mind, which can handle only three to five variables at any one time.

Confucius said: "Learning without thought is useless; thought without learning is dangerous." For the intuition to manipulate many facts or ideas simultaneously, these facts and ideas must first be consciously learned—usually one at a time. Consider a beginning tennis player. At first the player is slow. She has to think about each move, and she is likely to execute these moves badly or entirely wrong. A good coach will teach her to execute them correctly. The coach will show her perhaps six important elements that must be mastered to hit a consistently good forehand, five things that must be done to hit a good backhand, and seven things (all of which feel totally unnatural, or *counter*-intuitive) that must be mastered to develop a good serve. At first, beginners consciously think about each of these things as they do them, and it feels awkward and slow. But after two or three years of practice (some tennis coaches do not allow their students to play actual games for the first two years) they will execute each stroke entirely without thinking. By instinct!

Instructors in art and science encounter opposite problems. Science instructors must convince young scientists that creativity (the scientific method) is not all logic. And, conversely, art instructors must convince young artists that creativity is not all intuition; both logic and intuition are necessary to any creative process. Hence the creative process involved in the two areas is surprisingly similar.

Hans Selye explains that young scientists too often believe that "scientific research is based on the planned application of logic." But they come to think of this as the only possible avenue to success only because those who write for scientific journals tend to leave out all the blind alleys and "intuitively directed probings into the unknown" that led to their discoveries; they describe only the simplest logical path (Selye 1964, 265).

Peter Medawar tells us in *Advice to a Young Scientist* that "science involves the exercise of common sense supported by a strong understanding . . . combined with a resolute determination not to be deceived either by the evidence of experiments poorly done or by the attractiveness—even lovableness—of a favorite hypothesis" [which is known as 'preciosity' in art]. Heroic feats of the

intellect are seldom needed (Medawar 1979, 93). He reasons that the scientific method simply demonstrates the potential of common sense.

As Medawar warns that young scientists must "never be tempted into mistaking the necessity of reason for the sufficiency of reason" (101), I would offer the obverse warning to artists: never mistake the necessity of intuition for the sufficiency of intuition. Too many young scientists believe the road to success in science is logic alone, while too many young artists believe the road to success in art is intuition alone. Both are wrong. It is important to maintain the right balance between the two. Leonardo, who was exceptional in both science and art, was ambidextrous, indicating, we believe, a working balance between the left (the analytical) and the right (the intuitive) hemispheres in the brain.

The four most popular models for creative thinking are deduction, induction, classical association, and the structuring of Gestalten. Such methods may well be useful in problem *solving* when a recognizable solution is called for, but as Getzels and Csikszentmihalyi demonstrated in their previously cited study of creativity, problem *finding* is the more useful technique in art—where there is no previously stated problem. Problem finding begins with the discovery that some existing situation is not as good as it might be and thus needs to be improved. The first step, then, is the realization that the major problem is *finding* the problem (Getzels and Csikszentmihalyi 1976, 236–37).

This idea was corroborated by the king of problem finders, Edwin Land, who had more recorded patents that anyone since Thomas Edison. Land said many times that identifying and stating a problem correctly is 95 percent of the solution.

We all learn to drive by consciously performing each step of the operation. At first we must think hard to coordinate the steering with the accelerator with the brake and all the traffic that must be noticed and responded to. The car lurches erratically down the road. But after driving for years, all those separate things we learned consciously are now done *intuitively,* as one integrated process; and we drive the car well without ever thinking about it. What we have learned through the conscious mind we have finally assimilated into our intuition, so that when a dog or a child runs unexpectedly out in front

Advice to Young Artists

of us we may instantaneously execute several complex actions without ever thinking about them.

Something else drives the car for us.

We are driving intuitively.

This process is an excellent example of *mushin,* the first (not the final) goal in Zen discipline—in the martial arts, flower arranging, the tea ceremony, or painting. Phillip Kapleau, author of the classic *The Three Pillars of Zen,* expressed this state as practicing a discipline until we can "even in the most sudden and unexpected situations act instantly, without pausing to collect our wits, and in a manner wholly appropriate to the circumstances" (Kapleau 1980, 49–50). Here we see the link between Zen, discipline, and creativity, whether in science or the arts.

Some young artists are afraid that thinking too much or knowing too much can hinder or limit their insight or ability. Consider for a moment two artists: one knows only three things; the other knows hundreds. The artist who knows only three is likely to have those three things fixed firmly in mind when working; thus the work produced is likely to be consciously executed, analytical, and simplistic. On the other hand, the artist who knows hundreds of ideas, elements, and structures cannot begin to keep all of them in mind when working. Hence the second artist enables the intuition or the unconscious to roam free through 95 percent of the available knowledge, while the first is slave to three ideas that entirely dominate the more simplistic conscious mind. That is what is meant by the adage: A *little* learning is a dangerous thing.

Some artists purposely develop techniques that hinder conscious thought and force the unconscious to take over. Karl Appel, for instance, often faced away from his canvas while he mixed his paint and loaded his brush. Then he turned suddenly round and struck and exploded the paint onto the canvas in a frenzy of rapid activity. This action was performed so fast and continuously that the conscious mind could not keep up with it.

The young Robert Rauschenberg was known to work with exceedingly loud music playing. Such loud music overwhelms the verbal thought system in the left brain and drowns out any attempt to think in a conscious verbal

mode. Rauschenberg also uses other "tricks": he says he sometimes pretends to have an idea; and he allowed as how "sometimes Jack Daniels helps too." But he describes his favorite trick as "fatigue": "I like to start working when it's almost too late ... when my sense of efficiency is exhausted. It's then that I find myself in another state, quite outside of myself" (Gruen 1991, 269). The left brain is easily susceptible to fatigue; the right brain never tires. Rauschenberg's technique tends to inactivate the left brain leaving the right free to dominate his actions.

Some need no tricks. They drift into the right state naturally. Lucas Samaras said: "And when I'm working, I find myself being in a more or less unconscious state. That is, you couldn't call it good or bad or anything else. It's just *working*. Although I have conversations with myself while I work, it's on a different time level" (236). This loss of time awareness is one of the best indicators of the correct state of mind for any creative process, and also for good play. When we play, we are totally absorbed in the action, athletics, reading, or art, and we have almost no awareness of the passage of time.

Some artists watch television, closely, while they work. This helps engage their conscious mind with something outside the art they are working on. Still other artists who have learned hundreds of elements that relate to their direction will purposely concentrate on two or three of the least important to occupy the conscious mind, leaving the unconscious alone to take care of the more important elements.

Many use this last technique without being aware of it. One artist, whom I know well, lectures about his painting and explains how he "orchestrates the color and the composition." What he describes is little more than good art school junior- or senior-level competency. What makes his work unique, however, is his ability to create the most sensual and erotic nonrepresentational images I have seen. I have purposely never mentioned this. I would worry that what he now does so unconsciously might suddenly become a purposeful and self-conscious mannerism. Mentioning it might act like psyching out an opponent's serve in tennis.

This avoidance of self-consciousness is one of the cornerstones of creative activities. Perhaps artists must become so involved, so unaware of time, so

unaware of their own ego that they are free to perform at the unconscious archetypal level. Rainer Rilke describes a creative "poetic power" that "breaks out of him as out of mountains." "But," he continues, "it seems that this power is not always honest and without pose. (But this again is one of the hardest tests of the creative individual: he must always remain unconscious, unsuspecting of his best virtues, if he would not rob them of their ingenuousness and untouchedness!)" (Rilke 1954, 31).

When Richard Diebenkorn mounted his first major figurative exhibit in Los Angeles in the early 1950s, viewers and critics raved about the "spontaneous" drips and splashes that covered the surfaces of his paintings and demonstrated his spontaneous, rapid, and urgent application of the paint. When his next show opened I could almost see the thought process he might have undergone: "Aha," he might have said. "They like the drips and splashes. Well, I can give them drips and splashes." And the drips that had once been so natural and un-self-conscious degenerated into a purposely dripped and consciously manipulated mannered display in which he parodied himself. Not to worry. Diebenkorn is a consummate reflective and self-critical painter; and he quickly corrected his own mistake to go beyond even his first show.

How material is manipulated speaks, to those who know art, as eloquently as body language speaks to those who know people. Robert Henri tells us that a brush stroke can be "icy, cold, hard, brittle, timid, fearsome, apologetic, pale, negative, vulgar, lazy, common, puritanical, smart, evasive," or "glib" (Henri 1951, 52). Those who have studied and looked at painting for years may perceive, in how the paint is applied, more about the artist than those who meet the artist and note the peculiarities of gesture and body language.

The best artists learn to use the unconscious. Most keep several works going simultaneously. This method is efficient in the use of time as well as the intuitive creative process. When working on a drawing or a painting or a sculpture or a series of photographs, artists often come to an impasse. They have no idea what to do next. They cannot think of any major changes to make. They cannot think of a way to resolve the image.

Lesser artists tend to force answers. They "cat-lick" the surface in an attempt to make it look finished; they desperately strain to think of a solu-

tion to their problem. This response always reminds me of a cartoon I saw in *Playboy* several decades ago. Two people sit at a table in a cocktail lounge, staring at each other and holding their drinks in a tight and desperate grip, while one says through gritted teeth, "We've *gotta* have *fun.*"

Many studies have been done on the creative process: all indicate that creative solutions are never born in such desperate situations. Several studies have listed the same five steps to creativity in both science and art:

1. Subject thinks of a project or problem to solve.

2. Subject reads, studies, investigates everything that relates to the project.

3. Subject attempts to solve the problem but, in this desperately conscious attempt, fails.

4. Subject gives up on the project. (This is often an important step.)

5. A day or a week or a year or a decade after abandoning the project: insight! The problem is clarified, and the solution pops to mind while sleeping or reading or watching television. Once we give up, relax, and take the conscious mind off a task, the peripheral mind is allowed to work freely, and the solution, or the *question,* comes easily to mind. Writer's block is often a result of a desperate attempt to create. Wolfgang Amadeus Mozart said he worked best when relaxed: "When I am . . . travelling in a carriage, or walking after a good meal, or during the night when I cannot sleep; it is on such occasions that my ideas flow best and most abundantly" (Mozart 1961, 44).

Researchers have found again and again that all five steps seem to be a necessary part of most creative discoveries. Why? Because intuitive leaps are seldom made by the focused consciousness. Such leaps are usually made by the peripheral mind, the unconscious, the right brain—whatever your favorite term happens to be. This intuitive process is related to the futile attempt to remember someone's name. You are talking to a friend, and you tell a story about . . . Who? Suddenly a name well known to you eludes your grasp. The harder you try, the more the name eludes, like trying to pick up a slippery bar of soap in the bath. Then you say: "Oh! the hell with it! The name doesn't matter." You go on with the story; and thirty minutes later when your conscious mind has dropped the issue, suddenly the name pops up from your peripheral mind like a cork in that bathtub.

Similarly, when you are working on an art piece, you may stand back and look at it; the piece is nearly complete, but it does not "sing." You think. You strain. But you cannot dredge up the needed finishing touch. Finally, you set the work aside and work on another piece, or two, or three. You become involved in the other pieces; but you can still see the first out of the corner of your eye. That first piece still occupies a place, albeit perhaps a small peripheral place, in your mind as well as in your eye. Then, a day or a week or a month later, when your mind is focused on something entirely different, the solution (perhaps an embarrassingly obvious one) pops suddenly into your awareness. This is a highly efficient working method. It uses time well, and it stimulates the creative process.

Consequently, one reason that many artists work on several pieces simultaneously is to allow the conscious mind to vacate the formulation of the problem while the unconscious or intuition works it out. Setting a work aside allows the paint to dry, the ink to set, or the plaster to cure. While these physical things are happening, the artist is making another piece instead of wasting time; and the conscious mind is entirely occupied with finding a new problem. This leaves the unconscious free to play with the problem in the first work. The focused mind dwells on serious detail, while the mind at rest plays with the whole; and the playful contemplation of the whole leads to creative breakthroughs.

Unpredictability and an ability to think of many alternative solutions are almost synonyms for creativity. A movie or a book plot that comes up with one predictable situation after another is usually a boring plot. The interesting plots are entirely unpredictable. The surrealists, for instance, used unpredictability in content to create new images. They simply put objects and people in unpredictable contexts, as a schizophrenic might do: a baby alone in the desert or a drawer opening out of a human torso. Abstract expressionists, on the other hand, used unpredictability of form and gesture. They concentrated on fluid and unpredictable rhythms, proportions, shapes, and colors.

This unpredictability is simply an ability to think of many alternatives to the predictable. Alternatives are often nothing more than the awareness of other possibilities, which, again, we may stimulate through reading. This is

one of the principal purposes of reading for artists: to stimulate their awareness of various ideas as the gateway to possible alternatives. Thus, they are offered new choices.

And those artists with the strongest potential stretch their limits: they work beyond their abilities just as they read beyond their understanding. They are not discouraged by failure. Studies of successful people indicate that they do not mind failing. They think of each attempt and each failure as a learning exercise. Each failure marks a blind alley that does not have to be explored again, thus narrowing the artist's search for a direction. From each failure something is learned.

Thomas Edison thought of failure as a state of mind. He believed that each failure was just a learning experience on the road to success. During his attempt to develop a storage battery, one of his helpers asked if he was discouraged by the *thousands* of failed experiments that had apparently shown no results. Edison answered: "Why, man, I have gotten a lot of results. I know several thousand things that won't work" (Israel 1994, 13).

Though the first two or three years in learning art are fraught with frustration and demand a high degree of pain tolerance, once an artist has learned the necessary competencies the process should evolve into play. Advanced artists who do not enjoy making art are probably doing it wrong. Furthermore, if they have no fun, they are not likely to spend enough time at it and are thus not likely to continue for long. Personal discipline is a necessary ingredient for an artist, but discipline alone will not suffice forever.

The play aspect may seem like an easy idea to understand, but one of the hardest ideas to get across to young artists is how to play—with focused intensity. How do young artists learn to work their butts off, yet not give a damn? Three-year-old children play with this kind of intensity. They do not care about playing "right." They constantly test the physical and the dictated rules in their immediate world. And this testing fascinates them. They play in the attitude of: I wonder what will happen if I. . . but they will mess their pants before they will quit long enough to go to the bathroom.

When young artists learn to work in that manner they are on the road to success—a less messy road, perhaps, than children engrossed in play. Getzels

and Csikszentmihalyi's study indicates that creativity stems from an elaboration of "fantasies and ideas related to daydreaming and childhood play." Creative behavior is perceived as "a continuation and substitution for the play of childhood." The less creative personalities suppress these playful urges, but the creative personality welcomes them freely (Getzels and Csikszentmihalyi 1978, 238). Freud, for instance, focuses on the childlike playful elements in his famous evaluation of Leonardo da Vinci (Freud 1947, 47–50).

Still, the idea of play must be nestled tightly into what might appear to be its direct opposite: young artists must also develop personal discipline. Those who work only when the Muse strikes them make little progress. They often reason that there is little purpose in working during times when they are not "in the mood" because they may not do their best work then. They are wrong. Most artists (and athletes too for that matter) do not know at the beginning of the day how well they will perform. On the days they feel least inspired, they may create some of their best work, and on the days they feel the hottest, they may do some of their worst. Furthermore, on days when they feel the best and also do their best work, they can do work of that quality only because they practiced and read consistently when they were not in the mood, or when they were not doing good work.

If artists work every day when they have the Midas touch, when everything they touch turns to gold, that may not mean much. Anybody can do that. But if they work every day when they have the reverse Midas touch, when every thing they touch turns to crap (a technical term often used by artists), that probably means they are headed toward becoming an artist. In short, any young artist who finds steady, everyday work habits to be an imposition should perhaps consider another line of work.

When I was a university student in the 1950s, I watched a freshman painter begin the most frustrating experience I have ever seen. During her second semester in painting, everything fell together just right—for one single painting. She painted a heavily abstracted still life: the color, shape, composition, and pictorial space interlocked in a complex orchestration that was far beyond her ability. Her instructors and fellow students raved about that painting. She was so encouraged that, in those days when the art world was not nearly as

competitive as it is today, she took that single painting to La Cienega Boulevard to one of the better-known galleries. They looked at the painting and liked it; they invited her to leave the painting there so that they could exhibit it in a group show. (If an artist today approached a dealer with a single small painting, I have visions of a hit man suddenly stepping out of the back room and kneecapping the lout on the spot.)

After that one painting, the young woman could not do a painting of anything near that quality for three years. Three years of seeing no improvement. Three years of being unable to match a previous performance is one of the most discouraging things that can happen to any young artist. She was disheartened. She felt like a has-been after her second semester. But this young woman was tough and disciplined. She gritted her teeth every day and went into that painting studio for extended periods of work. She accepted advice gracefully and she read steadily. Suddenly, during her senior year, she blossomed into a fine young painter; and those around her, especially the graduate students, complimented her on her "talent" and envied her quick and easy success.

Most young artists fail to realize that slumps are evidence of learning, so they feel discouraged when their work suddenly seems to get worse. A slump, however, means they have learned so much that they can no longer do what they had previously been doing; but they have not yet learned to apply this new learning to a fresh and better direction or image. A slump should, in a sense, encourage. The way out of a slump is to work your way out. Redouble your efforts and experimentation.

Steady work and consistent reading will greatly improve anybody's potential over an extended period: it will help those with real ability achieve success and it will help even artists of a lesser Muse become damn good. And there are not nearly enough damn good artists out there.

There are so many good and relevant books that no one is likely to ever get through all of them, so try not to waste your time plodding through books that cover ideas that you are already aware of. Do not spend time on ideas that you think are irrelevant to anything you might ever be interested in. Do not waste time reading about ideas that you find boring—as opposed to exciting ideas boringly written (some of the writers with the most excit-

ing ideas cannot present them in an interesting manner). Rip through books quickly. Toss them aside. Grab something else.

A method I have used, when I knew of no interesting books, is to ask everyone I respected to suggest the best art book they had ever read. Then I get that book and look through it. If they recommend two or three, I look at all of them.

Until you have formed your own list of books to be read, you may want to look in the bibliography for the entries that I have marked with an asterisk or a dagger. These works focus on current ideas, which I believe will be of interest to most young artists at the beginning of the twenty-first century. Entries marked with an asterisk (*) stress concept and idea; those marked with a dagger (†) deal with the realities of the art world. ⌒

Artists and Teachers

YOUNG ARTISTS SHOULD FIRST DECIDE what they may reasonably expect from their teachers: what should a competent responsible teacher be prepared to offer? It follows then that they should also decide what they *cannot* reasonably demand from their teachers.

Some young artists assume that teachers can do everything for them; they expect too much. Though such artists are quick to claim all the credit for their own successes, they hold teachers responsible as the sole active agents in the learning process and ultimately responsible for their students' professional failures. Some, on the other hand, may assume that teachers can do nothing for them: they believe art should spring unaided from the font of their own intuition and talent.

Both assumptions are unreasonable.

Those who expect too much sometimes demand the wisdom of a guru from their teachers: They may expect to be taught art with little pain or effort on their part; and they may believe the teacher is responsible for their fulfillment in life. In short, they may be looking for a father figure or some ersatz religious leader. Furthermore, when such students learn that a teacher falls short of these expectations, they "lose respect" and decide that teacher now has nothing to teach them.

My experience as a faculty member at four colleges leads me to believe that few teachers in any discipline qualify as gurus. They often have faulty marriages, weak social relationships, and a shaky emotional makeup—like most of the population, which has no bearing on their professional competency. Most of them know enough about their field to be a great help to students. Their personality or bedside manner is irrelevant. Llewelyn Powys advised his young poet friend: "Follow every person from whom you can learn *anything*" (emphasis mine) (Powys 1969, 85).

Those who assume that teachers have nothing to offer tend to gain little from their education. When teachers make suggestions, such students often look at them suspiciously, as if they were being offered a vacation in Bosnia Herzegovina. Most teachers remain in the field because they do want to help students. Consequently, they find tiresome the few students who insist on establishing an adversary relationship with their teachers—"Us against Them." Such students cannot take suggestions, and they gain little from their educational opportunities. They often pay several tens of thousands of dollars' tuition to go to school, and I have never quite understood why such resentful students start, or remain, in school. If they feel teachers have nothing to offer, they should logically go home, work on their own, and avoid the possibility of contamination. But few people are guided by logic. If people were logical, it would have been men who rode sidesaddle.

Some of these students have learned just enough to form a few inchoate and inconsistent opinions. They think they already know where they are headed and what they need to learn; or they come to class only to show their instructors how much they know and how good they are. Their cups are so full that they cannot hold more.

We have long known that grades in disciplines other than art do not predict future success. In fact, a *slightly* negative correlation exists between *very* high academic grades and success in the world outside academia in every other academic discipline. Consequently, some students may believe that their instructors' opinions bear little relevance to their future success. But Getzels and Csikszentmihalyi's exhaustive longitudinal study of factors that contribute to the success of young artists clearly demonstrates that this negative correlation does not hold true when comparing studio grades to the later success of young artists. They found, in fact, a surprising correlation between good grades in studio classes and later success in the art world.

Five or six years after graduation, students who had received the best grades in studio classes had a pronounced tendency to be the most successful artists. Moreover, the instructors' judgments as to the talent, potential, and originality of students was proved to be surprisingly reliable. *Extremely* high grades in academic classes, however, still showed a *slight* correlation with failure in the art world (Getzels and Csikszentmihalyi 1976, 167).

Artists and Teachers

Perhaps the tendency to neglect academic courses for studio classes points again to the fact that successful artists are obsessive about working in their field—even at the expense of other classes. Is it fair to conclude that art and science teachers have better priorities than teachers of academics when it comes to the training of professionals in their field? Or perhaps in other fields the ability to get along with their colleagues is a better predictor of success than grades?

Moreover, Anselm Strauss's earlier study of students at that same school, Chicago Art Institute, led him to conclude that the better students "tend to think of instructors as helpful critics." Some even think of themselves as an apprentice to their favorite teacher (Strauss 1970, 168).

Art cannot be taught.

That statement may be as true as anything in art can be. But it is often misinterpreted by both students and teachers. A few teachers have leaned on that cliché to avoid teaching anything; and students may exploit it to avoid listening to candid criticism or to avoid hard or painful choices and changes. You can lead students to water, but you cannot make them think. Many students would rather follow the line of least resistance, roll downhill, the easy way, rather than struggle uphill on the road to self-discipline; and that easy road is precisely what a good teacher can help them avoid.

A good teacher can be a valuable tool for a young artist who wants to learn. Such teachers are valuable in the following ways: they can bring ideas to the awareness of young artists; they can help young artists become familiar with the considered opinion of the professionals in their discipline; they can make students aware of what issues are currently being discussed in the art world; they can suggest and teach new techniques; and they can let students know when they are taking the line of least resistance.

If left to their own devices, most students would drive a long and tortuous road in their attempt to discover current ideas in their discipline. Jean Guitton observes that art, like literature, demands technique, method, and knowledge. Successful writers and artists either learn these things from others, waste many precious years learning them by themselves, or risk never knowing them (Guitton 1964, 50).

Students should become aware of as many ideas and theories as possible

Advice to Young Artists

while still in school. They need not become expert in any of these. Later, when they are aware of many possibilities and their direction begins to mature, they will know how to ignore ideas that do not interest them in order to concentrate on ideas that do. It is possible, perhaps probable, that the lack of awareness of just one single idea, if that idea is in an artist's strongest ability, may be the precise one that precludes that artist from finding a successful direction.

When an idea is presented to a class, I have sometimes heard students say (even in a hostile manner) that they cannot accept such an idea. That is a complete non sequitur. There is nothing to accept. An idea in art is not a religion that must be believed in order to avoid Hell. It is not an albatross to hang permanently around an artist's neck. It does not need to be fed every day. An idea is nothing more than a tool to be stored when not needed and used when needed. Most artists are pack rats. They collect all kinds of interesting junk that they think might come in handy sometime. Why not, then, collect ideas? Store them in the back of your mind like a drill in the toolshed. If you ever need to drill a hole, pick up the drill. If you ever need to know the true complement to a color, dust off the color wheel (the red, blue, green one—the old red, blue, yellow one does not render accurate complements). Aristotle insisted that the mark of an educated person was the ability to *entertain* an idea without believing it.

In my experience, it is the rare teacher who does not have at least one valuable idea to contribute to a young artist's training. A few good teachers may have several ideas. Stay with any teacher you can learn from until you think you are aware of every valuable idea she or he knows. It is not necessary to stay until you become expert in all those ideas, just until you are aware of them. Gerald Kushel, in "Peak Performers," tells us that those who perform at their best in any field are "always searching for ways to do better." They "seek out mentors to guide their careers and help them master their chosen fields. Even after reaching the top, they continue to seek advice from others" (Kushel 1991, 1). And when offered advice, they act on it. Robert Henri notes that "many [students] receive a criticism and think it is fine; think they got their money's worth; think well of the teacher for it, and then go on with their work just the same as before" (Henri 1951, 127).

Artists and Teachers

Sometimes it takes effort to discover what a teacher has to offer. I have witnessed two scenarios that illustrate this well. As a graduate student I once watched every day as a hard-nosed graduate professor entered the studio assigned to a new graduate painter. Every day for two weeks Nick would look at the student's current painting, shake his head in disapproval, and walk out. Finally, the student said: "Nick, don't shake your head and walk out. That's not the way I learn best. I'd like to know what you think."

"Wanna know what I think?"

"Yes, I do."

"I think that if that were my painting, I'd put my damn foot through it." And Nick turned to walk out.

"No, Nick. You don't say, 'If that were my painting, I'd put my damn foot through it,' then walk out. You say: 'If that were my painting I'd put my damn foot through it because . . .'"

"Oh. Wanna know why I'd put my foot through it?"

"Yes."

"Because you don't know the ABCs about painting." Again Nick turned to walk out.

"No, Nick. You don't say, 'Because you don't know the ABCs about painting,' then walk out. You say: 'You don't know the ABCs about painting. A is . . .'"

A slight smile crossed Nick's lips at this point. "You really wanna learn somethin' about painting?" And he began to work at teaching that student. Disappointingly, in the end he turned out to be a one-trick pony. He had only one thing to teach, but she did learn how to cultivate a rich sensual painting surface from him. Nick's approach was certainly not the best, but that student squeezed out everything Nick had to teach. Some instructors have personality problems. They may be less than perfect. Students should try not to make the instructor's problem their problem. Students need not refuse to learn something from instructors simply because the instructors are not likeable or even because they are not excellent teachers.

In the second scenario that I observed, a young man—who was an excellent painter, with his own direction, when he came to graduate school—was receiving little advice from his instructors. His paintings were exciting but

they were nothing like the work that was being done at that school. His professors would come by and grudgingly acknowledge each new painting. They liked his work but they did not know how to criticize it.

He talked to me about the situation. He said he knew he was good enough to get through the program and finish the degree, but that was not the reason he had come to school. He had come because he knew he still had things to learn. He knew that if he kept painting in his established direction, the instructors there could not help him. Consequently, he decided to drop his current direction and paint in a style that was compatible with what was being taught there. Some of the other students were indignant because they thought he had "caved in." They thought he ought to have the courage to defend his convictions and his direction. But he had not made that change to curry favor with his instructors. He changed because he thought he could learn more that way; and he was right. He learned about everything his instructors had to teach.

After graduation he accepted a position teaching at another university. As soon as he arrived there and set up a studio he immediately returned to his old direction. But his new paintings were four times better than they had been when he had entered graduate school. Many of the ideas those instructors taught were relevant to the way he painted; but they would never have known how to apply their own ideas to his direction if he had not known how to learn what they had to offer.

Young artists who have the strongest potential are determined to be good, desperate to learn, and they know how to glean as much information as possible out of each situation. There are no guarantees in art, but such students significantly increase their potential as artists. Furthermore, an artist's entire career is such a learning process.

Teachers can become lazy as they get older. They offer their best advice and often see students roll their eyes heavenward and assume the expression that crosses children's faces when their mother tells them for the ten-thousandth time to be careful crossing the street. By the time teachers have taught long enough to learn their subject well, they begin to wonder why they keep offering this apparently unwanted advice. Most of them entered

teaching because they believed they could help students, not because they wanted to fight with them. Consequently, they are revitalized when they come across a student who is eager to learn and is mature enough to show no defensiveness. Now and then I have an interested student, with good instincts, who asks great questions. And once again I feel as enthusiastic as I did thirty years ago.

When I am speaking to a class that seems particularly wooden faced and unresponsive, I sometimes ask: How many of you have had boring teachers? Most will raise their hands enthusiastically. I then ask how many of these boring teachers are older. The collective opinion of the class seems to be that the most boring teachers are the older ones.

Why then, I ask, do you think the boring teachers are the older ones? Certainly it cannot be true that all these teachers were boring thirty years ago when first they set out to teach. I know that all the older teachers are not necessarily out of date in their knowledge of the field; on the contrary, many of the good ones have a profound knowledge that is difficult for a younger teacher to match.

Older teachers may often be boring because students have had decades to condition them to be boring.

A story circulated around college campuses during the early seventies that a sociology class had agreed to condition their instructor to unbutton the center button on his shirt and place his right hand in the opening while he was lecturing. The class agreed to do nothing more than lean back in their seats and look stony-faced when the instructor's right hand was extended. When his hand moved closer to his abdomen, they began to sit up. As his hand approached the middle button, they leaned slightly forward and began to look interested. And so on, until they had that professor sticking his hand in his shirt like Napoleon by the end of the semester.

If that story is true, I have often wondered if that instructor ever noticed it and perhaps said to his wife: "You know? In my afternoon sociology of stigma class, the strangest thing happens: I seem to get this overwhelming urge to undo one button and stick my hand in my shirt."

Students do constantly condition their instructors' behavior. When I

Advice to Young Artists

have a good lecture going and get carried away with interest in the topic, and I suddenly notice a sea of expressionless stone faces, I think: What kind of jerk am I making of myself up here? And each time this happens, despite my attempts to resist it, I become just a little less willing to show excitement, a little more monotone, and a touch more boring. Cool—in the words of trumpet player Branford Marsalis on the *Tonight Show*—is the showing of a limited range of responses to a variety of situations. And today's students are nothing if they are not sophisticated and cool. Students receive what they earn. If they want interesting lectures they can easily have them. All they need to do is demonstrate interest. But they can just as readily end up sitting through boring lecture after boring lecture. All they have to do is look bored.

A recently graduated student asked if I thought it was worth the exorbitant tuition to attend a prestigious graduate school that had accepted her application. I told her that it might be worth the extra money if she would make up her mind to squeeze the most learning possible out of her time there, but if she continued to go her own direction in the face of the considered advice of her instructors, the money would be wasted. I reminded her that she had not listened well, nor accepted suggestions that might have moved her further along, while she had been in school here. If she planned to continue in that vein, she should probably go to the second-choice inexpensive but lesser school and save her money. She admitted that I was right about her stay here. She said she knew this was a good school, but she insisted that the reason she had not been quick to follow suggestions was that she did not want to seem like a "kiss ass." She had, I informed her, never been in any danger of giving such an impression.

Nearly two-thirds of the well-known modern artists studied with either Hans Hofmann or Josef Albers, probably the two most successful teachers in the modern era. Albers taught, along with Jack Tworkov, at the famous art school at Black Mountain. Robert Rauschenberg, who attended the art school there along with other modern giants, such Motherwell and de Kooning, told Barbara Rose that the visual arts curriculum at Black Mountain "was focused on discipline and control—and control of control.

Artists and Teachers

There was almost a policing going on at Black Mountain in the arts" (Rose 1987, 102). Perhaps many of the young artists who studied there did not like the rigid discipline of the school at the time, but that school turned out more successful artists than any other school I have heard of.

On the other hand, the early history of the once radical California Institute of the Arts (Cal Arts) demonstrates the alternative to discipline. In her careful and exhaustive history of Cal Arts, Judith Adler tells us that the educational philosophy of the school when it opened in the early 1970s was based on three basic beliefs:

1. students were to be regarded and treated as colleagues and "fully-fledged artists";

2. teaching would be tuned to the "developmental rhythm of each student," thus entirely "noncoercive"; and

3. faculty should teach only those "subjects in which they were immediately and personally engaged" (Adler, 1979, p. 102).

Because the most advanced and radical artists of the time were attracted to such a philosophy, Cal Arts found it easy to hire the best available. But the "best" (who were entirely in agreement with this philosophy in the beginning) quickly found that the failure to teach fundamental skills and the absence of discipline created an untenable learning situation. Because there were no formal course requirements, instructors found it difficult to control access to scarce equipment, or be guaranteed a minimum course enrollment, or to protect themselves from the harassment of constant demands to demonstrate to each individual the use of simple facilities, such as printing presses.

This radical experiment, Adler explains, in a classic demonstration of cause and effect, quickly produced the following related results: the most popular courses became more inspirational than professional; teachers could find no guiding standards that did not erode faster than they could be established and thus they found no common agreement as to any basic skills that should be taught; some teachers came to view their teaching jobs as no more than "an attractive gig, a source of easy money"; and others sought easy popularity and became little more than entertainers who refused to criticize (133–38).

This attitude among the teachers affected students in the following ways: students began to derive their ideas more from art journals than from their teachers (they could easily have stayed home and done that); most students were visually literate only in their own terms; and because students came to be interested in establishing themselves in their field at an early age, they felt no inclination to invest precious time in learning developmental skills or concepts that take time to mature (133–38).

Consequently, Cal Arts soon returned to the traditional methods of teaching fundamentals. The school that had dreamed of initiating an entirely new and radical method of teaching the arts thus became one more example of conventional academia: the utopian charisma died, to be quickly replaced by the harsh competitive world of work (108–9). Soon after this change, the school began to turn out very strong graduates, who were highly visible in the art world.

Paolo Soleri, well known for designing cities to be placed in areas that are often deemed useless and for his seemingly perpetual building of the earth-formed *Arcosanti* in the Arizona desert, is perhaps the most radical, influential, and avant garde city planning architect. He calls himself an "archologist" (archeology/ecology) rather than an architect. Soleri spoke at a symposium at Central Washington University in 1965 at the apex of the student search for freedom. At a colloquium after his speech, one of the art students, obviously hoping to find a kindred spirit, asked: "Mr. Soleri, I understand you have a lot of students and apprentices at your site in Arizona. I imagine you give them a lot of freedom in their direction, don't you?"

Soleri's answer stuck in my mind, and I remember it well enough to paraphrase accurately: Absolutely not, Soleri quickly answered to an assembly of shocked student expressions. When I say I want a specific exercise, I want that specific exercise. When I say I want something to happen at 7:30 in the morning, I want it to happen at that time, no later. I find that when I allow students to explore on their own, any direction they wish, they jump around like grasshoppers from one unrelated idea to another because they have no idea what they want to do nor what they believe. But if I discipline them—if I force them and compress them tightly into one rigid direction, they finally

Artists and Teachers

burst out of their training in one single thrust that heads them in a consistent direction. They do this because they have learned what it is they are reacting against. They have learned what they don't believe. And, consequently, they know what they do believe and what they want to do. In order to be efficient, any action or reaction must have something to contain it, something to push against. An uncontained explosion generates little effect.

Teachers themselves have responsibilities also. Students have passed on to me some incredible fiats that they have heard from teachers: never use black; never use green; do not paint with a brush; never paint with a palette knife—these are some of the things students swear they have been told by previous teachers. "Never use black" is by far the most popular. I have never been able to understand what would prompt such a consistent and universal caveat. Such teachers must never have seen a painting by Leonardo, Caravaggio, Rembrandt, Ad Reinhardt, or Anselm Kiefer.

I have guessed that perhaps those teachers studied under someone who wanted them to mix black in several different ways to teach them some sensitivity to the temperature and opacity of different blacks. (Beginners tend to think that black is black is black.) The second teacher then passed this on to later students but never understood that this was an exercise intended only to help beginners. That teacher did not understand that it was not an inviolable rule. The obedient teacher learned the device well but never understood the purpose of it and so passed in on as a rule.

This habit of converting learning devices, which are intended only to help beginners, into inviolable rules is a common occurrence in every field. When the "academy" of abstract expressionism dominated the art field, teachers insisted that their students learn a painterly approach to painting. These teachers were interested in teaching painterliness (as opposed to linearity) in both of its guises: (1) painters use the term "painterly" to mean painting wet paint into wet paint, often with thick paint; (2) art historians, however, tend to follow Heinrich Wölfflin's definition that painterliness refers to the loss of silhouette, meaning that the silhouettes of the objects represented are not the assertive shapes in a painting. The assertive shapes are the dark and light shapes that define volume and create the composition (Wölfflin 1950, 18–54).

When students traced or copied photographs or other paintings, they tended to stress the outlines, the silhouettes of the objects; then they maintained tight control of the medium while they carefully filled in between the outlines. Tracing inevitably led to a tight linear technique.

Consequently, the abstract expressionists, who sought painterliness, did not allow their students to copy or trace. They wanted students to master wet-into-wet painting to support an automatistic technique that allowed accidental images, and compositions that were generated by the unconscious, to be discovered in the painterly smears of paint.

Many students who were trained by abstract expressionists learned the rule but not the reason. Hence when these students went forth to teach, they taught their students that it was *wrong* to trace or copy. Painters who traced or copied, they insisted, would not go to the Great Studio in the Sky when they died. They would probably end up in the basement grinding pigment. Then when postmodernists began to wrestle with concepts unrelated to painterliness, they found that tracing a slide, copying an image, or pasting a photograph or a Xerox copy on the surface of a painting was indispensable (the foundation of appropriation). But teachers who understood the purpose of neither technique were still teaching that it was wrong to trace, wrong to copy. Their misunderstanding severely limited the potential of their students.

But there are no rules in art (not even this one).

Any device taught to beginners should be intended only as an element to be played with, stretched, probed, questioned, and violated by those same students as they become advanced artists. And this should be constantly explained to them.

Many training devices can be helpful to young artists. But it must always be remembered that these devices are intended only for beginners: they are used only to keep beginning work from looking so bad. They should *never* be used as a yardstick to judge art. If teachers teach nothing, if they just allow beginners to work on their own, beginning work would be terrible in most cases and would be slow to improve. Some teachers may restrict or expand a young artist's horizon, by means of the projects they assign, to set

up a situation in which beginners can experience some successes, create some half-interesting images, and learn rapidly. These restrictions and expansions are good starting points, and they are sometimes quite successful in helping beginning students improve the quality of their work.

But, when a doctor tells you to take antibiotics to help you over a problem, do not feel you must take them the rest of your life.

Teachers themselves often harbor the wrong image of what a good teacher is. America abounds with misguided myths about the hard-nosed, even cruel, teacher that students disliked during their time in class but came to respect and admire when they were older. I have heard variations of the following anecdote so often I cannot count: "Old Ms. Bowe, in the seventh grade was the best math teacher I ever had. Boy! Were we scared of her. If I didn't get my work right she'd smack my knuckles till I could hardly hold a pencil. But, by God, I learned my math under her."

The first question I ask is: how much math did you take after leaving her class? And I find that Ms. Bowe's was often the last math class that person took. Many teachers shape their methods according to this myth. I have seen mediocre teachers convince themselves that they were good teachers by grading hard, disciplining strictly, demanding immediate excellence without teaching it, and offering little or no approval. They subscribe to the adage: "I don't want to be liked; I just want to be respected." Generally, they are feared.

Teachers cannot coerce respect. It must be earned.

The best teachers plan their teaching and their curriculum to lead their students into *legitimate* successes. I definitely do not suggest passing out quick, easy, or unearned compliments. I do not even think it is necessary to find something in each work to praise before offering suggestions. If young artists cannot take criticism, they are in the wrong field because even the best young artists are destined to collect far more criticism than praise during their careers.

But any jerk can point out failures; it takes a good teacher to teach students worthwhile ideas that they can use in their work. The rule is simple: offer *constructive* criticism. Most students will recognize the intentions of any criticism that is sincerely intended to help; they will also recognize crit-

icism that is intended only to bolster the ego of the instructor. They will understand when criticism is meanly intended.

Regarding the question of talent versus discipline: I wholeheartedly believe that reasonable guidance and discipline in early training will not hurt the truly talented; it may often help them, if history teaches us anything. Furthermore, we do know that strong guidance in the beginning can offer enormous help to young artists who may not have been successful otherwise. Llewelyn Powys told his young poet advisee: "I think you have the intensity and passion of spirit to go far: but learn, learn, learn, from everything and everybody and every circumstance of your life—*Learn to Discriminate*" (Powys 1969, 115).

As a drawing and painting instructor who focuses on the useful aspects of both modern and postmodern attitudes, form, and concept, I encourage students to begin by learning basic traditional formalist competencies. I do not stress the obvious, such as linear perspective or the shading of volume; these are too obvious, and modern artists rejected them as early as the 1870s. Even rococo painters had searched for ways to hide any obvious linear perspective by placing figures in a surrounding of clouds or billowing draperies that disguised any straight lines. Norman Bryson points out that one of the two most widespread and erroneous beliefs about European painting is that "Quattrocento" linear perspective "reigns unchallenged from Giotto until Cézanne" (Bryson 1981, 89). He maintains that rococo space was a distinct break with Albertian space; they no longer used linear perspective to place objects behind an implied pane of glass so to distance them from the viewer (89–93).

Rather than devices such as linear perspective, I stress, instead, competencies that most viewers fail to notice. I stress competencies that the best artists in almost all periods and schools of painting seem to have learned. I do not teach these structures because I want to turn out traditional competent artists. I teach these competencies because I believe quality work depends on developing certain sensitivities, and learning these basic elements helps young artists develop these sensitivities. Consequently, they learn to make subtle visual distinctions.

Artists and Teachers

For example, when students learn to compose in areas of dark and light—an organizational competency that has been practiced by most of the best artists from Leonardo to Anselm Kiefer—they train their sensitivity to shape and proportion as well as an awareness of the relationship and the balance between fragmentation (multiplicity) and unity. The modernists, for instance, stressed unity; the postmodernists stress fragmentation. This organizational competency is a device that trains sensitivity; it can also be useful in most styles or schools of art, and it tends to be noticed only by expert viewers.

Viewers may not notice the method but they are moved by the effect. This sense of being emotionally moved but not knowing what is responsible for that feeling is what creates the magic in art. If a magician does a palming trick, his audience understands what is happening whether or not they can see it happen; consequently, they simply think of it as a good trick. But when David Copperfield makes the Statue of Liberty disappear for three seconds to a crowd on the New York shoreline, they know that is no palming trick. He creates an illusion for which the audience can find no explanation. The utter unbelievability of the act, and the inability to explain or understand it, takes it far beyond the arena of a simple trick.

Speaking of this kind of magic in Mary Wigman's dancing, Arthur Michel wrote: "When she is dancing, her torso and limbs seem to be governed by a power of nature acting after secret laws" (Langer 1953, 185). Such complex illusions, which are completely beyond the understanding of the audience, come as close to passing for magic as anything can in this age of durable skepticism.

Similarly, if an artist fills a painting with skulls and frightening images, viewers will recognize the terror in the image; but the cause of the terror is obvious: the skulls and the frightening images. This is an easy trick. Viewers understand it easily. But if they see an apparently tranquil landscape yet still feel an unexplained presence of terror, they may consider this more magic than trick—a wonderment rather than a recognition.

One of the most common statements I hear from teachers is: "I don't like postmodern art. I think it is superficial, so I don't teach it."

It is hard to understand how any teacher can take responsibility for such a judgment. Art teachers may legitimately choose not to follow the current style in their own work; certainly, serious artists should choose to follow the direction their interests and abilities lead them. But they do not have the right to make that determination for their students. What they teach should be informed by the latest information available. Young artists should decide for themselves what they wish to accept and what they wish to reject, but they cannot make this decision if they do not know the choices.

In their elaborate study of the creative elements that lead to success in art, Getzels and Csikszentmihalyi observed that artists are more likely to be successful when they are aware of and "consider a variety of potential expressive elements," even if they make use of only a few of these "expressive elements" in the final version. If they are restricted to only a few elements from the beginning, the problems they invent are less likely to be either complex or original. "The artist must be sensitive to many visual forms" (Getzels and Csikszentmihalyi 1976, 247).

When teachers refuse to teach what is current in art, they limit their students' awareness of, and access to, many "expressive elements" and "visual forms" that are necessary to the current discussion in art and a part of finding their *own* problems. The refusal to teach what is current in art is tantamount to a science instructor saying: "I don't like quantum physics (or the new chaos theory, or fractal geometry) so I won't teach it."

Einstein said he did not really *like* quantum mechanics, but he often explored problems from that point of view to expand his alternatives and his understanding. The university, it seems to me, pays teachers to teach the current state of their discipline. Art consists of a continual discussion between artists, critics, and *knowledgeable* viewers. This group is engaged in discussing thirty (or fifty, the number is arbitrary) issues related to art. Michael Heizer is well known for his visionary desert structures, such as *Double Negative, Complex I,* and *Displaced/Replaced Mass.* Heizer says, "What people don't seem to realize is that I'm interested in the *issues* of art. Frankly, I'm tired of having my scene slowed down by people who don't get what I'm doing. *I'm* working, but they're not working" (Gruen 1991, 174–75).

But the issues involved in this continuing discussion among artists, critics, and audience change from time to time. Modernists discussed issues that were related to illusion: human perception, pictorial space, visual form, and the relationship between time and space. They tended to purposely ignore such things as content, sign, and symbol.

Postmodernists, on the other hand, discuss issues that are related to linguistics: content, signs, symbols, syntax, texts, and hermeneutics (meaning). They tend to ignore or even revolt against the ideas that so fascinated modernists. Teachers who will not teach postmodernism because they "don't like it" simply may not know what the current conversation is about (though they often deny this), thus they do not perceive the "structure" in it. Furthermore, they may refuse to teach it to save themselves the effort of learning an entirely new system. They may have several decades invested in learning the one, so they may strenuously resist having to junk what they have learned to acquire something entirely different. They cannot empty that cup, which they found so difficult to fill.

Young artists who do not know what topics are under discussion cannot enter the discussion (or galleries, museums, and exhibits). If you approach a group that is discussing football, you are unlikely to command their attention if you speak only of ballet. If a young scientist today writes a paper— no matter how beautifully—arguing that the earth orbits the sun, there is likely to be no significant audience for that paper. That topic was exhausted and agreed upon long ago. Scientists now discuss such things as imaginary time, black holes in space, and chaos theory.

As a young art student I attended what were then two highly respected art schools. After completing two terminal degrees in art—one in sculpture and one in painting—I felt that I had a good understanding of what I was seeing when I visited museums that were showing historical work. But when I visited the avant garde galleries in Los Angeles, Chicago, or New York, I had absolutely no understanding of what I was seeing there.

I had no idea why most of these new works were considered good. Andy Warhol left me puzzled. Keinholtz's cardboard boxes and mutilated baby dolls made me far too angry. I realized that I was visually illiterate—and I

resented that. I had no idea what topics were currently under discussion in the art world; therefore, when I was rejected from art shows, I had no idea why I had been rejected. I manufactured reasons for my rejections, reasons that placed the blame on juries, or on those who ran the art shows.

I am not suggesting that young artists should agree with the current party line. They can agree, disagree, argue, ignore, or change the emphasis—as long as they have a sense of what topics are of interest to their audience. Once they know the issues under discussion, they can join the discussion. They may even introduce an important issue that they feel is being overlooked. The point is that once writers learn to write, they can write about any issue they are familiar with; and once painters learn to paint, they can use their visual literacy to say anything they want about any topic—if they know what topics are of interest.

Some very persuasive and powerful artists may even succeed in shifting the direction of the discussion, adding new topics, or subtracting some of the old to foster new and unforeseen traditions. ﾉ

Artists and Teachers

Tradition and the New
in Current Art

EVEN ARTISTS WHO INITIATE NEW TRADITIONS must demonstrate those new traditions in terms of the old.

Suzi Gablik tells us that "the history of art begins with tradition. Traditions give us something upon which we can operate: something . . . we can criticize and change" (Gablik 1977, 167). And John Dixon explains that Cézanne, like Giotto, exploited the old tradition as he simultaneously destroyed it when he initiated his new version of pictorial space (Dixon 1984, 293).

New ideas are variations, alternative solutions, further developments, and new forms that spring from and are firmly related to the old traditions rather than destroyers of them. Old traditions, or previous discussions, always shape the new, and, therefore, future directions will grow out of the most recent discussion, the last tradition. Consequently, whatever follows postmodernism will grow out of postmodernism, though it may also be related to modernism or some earlier tradition. In short, we cannot thoroughly understand any tradition if we do not understand what went before it.

But art is ultimately about the artist's own experiences. Artists will discuss the issues as they perceive them through their own experiences. But brand-new experiences are difficult to incorporate and express immediately after they happen. My background tells me that there is a "lag time" between any new experience and the incorporation of it in my work. I have discussed this with other artists, and we seem to agree that there is a lag time that can range from three months to seven years (sometimes even longer) from any new experience to its inclusion in our image.

For instance, when I moved from Los Angeles to Phoenix, I had never before seen that kind of light. The light in the Phoenix area can be represented only in overexposure. The terrain was even, level as a tabletop, as if it had been hammered flat by the eternal bombardment of unrelenting parti-

cles of brilliant light. The blinding light burned the shadows off the dark side of objects, which seemed to be illuminated from within. Objects and even people glowed as if, cast in metal, they had just been released from their mold, still luminous from the heat of some primordial foundry.

The trees, the buildings, the cars, and the people on the street squirmed in the brilliant atmosphere, their image distorted by near liquid waves of heat. Sometimes objects almost disappeared from sight. Matter seemed ephemeral, as if glimpsed through clear running brook water—now visible, now dissolved in a wavy flow of liquid light.

And there was never a dark night in Phoenix. A constant radiance floated up from commercial buildings, street lights, and neon signs. The region glowed as if to suggest that more light poured down each day than the environment could assimilate. Light seemed to have been absorbed into the landscape and stored, to be slowly released throughout the night.

The surrounding desert itself was all luminous illusion. Nature is exceedingly clever: she imitates herself even within herself. In the heat of the desert landscape, nature paints mirages that look exactly like water. Water, in turn, reflects perfect images of that fiery landscape in its mirrored surface. Animals were patterned to appear invisible in their surroundings. Insects camouflaged themselves as twigs, leaves, even as other insects. And plants, in turn, camouflaged themselves as insects and other plants.

I was so taken with this new light and pervasive illusion that I tried to change my painting to fit this new experience. I painted fifteen or twenty paintings in which I attempted to capture the quality of light and the desert illusion, but they were failures. I could see and feel a powerful image, but I could not paint it. I could not give expression to that new idea until I had had a chance to absorb it, until the experience itself had had time to become part of everything else I knew, part of my psychological makeup. I gave up.

Two years later I went to Illinois for a year; then I took a teaching position in Washington state. About four years later, still fascinated by the misty mystical atmosphere of that new climate, my paintings suddenly began to glow, while the figure and ground began to integrate in ways I had never done before, echoing the atmosphere and the camouflage I had observed so carefully in Phoenix. I had finally internalized that visual experience. It had been

a part of me so long that it was forced to exert some influence on all my other thoughts, and all these other thoughts had had time to mature and assimilate that experience so it finally became part of the whole.

What we learn from other sources—school, reading, discussion, and looking at other paintings—is also experience. These ideas may also lag before they become a natural part of an artist's image. Young artists should do their work, and they should learn from other sources, but they should not mix the two. What they learn will eventually affect their work. If it is relevant, they will not be able to keep it out. But if they try to force these ideas into their work too soon, the work may seem too desperate, too analytical; the image may seem unnatural, mannered, and self-conscious.

This may happen because different learning times are required for different concepts. Students can learn and apply some ideas quickly, practically overnight. Some concepts, however, seem to take years to absorb and internalize to the point they can be sincerely executed. There sometimes seems to be no other route than patience.

Still other concepts we learn only from total immersion. I know artists who have studied and worked for years who do not demonstrate in their work that they understand certain ineffable ideas. I often suggest to advanced students who have a strong mastery of most of the other ideas that they should take a three- or four-week period—Christmas vacation is often an ideal time—and do nothing but art.

Start early each morning, I tell them, and work till you are tired, then work some more; then, when you cannot work any more, work some more. Do not read anything except art. Do not watch television except for art programs. Do not associate with friends unless they agree to talk nothing but art. Take art with you to the table; take it with you to the bathroom. Crowd everything but art out of your mind and your life for just one month. Every young artist who has taken this suggestion has been enthusiastic about the leaps in understanding they were able to make during that period. Many of them have made a practice of repeating that formula regularly, perhaps every two to five years. The best almost live their lives in that kind of obsession.

And never be afraid to try new ideas.

Test new traditions.

Advice to Young Artists

Some teachers are *too* persuasive when warning students away from the new. They sometimes argue a rationale that sounds logical on the surface, but when carefully considered does not hold water. Young artists must learn to hear what is meant rather than what is said—what is implied rather than what is directly stated. As D.H. Lawrence put it: "Trust the tale not the teller." It is the young artist's responsibility to discriminate gold from fool's gold, in terms of their direction and interests.

Many classes, techniques, and concepts that are taught in art departments throughout the world are taught for no other reason than because they have always been taught. Teachers give assignments because that is what they were assigned when they were students—or perhaps they have nothing else to fill the time allotted. They fail to reevaluate old ideas in the light of the current issues of discussion in the art world. These old habits and ideas may have little relevance to current issues and ideas.

Most art departments, for instance, still require their art majors to take design classes, which are invariably structured to teach antiquarian ideas: neatness, the Brewster color wheel (red, yellow, and blue as primaries, outdated by the late nineteenth century), classic formalism (harmony rather than tension), and outdated Bauhaus ideas. These are the same ideas that were being taught when I took my first art class in 1952.

When I first started teaching, I taught design classes in the manner I had been taught, but I knew immediately that there was something wrong with this method. Some of my students were not very good in design; their work was not neat, they refused to work within the problem assigned, and they hated being restricted to pure geometrics and hard edges. I remember telling some of them that all the characteristics that made them inept at this kind of design would probably serve them well in other art classes, especially painting and sculpture. Furthermore, I quickly observed that many students who performed the best in these design classes were weak in other art classes. I decided that I could not teach a good design class at that time, so I moved into teaching other areas.

Even the formal elements that design lends itself to are not the important ones. Students are generally taught to establish harmonious relationships that do not disturb the viewer—classic relationships. They are often taught not

to create tension, and tension is the backbone of current art, and even of modern art. Design classes tend to stress frontality rather than an awareness of pictorial space, and retinal rather than linguistic elements. If design classes were redesigned to teach linguistic or semiotic concepts of communication, they could be highly relevant to today's art.

A common argument that I have heard many times from instructors, first as a student and later as a teacher, is: "You don't need to jump on every new fad that comes along. You must have a strong backbone. You must have the courage of your own convictions." On the surface that sounds like good advice. Certainly no one wants to be a spineless wimp. But consider for a moment what this means. Listen to the tale, not the teller. This advice is usually offered to young artists who are excited about current directions. It is often offered by older instructors who are not quite up to date (a not uncommon situation). What such advice implies is: "Don't do what those new young artists are doing (because I can't help you in that direction); do what I was taught when I was in school." In other words: Don't jump on every new fad that comes along; jump on my fifty or one hundred- or four hundred-year-old fad.

Another common argument is: "I don't like this new style (modern art, conceptual art, postmodern art, etc.); I find it (choose one or all of the following) superficial, shallow, decorative, lacking structure. I'll wait till the art world wakes up to the fact that (choose one) trompe l'oeil painting, the Renaissance style, abstract expressionism, happenings, funk, etc., is the real art. They'll come back someday."

"They," however, will never "come back" to that style in the same form. Ideas in art do return in cycles. Some ideas and concepts, even styles, are revisited regularly, but the new use of an old style is never recognizable to the old holdouts. In the late 1950s I knew two trompe l'oeil (fool the eye) painters in Los Angeles. Both insisted that the pure flat illusion of painters such as Harnett and Peto was the only substantial way to paint. "Art was illusion," they proclaimed. Both insisted vocally and often that the art world would wake up to this "fact" someday and come back to the "real stuff."

Funny thing: the art world did just that. They did return to trompe l'oeil painting: young painters made the canvas appear to be three-dimensional;

they induced the eye to see color in the colorless interstices between black and white elements; they made painted pigment flash and bounce like neon; they exhibited a rampant play of illusion and fooled the eyes of everyone. A child of five, viewing an exhibit of optical art, once said with delight, "The paintings are playing with me!" (Parola 1969, 9). But my two committed friends never noticed. They had no idea that op art was the new form of trompe l'oeil painting. Styles return. But they never return in the same way to the same place. You not only cannot step in the same river twice, but, as a philosopher once said, you cannot even step in the *same* river once.

"You must first learn to paint what you can see before you can paint what's in your mind," I was told as a student. That made sense to me. I wasted several years learning to paint "realistically"—or illusionistically, if you prefer Ernst Gombrich's terminology. But Renaissance perspective and illusionism are now considered by postmodernists—as argued by Erwin Panofsky in "Perspective as Symbolic Form" (1925)—little more than a societal convention, no more related to truth than is iambic pentameter in poetry.[1]

Yet realism can easily serve as a crutch to avoid having to use the imagination: a realistic scene, well-enough crafted, will often garner attention and praise (from people who have given little thought to art) even though it demonstrates little original thought. The realist technique came easy to me; consequently, I found it difficult to drop that crutch and strike out in my own direction. Few important painters in the past hundred years have been realists. Why then should young artists have to learn how to paint realistically before they can begin to try other directions and search for their own direction?

Perhaps many art schools place so much emphasis on rendering and realism because the rendering techniques required for mimesis are easy to judge. Furthermore, rendering technique is easier to teach than is concept. Any beginner can determine that a face or an arm is not rendered well. The treasury department has always represented familiar faces on its printed money because any minor mistake or deficiency in skill will be readily apparent in the rendering of a face. Thus, some art teachers find it easy to judge, grade,

1. Panofsky's article "Perspective as Symbolic Form" (1924–25) is probably more influential on current writers than any of his other work. This influential article has only recently been made easily available in an excellent annotated translation in the 1991 publication by Zone Books.

Tradition and the New

and rank students who concentrate on skill, although they may be undecided about the potential of a new direction that does not demonstrate skill—particularly directions that do not resemble something the teacher has previously seen that has been accepted as art.

Furthermore, rendering a semiphotographic appearance, of anatomy or landscape, is a skill that most normal students can learn in three or four years of hard work, if the teacher is proficient at teaching that skill. Rendering is a skill that most teachers who have painted in this manner for years will have learned, more or less. But it is much harder to teach something meaningful once this obvious skill is discarded as a measure of success. Such teaching demands a depth and breadth of knowledge and understanding that may not be required to teach technique and skill.

I find that many art schools subscribe to the theory that young artists should first learn technique and develop their skills, then find their own direction. Again, this rationale seems reasonable at first glance but reveals its weaknesses with even a cursory examination. There are hundreds of possible techniques that could be taught. Should we teach representational skills and techniques? If so, should we teach the diffused-light method of shading (Correggio), the spotlight or unified source method (da Vinci, Michelangelo), heraldic counterpoint (medievals, Seurat, some surrealists, and painters of heraldry), or an empirical method (van Eyck, Courbet, and Lucien Freud)?

As Hiram Williams notes: "There are countless systems of representational drawing" (Williams 1963, 103). But, in truth, most successful artists today care no more for rendering skills, the grand manner, or *belle peinture* than current popular singers care to sing the scales and develop a beautiful operatic voice. Singers now may prefer more expressive voices: loud, raspy, or guttural.

If realism is not the preferred technique, what should we teach: the Zen-like disciplined automatism of surrealism and abstract expressionism? the "found object" painting initiated by Tchelichew? the disciplined value control of field painting? the illusionist control of the picture plane as in modern art? the tight clean sign-painting techniques of op art? the signing content of postmodern art? formal elements? or linguistic elements?

Technique, isolated from concept, is not that difficult to learn. Perhaps the goal of young artists should be to develop an awareness of, not a proficiency in, the various techniques and alternatives while searching for their own viable direction. Ultimately, most artists who are strong in concept will need only enough skill that a lack of craftsmanship does not limit the idea itself. They should probably not strive to be admired for their craftsmanship alone. In the years since 1955, I have worked with many young artists, and I have visited galleries to watch other new artists evolve. I have seen many young artists with exceptional skill and technique who failed because they lacked concept or idea. But I have never yet seen a young artist who had exciting concepts and ideas fail because she or he lacked the necessary skill and technique. If the ideas are there, technique will follow. Robert Henri cautions us that "teachers have too long stood in the way; have said: 'Go slowly—you want to be an artist before you've learned to draw!'" (Henri 1951, 55).

The goal in skill development might be to develop in young artists an awareness of the fundamentals and alternatives that will allow them—after they discover their direction—to develop the necessary skills to support that direction, with no more than two or three years of additional practice. Keep in mind that few artists can expect to find a direction and execute it at a mature professional level by the time they receive their master of fine arts degree, much less their bachelor's. It takes a minimum of ten years for most young artists to reach a consistent professional level.

A strictly empirical observation: When I think back over the decades of past students and remember the habits of those who finally became the strongest artists, I see three distinct patterns emerge: those who *started* the most works over a long period improved the most, those who learned concept faster than they learned technique ultimately outstripped those who focused on skill and technique, and those fearless young artists who consistently worked beyond their abilities always became stronger painters in the long run than those who limited their attempts to what was easily within their grasp. To paraphrase a well-known statement by Leonardo, I have no hope for artists who work within the bounds of their meager understanding. They only repeat what they have been taught. I have hope only for those who

work beyond their abilities. And Robert Henri warns us that "some people study hard for a time, then they 'graduate' and sink back into the little they have learned" (151).

Most instructors have good intentions. Few intentionally hide useful information from their students. Then why do some feel that new styles lack structure? Consider that there are perhaps one hundred, or one hundred fifty (an arbitrary number) structural elements or fundamental concepts in art. No one learns all these elements.

In fact, most instructors were taught, and in return they teach, only a single style. They teach rendering, a modified Renaissance approach in which volume is considered "structure." Or they teach landscape painting (in which pictorial space is synonymous with structure). Or they teach abstract expressionism (in which the flat picture plane is considered structure). Or they teach a postmodern semiotic approach (linguistic structure related to signs and symbols). They may teach any one of several possible styles. Some may even offer a choice. Perhaps they understand and value two, three, or even four directions. But most teach some variation of what they themselves do, or a variation of what they were taught. This method of teaching is a modern form of the apprenticeship system from the Middle Ages.

Furthermore, no single style attends to all the hundred or more possible elements in art. Each style uses only seven to fifteen (again an arbitrary number) of these structures, and the different structures may be combined in different permutations to make thousands of different possibilities. Instructors who were well trained in abstract expressionism, for instance, perhaps learned such elements as expressiveness, a sensitivity to and control of pictorial depth, sensitivity to proportion, dark-light composition, the integrity of the picture plane, value control, wet into wet painting technique, the discipline of automatism, the quirks of human perception, the relationship between reality and illusion, and so forth.

Postmodern painters, however, reject most of that list and give high priority to entirely different elements, such as the relationship between writing and painting, the semiotic significance of content, or even of the paint itself (hermeneutics), and especially politics as related to questions of minority status, gender, and totalitarianism. When trained abstract expressionists are

Advice to Young Artists

confronted with postmodern painting, they perceive no competency in the handling of proportion, composition, or the picture plane; therefore, they perceive no "structure," though linguistic structure may be the very focus of the painting. Extend this concept to teachers who themselves study under such abstract expressionists. They will be even further out of date and even less congruent with current concerns than their teachers were.

Hiram Williams explains, for instance, how students and teachers felt about modern art in the 1930s. After visiting a Paul Klee exhibit, Williams decided (he was embarrassed to say) that Klee "was no artist, for he could not draw." He explains how hard it was to confront modern art; this new style seemed to mean "that a number of years of good training must be cast aside." Many of his peers considered modern art their enemy and were intimidated by it. Through study and help from his friends, Williams finally made the transition into modernism, but his instructor, he notes sadly, "never made it" (Williams 1963, 10).

It should be clear by now that I advocate the teaching and learning of concept over technique, practice, or drill. Let me illustrate the efficiency of this method by comparing it with recent facts that we have discovered about the teaching of math and science, which I have demonstrated previously share much in common with the teaching of art. Public schools in the United States spend 143 and 140 hours per year teaching math and science, in the order listed. Japanese schools spend only 117 and 90 hours per year teaching the same two subjects. But only five American students (from a nation of almost 300 million) scored among the top 10 and 13 percent of eighth-graders on the international test in math and science, while thirty-two and eighteen Japanese students (from a nation of 120+ million) scored in the top 10 percent on the same test. Perhaps some of this discrepancy (even though America spent 30 to 50 percent more hours per year on these subjects) may be accounted for by the fact that American schools spend 78 percent of their yearly hours spent on math and science doing drills and practice and only 22 percent on concept, while Japanese schools focus only 17 percent of their time on drills and practice and a whopping 83 percent on concept (Wingert 1996, 96).

Perhaps the most important message I have for young artists is this: Never, never get caught defending the status quo.

Tradition and the New

On the other hand, many of the mistakes made in the relationship between instructor and student may be ascribed to the student. Often students blame their failures on their instructor. Such students may believe that a really good instructor would turn out nothing but good students. This is not logical. Some students have no ability; many are lazy; some expect to be the passive element. "Here I am. Learn me." I will—they mean—sit here like an anvil while you hammer art into me.

This is the way learning works in many academic classes, but it seldom works that way in studio classes. Perhaps this is the reason many excellent academic students are so frustrated with studio classes at first. In academic classes students are often told to listen to the lecture, read the book, and learn the facts. They are told what to learn. If they work and learn what they are told to learn, they can repeat that knowledge on a test and get A's.

But when they come to studio classes they are told: "We want you to learn something, but we're not sure what. You have to decide for yourself what you want to learn." How damned frustrating for a student who has learned all the tricks needed to operate as a passive learner—an anvil. But a young artist must be a hammer not an anvil. Artists must actively pursue their own direction, their abilities and interests. This is no mean feat for beginners who do not yet understand enough about art to know what they are interested in or what their abilities are.

Good teachers can be an indispensable help in guiding a young artist's direction. The least helpful teachers I studied under tended to criticize each painting. Their energies were focused on making each painting a little better. They offered little guidance in overall direction. I think of teaching as analogous to rolling a tire to the next town. Some teachers overteach; they try to roll the tire, hand over hand, the entire direction. This is tiresome for both the teacher and the taught. It makes more sense to start the tire rolling in the general direction of the town desired. As long as the tire rolls easily in the right direction, leave it alone. Perhaps tell it: "You're headed right, tire. You cannot continue in this direction without ending up in Ellensburg." When headed the wrong direction, a slight nudge should be enough to put it back on track.

During my first year as a teacher, one of my colleagues, Bill Lovelady, asked me the single best question of my career. He asked, "In your classes, are you trying to turn out paintings or painters?" Over the years, I have tried to keep that question foremost in my mind. A teacher who quickly trains students to turn out finished works teaches entirely differently from one who intends to turn out artists. Furthermore, there are strong temptations—rehiring and tenure, for instance—for new teachers to push their students to turn out finished works.

Teachers who concentrate on turning out finished works tend to teach their students to work in two ways: they have their students draw and paint representationally from models and still lifes, or they teach them to work in the teacher's style. Either route shows quick results because the teacher has established a personal bag of tricks that can easily be passed on, and the student works directly toward a recognizable goal.

This teaches problem solving, not problem finding.

The best teachers are more patient. They search for the unique abilities each young artist possesses and encourage them in their own interests and direction. The best teachers I have seen encourage young artists to experiment heavily. Artists should be pushed to try everything that comes into their head—even in graduate school. Llewelyn Powys told the young poet he was advising to "experiment!" (Powys 1969, 98). Hiram Williams says he tells his students "to create 'soups' of ideas" (Williams 1963, 2).

Young artists should be taught how to search for their own direction. As they try one image after another, they will reject one idea after another; hence, their direction will gradually narrow to focus on one idea or group of related ideas. The teacher's job is to remain alert, to constantly look for the things that a particular student does well, then bring these abilities to the student's attention. Various students have various abilities: some are better at simplification, some at complexity; some are naturally painterly, some are linear; some have a sensuous interest in retinal painting, some have a more intellectual bent. Each student will then decide if the teacher's assessment makes sense and whether that direction is an interesting one for them.

I find that most young artists have a natural ability in some aspect of art.

Tradition and the New

This inherent ability may take some hard searching and much experimentation to discover, but it may take only one such ability to give a young artist an opportunity to excel. Many possible abilities may be exploited to allow a young artist to achieve success. Any one or more of the following might lead to success, even prominence, in art: a philosophical ability, an ability to create a new system of order or its opposite, a high tolerance for sweet chaos; ability with a brush, chisel, torch, saw, potter's wheel, or the chemistry of glaze mixing; a painterly ability, a linear ability, verbal ability, an ability to simplify, an ability to create complexity, an ability to recombine elements and images in new ways, the ability to extend the envelope of current traditions, an ability to see the fallacies in current traditions, or an ability to find unexplored strengths in current concept. The list is endless.

In *Frames of Mind* Howard Gardner, who builds his theories around such separate kinds of intelligences, warns us to never mistake these "useful fictions" for real separations. Such fictions are extremely useful for understanding or explaining our thought processes, but "Nature brooks no sharp discontinuities of the sort proposed here" (Gardner 1983, 70).

Various artists through the centuries have exploited a variety of abilities to lead them to success. Remember, the important skill in art is the ability to find important problems.

Art consists of questions, not answers.

The downfall of many young artists is that they may try to emulate the success of a particular artist. Perhaps they admire Anselm Kiefer: they may then believe that all successful artists must be cut in the mold of Kiefer. Perhaps they have none of the abilities that Kiefer demonstrates, but they may waste their career attempting to live his life and emulate his abilities. They may thus come to understand the importance of only one or two abilities in their field; therefore, they strive to develop only the abilities they are aware of.

Such a limited outlook places a severe limitation on their potential. The odds that they are likely to be exemplary at one of these two limited possibilities are discouraging. Artists are searchers. Art is a constant search. Those who develop an efficient search method and learn to extend the area in which

they can search are more likely to discover the areas of their own abilities and thus create something of substance. This searching is so fundamental to the sciences that scientists call it "the scientific method."

Some young artists have a hard time accepting criticism. They want someone to tell them how wonderful and talented they are. They often refuse to accept even the most well-intentioned criticism. When some young artists find an instructor, or even a friend, who will flatter them, they may be ruined for further teaching. Many will not listen to an instructor who finds fault with their work when they already have one who thinks the work is wonderful. In the sixteenth century Leonardo da Vinci observed: "Nothing is more apt to deceive us . . . than our own judgment of our work. We derive more benefit from having our faults pointed out by our enemies than from hearing the opinions of friends. Friends are too like ourselves: they deceive us as much as our own judgment" (da Vinci 1990, 137).

Because many young artists are so resistant to criticism, some instructors have been conditioned to offer little criticism. They find that the less they work, the less resentment they generate in students, and the more popular they become. On the other hand, some instructors have seen so many students ruined by flattery that they become too wary of making any positive comments. Even some of those who have the student's welfare in mind come to believe that compliments will "ruin" a student.

In some sense they are right: unearned flattery can easily ruin a young artist. But I have never seen artists hurt by a realistic appraisal of their progress, no matter how complimentary. Students should be told when they have improved or that they are heading in the right direction or that they will succeed if they keep going the direction they are headed—if this is true. They can fruitfully be told they have ability and potential, and they have a strong chance for success if they work hard and learn more. If young artists believe they have a chance to succeed, most will work harder and listen better. But if an instructor tells students their work is professional, mature, finished, those students might well wonder why they should listen to further criticism from anyone. They will just keep coming back to that instructor for their regular ego fix.

Such flattery is poor teaching and almost always without foundation. Only

one student has ever applied to our graduate program who showed a consistent body of professionally competent work. That student had painted in New York for fifteen years after receiving an undergraduate degree from the School of Visual Arts in New York, and he had exhibited in two respected New York galleries for several years. He needed an M.F.A. because he wanted to teach. We encouraged him to come here for the degree, and we planned to get him through the degree as fast and painlessly as possible. We also believed he might still learn something here, but he was already advanced enough that we would have graduated him whether he learned anything we had to offer.

I have had three students over several decades that would have become excellent artists without any help. All three had good instincts from the start, and each of them refused to listen to their instructors. They insisted on heading their own direction. But all three read and explored the world of art in every other way possible. They worked constantly and experimented wildly, trying everything that came into their heads. They seemed never to be interested in the superficial aspects that lead so many young artists astray. They all had an inherent sense of dissatisfaction with their work that prodded them to push their abilities, and they seemed to have absolutely no fear of failure on any project; they simply considered each failure a learning experience that would help narrow their focus.

I finally spoke to each of them. I explained the things I believed they were doing right. I told each of them that I believed the process they had evolved would eventually lead them to become accomplished artists whether they listened to anyone or not. But I also explained that I believed they would learn faster, and perhaps get there sooner, if they learned to listen to suggestions, openly but critically. I explained that I believed we could bring some ideas to their awareness that might take them decades to find on their own.

Two of them were convinced and began to take advice. Both began to improve more rapidly. The third still went her own direction. She applied and was accepted to a good graduate school, where she elected to complete only her M.A. Two years later she returned here for a year. She took a few classes so that she could use the studios and workshops, but, after spending some time at another school, she also seemed to realize that perhaps we did

have some things to teach her. She began to listen carefully, and her work suddenly leapt to levels she had never before attained. She later went to a major art department and completed an M.F.A. She is now a promising young artist who has taught in the art departments at three universities.

Most successful young artists learn to pursue their abilities, and they eventually build their personal repertoire—their own bag of tricks. Years ago I watched Dick Cavett interview Larry Rivers on television. Like musician Paul Simon, Rivers at his best is very good at verbalizing about art; he is relaxed, unpretentious, down to earth, and lighthearted. Cavett, in a flash of insight, asked Rivers an excellent question: "Larry, when you decide to paint something—a still life or a landscape—what is it you look for? In other words, if you decide to do a painting of me, what is it about me that makes you choose me as a subject?"

Rivers answered in his most forthright manner: "I've been painting for thirty-five years, Dick, and I've developed my own particular bag of tricks. When I evaluate you as a potential subject, I ask myself: what is there about you that lets me use my bag of tricks?"

In other words, besides content requirements, Rivers, as a modernist, was looking for certain formal qualities: the model was simply a vehicle to inspire his dark-light composition (dark and light shapes that stimulated his ability to create good abstract shapes), shapes that were consistent with his semi-rectangular motifs, and a visible opportunity to exploit the clear-cut consistency in the abstract shapes and proportions for which he was so well known. He exploits all the things he has learned combined with all the personal ideas he has invented.

Consistency in concept and an elaborate bag of tricks makes an artist's work distinctive. ⌐

5

Artist and Artist's Image

EINSTEIN WAS ECCENTRIC; THEREFORE, EINSTEIN WAS A GENIUS. Thousands of young artists (and scientists too perhaps) unthinkingly reverse equations in this manner to create a classic confusion of cause and effect. From this simple starting point some young artists begin an elaborate process that Tom Wolfe, in his *The Painted Word*, calls the "Boho dance," and Hiram Williams calls such artists the "elbow benders" (Williams 1963, 4).

Because so much postmodern art and literature centers in alchemy as a metaphor for purification and healing, I associate such triflers in art with the alchemical term "puffers." True alchemists treated the transmuting of base metals into gold as a metaphor for self-discipline and the purification of the soul. Few of them expected to make gold. But some, who had a superficial understanding of the true aims of alchemy, did try to make gold. Because these triflers needed higher temperatures to melt the base metals for transmutation, they were forced to work the bellows harder (puff, puff, puff) than the more philosophical alchemists; and this practice also generated more explosions (PUFF). Hence the term "puffers" to mean those who trivialized the sacred science.

Puffers waste their creative energy cultivating their image, a stereotype of the cliché "eccentric creative genius." Such geniuses, they assume, are weird, spacey, a little (or very) crazy. Perhaps they have seen too many Hollywood movies, which often spend more time on romantic stereotypes than on substance. Stereotype and romance sells better than philosophy. Puffers work hard to dress creatively, act creatively, talk creatively, furnish their apartments creatively, drink creatively, and eat creatively. They have little creative energy left for making art. They act eccentric, even neurotic or a little crazy, to convince others, and perhaps themselves, that they have true talent.

But crazy is commonplace today; sanity is perhaps the more remarkable state. When Diane Sawyer, in an ABC News interview, asked Charles Manson, "Is Charlie Manson crazy?" he answered, "Sure he's crazy, mad as a hatter. What difference does it make? You know, a long time ago being crazy meant something. Nowadays everybody's crazy" ("Perspectives" 1994, 19).

A long time ago being crazy meant something!

Artists, however, come in all sizes, shapes, and colors. Some are uninhibited; some, on the other hand, act as if they were toilet trained with a cattle prod. Some have a high tolerance for sweet chaos; some have a powerful need for order. Some are eccentric; some are quite conventional and well adjusted. In Richard Anuszkiewicz's words: "I really had a very happy childhood and never wanted anything. . . . I had companionship, affection—all the good things" (Spaced 1991, 119). Furthermore, the longitudinal study conducted by Getzels and Csikszentmihalyi demonstrated that "despite common belief to the contrary, family disruption through divorce, separation, or death of parents" was three times less prevalent in the successful than in the unsuccessful group of young artists from Chicago Art Institute—40 percent versus 13 percent (Getzels and Csikszentmihalyi 1976, 165).

In *Advice to a Young Scientist* Peter Medawar tells us that the stereotype that represents scientists as emotionless ciphers engaged in cold calculations and the collection of facts is as much a caricature as the image of a poet (or an artist) as "poor, dirty, disheveled, tubercular maybe, and periodically in the grip of a poetic frenzy" (Medawar 1979, 40). And, in his article "Conformity and Nonconformity in the Fine Arts," Quentin Bell tells us unequivocally that the popular myth of the nonconforming artist is wrong: the habits of many artists are almost indistinguishable from the habits of people in other professions (Bell 1970, 687).

An understanding of how the cliché image of the bohemian artist developed might help young artists formulate their own opinions as to its relevance. In her seminal study of the rise of the bohemian image among French nineteenth-century artists, Marilyn R. Brown explains the factors that led us to develop the stereotype of the starving bohemian artist. Such an image did not appear on the scene until the 1840s when artists began to sympathize and

identify with the romantic image of "outsiders"—street bohemians who operated on the fringes of society. Gypsies were particularly colorful outsiders, and they were erroneously called bohemians in that era (Brown 1985, 1–3).

In the homemade world of the nineteenth century when old people still died at home in their beds, society believed that social outsiders (such as Gypsies) had a clearer vision of the future than did middle-class conformists. Consequently, the image of the artist as an outsider and a bohemian became a founding tenet of modern art, and the image of the bohemian avant garde artist was generated by that notion (3).

Identifying with these Gypsies and bohemians, the avant garde (as well as numerous establishment artists) from the 1840s to the 1870s painted images beyond counting of Gypsies and bohemian subjects, which were intended as self-referential metonyms that signified a distancing of artists from society and their opposition to the middle class—the bourgeoisie. These artists transmuted the image of the Gypsy into a "mythic prototype of the social outcast" (5).

Wearying of the capitalist industrial lifestyle, artists envied what they perceived to be the "natural" state of primitive wanderers such as Gypsies. In 1850 Gustave Courbet wrote: "In our oh-so-civilized society it is necessary for me to lead the life of a savage. . . . To that end, I have just set out on the great, independent, vagabond life of the gypsy" (Brown 1985, 78).

This purposely adopted bohemian image came to be expected of nineteenth-century artists, and the French artist Adolphe Desbarolles observed in 1843 that artists could court success by "calculatedly maintaining an appearance of poverty" (Brown 1985, 11). In *The Artist* Edmund Feldman tells us that assuming a bohemian image had little relationship to an artist's politics: Cézanne the reactionary, Delacroix the conservative, and Gauguin the socialist all adopted that lifestyle. The style of dress seems to have little to do with an artist's style, content, or themes: it seems to be little more than a way to needle the establishment (Feldman 1982, 129).

Brown notes that Emile Zola, in his nineteenth-century novel *The Masterpiece*, wrote of greedy dealers who discouraged their pet artists from exhibiting in the official salon so they could take collectors to visit them at work and thus foster the illusion that the collector had discovered an unknown artist in the exotic surroundings of the studio (Brown 1985, 5).

By the end of the nineteenth century, however, both the depiction of Gypsies and the romanticized lifestyle had become a tired cliché, and the impressionists never adopted the pretense of the bohemian role. Often middle class themselves, they chose instead to represent, and identify with, the bourgeoisie. A well-known anecdote portrays James McNeil Whistler's first encounter with the early impressionists. Whistler worked hard at his bearded bohemian image and eccentric behavior. When Degas and Manet, who had rejected the bohemian uniform, first met Whistler in a restaurant, they watched him and listened to him for a while; then they rose in tandem, and Manet said: "Sir. You dress and act as if you had no talent." In their opinion Whistler was trying to attract notice with bohemian actions because he could not do so with his paintings.

In the early twentieth century, when the courage of people such as Crazy Horse and Florence Nightingale were still fresh in the collective mind, Picasso (as if he had no understanding of what his membership in the Communist Party meant) assumed a permanent role as the establishment's bohemian. Duchamp, on the other hand, insisted that "the painter has already become completely integrated with actual society, he is no longer a pariah"; he then chose to act the "nihilistic dandy" (99).

Consequently, the bohemian image faded until sympathetic modernists, during the antiestablishment counterculture of the 1960s, looked once again to the nineteenth century to rediscover their bohemian image. But the basic construct of the avant garde artist is now being reevaluated by current revisionist historians, and the role of the artist in society is also being revised.

Roger Gilmore insists that the cliché of the starving outsider artist is gone: the postmodern paradigm is a "thoughtful, well-read, concerned artist who is often in the lead on such issues as the environment, ecology, health, housing, politics, and Third World needs" (Gilmore 1991, 36). Hiram Williams maintained that "few painters of any worth are 'Bohemian' in a loose sense. Most painters are moral . . . intellectual individuals" (Williams 1963, 79). In fact, William Grampp, among others, tells us that the image of the genius artist who was ignored in his time is largely a fiction; contrary to public opinion, the work of most artists is worth more while they are alive than after they are dead (Grampp 1989, 86).

Artist and Artist's Image

Consequently, the bohemian image has once again been left behind as inappropriate to postmodern issues. Gilmore notes that the new paradigm of the artist is a recasting of one aspect of the Renaissance artist's image: artists then were central to the "life and culture, the politics and economics," of their time (Gilmore 1991, 36). But it should also be recognized that pretenses and eccentricities will probably not harm a young artist's potential—unless the effort of cultivating such an image (puffers spend more time putting paint on their Levis than on their canvas) usurps creative energies that might better be spent making art. Feldman expresses a similar thought: some artists "spend more time perfecting their lifestyles than making art" (Feldman 1982, 121).

In reality, few people have done their most creative work when they were hungry or uncomfortable. Extending the concept that creative behavior is related to children playing, Getzels and Csikszentmihalyi explain that children do not learn or create best when they are hungry or thirsty; "only after their basic needs are satisfied do they manifest curiosity and exploratory activity." When children's needs are most satisfied, they play most vigorously (Getzels and Csikszentmihalyi 1976, 239). Perhaps this explains why so many successful artists and poets have had some means of support—a friend, a patron, a subsidy from their family, or their own commercial success.

Another point of view is expressed by Edmund Feldman, who explains that even though the bohemian image at first appears to be nonconformist in the extreme, it is often a "highly standardized code" for art students (Feldman 1982, 121). And in his seminal study of the semiotics of human behavior, *Gender Advertisements*, Erving Goffman explains that all behavior and style of dress communicates social identity. Behavior and appearance inform us as to each individual's mood, intent, expectations, and relationship to us and other groups. Furthermore, every culture develops distinctive categories and specializations of behavior and costume that are designed to communicate more specific information, though often this is neither admitted nor understood by those who affect such specialized behaviors and dress. Goffman calls such indicating behaviors "displays," and he tells us these displays establish the terms of any social interaction—"the mode or style or for-

mula for the dealings that are to ensue between the persons providing the display and the persons perceiving it" (Goffman 1979, 1).

Displaying the image of a poverty-stricken eccentric artist might be seen to signify two ideas in today's context: a uniform for artists or an emblem of anticapitalism, especially in opposition to the idea that art is a capitalist investment. In other words, artists might well choose to dress in a certain manner for the same reason members of the military wear a uniform, priests in many religions wear identifiable uniforms, or gang members wear specific colors and styles: to identify themselves as members of a particular group.

Go to any area that is rich in art galleries and you will find many (but not all, by any means) there who are easy to identify as artists because of their dress. They want to be recognized as artists. At gallery openings I have seen young people trying desperately to identify themselves as artists as they simultaneously try to stand out as "different" from the others.

One young man in Los Angeles stands out in my memory. He came to the opening of my exhibit wearing a complete English habit for riding to the hounds: red coat, riding breeches extremely bloused at the thighs and tight at the calves, cute little cap, quirt, and all. I expected to see a fox run panicked through the room. I could not decipher his message.

Perhaps the stereotype of the eccentric artist is also generated by the fact that artists develop their abilities to the point that they are one of the best in their field by obsessing. The best in any discipline define their lives in terms of that discipline. They are bored doing anything other than their chosen vocation. All other activities are simply obstacles to them. In Lucian Freud's words: "The painter's obsession with his subject is all that he needs to drive him to work" (Spaced 1991, 318). The obsessed may resent time wasted buying or choosing their clothes, so they often do not dress in the mode that others consider normal—even others in their profession. Often they wear the same kind of clothes all the time; they find freedom in everyday thoughtless habits.

Intensity is the first ingredient necessary to the artist. Llewelyn Powys told his young poet friend: "You approach your life with an intensity that only belongs to imaginative people" (Powys 1969, 119). It is hard to tell the difference (if there is any) between obsessive interest and what some may call talent.

The focused intensity that generates good artists or good scientists might also generate bizarre behavior at times, and the anecdotes about such behaviors, these departures from the norm (amputated from anything of substance), the media remembers and writes about, thus perpetuating myths.

When young artists then try to emulate behavior the media emphasizes, they tend to expend their energies on the bizarre behavior rather than on the obsessive work. In other words they try to emulate the effect and ignore the cause that generates it. Puffer behavior is considered interesting by those who do not know, it is sometimes mistaken for talent, and it takes less effort than hard work does. But such behavior may also become an obstacle to efficient work habits.

Artists must often support themselves with outside work, so they have little spare time. They must learn to use that time efficiently. Not for a moment do I mean to imply that their appearance or behavior is important, one way or the other. I simply wish to caution against a needless waste of time and energy. I also want to caution against focusing on the wrong priorities.

Art is a manifestation of the artist's priorities. Whether an artist or a writer or a scientist or a doctor focuses on the trivial or the profound is of ultimate consequence. The best artists I have met, from recognized professionals to students with strong potential, have learned efficient work processes and methods that they use in their search for a direction. Michelangelo, for instance, was considered by his peers the best poet in all of history, the best sculptor, one of the best painters, and one of the best architects. He left an intimidating amount of work in each area. I once calculated that Picasso must have averaged three to five signed works (including sketches, ceramics, etc.) per day (every day) for fifty years to have left the number of works that he did. Neither artist could have accomplished such a sheer quantity of work had they not practiced efficient and steady work habits.

Such efficient work habits support and powerfully reinforce creativity. For instance, when students from other schools come to the school where I teach, many of them have been taught to sit and "look" at their work—sometimes for hours. I have sculpted, drawn, painted, printed, read, written, and experienced art for more than four decades. I know enough to look fruitfully at

my own work for up to five minutes. Most students, however, gain little from spending more than two or three minutes sitting and looking directly at their own work. Everything that is there, they put there; they are unlikely to discover much in extended bouts of looking. Extended looking is sometimes little more than an excuse to avoid work.

When students are left to sit and look, their work often develops, after a time, a rigid desperate appearance. Often young artists confuse time spent looking with time spent working. In my drawing and painting classes, I try to convince most (certainly not all) students that they can count as time spent painting or drawing only the time they spend with the drawing or painting tool touching the paper or canvas.

I have found that students want to stop and look for extended periods when they do not know what else to do. They can think of no major changes to make. If they continue to work on a piece at this stage, they simply "cat-lick" the surface, whether in drawing, painting, ceramics, or sculpture. Here is a simple alternative: when your work reaches the stage where you can think of no *substantial* changes to make, put the work aside and work on something else, as described in chapter 2.

Besides the bohemian image, there are two other pervasive stereotypes of the artistic personality. One perception is that artists are cultivated and elegant. Many people believe artists are delicate sensitive snobs, and I see a few young artists who emulate this manner. They feel obligated to appear haughty and condescending, and they feel that anything that is not in excellent taste is "bad art"—as if art and good taste were synonymous. I have seen mediocre, and worse, so-called fine artists denigrate excellent examples of commercial art or western art (cowboy art as opposed to Western art) as bad art.

Such people are prone to judge one thing by the standards of another—such as a tennis player who attends a racquetball tournament and calls it bad tennis. Racquetball is not tennis and it is not judged by the same standards as tennis. Commercial art (graphics) and western art are not judged by the same yardstick as other arts. Movie critics and the academic community, for instance, are prone to criticize as bad art movies that are intended only as entertainment.

Another stereotype about artists is that they are arrogant. Many young artists

and a surprising number of art instructors nurture the belief that all good artists are arrogant jerks. Art, like anything done well, often (not always) requires self-confidence; it requires risk, even to the point of arrogance. But that arrogance need be demonstrated only in the work, not necessarily in the personality.

When Jackson Pollock discarded his first successful style, a series of child-like mythic figures, to lay his canvas down upon the floor, poke holes in cans full of paint, and drip that paint all over the canvas, that was risk, even arrogance. He did not know if what he was making were even a painting. It is said that he called in his wife, Lee Krasner, who is also an excellent painter, and asked: Lee, is this a painting? (Those who consider a painting good only if it reflects something they have previously seen that has been called art would have told him it was not a painting.)

Howard Haas tells us that leaders in any field must take risks: leaders create change, and change involves risk (Haas 1994, 12). When Francis Bacon finished a fine painting then laid it down on the floor and poured a large splash of white enamel paint across the surface, that was pure arrogance. Many of us could have told him ahead of time that the white paint would ruin the painting. When I see those paintings I think: what kind of arrogance allowed him to take that kind of aesthetic risk, and succeed? But that kind of arrogance is manifest in the painting, not necessarily in the painter. Medawar reminds us that "the old-fashioned remedy for hubris was a smart blow on the head with an inflated pig's bladder" (Medawar 1979, 51).

The most important single thing a young artist can learn, or develop, is self-discipline. Art is inundated with a need for self-discipline. In most professions, workers are not allowed to miss work: the second most common cause for dismissal from a position, right after an inability to get along with coworkers, is absenteeism. But, after finishing art school, no one cares if an artist works regularly or not. If you take a day off when the weather is beautiful to go to the beach, no one cares. If you find this day so much fun that you want to do it again, no one cares. Soon the fun time between working days grows longer and longer. Eventually, you cannot remember the last day you worked.

In *Careers in Art* Gerald Brommer and Joseph Gatto list five important

qualities that are necessary for success in any area of the visual arts. They list self-discipline as number one (Brommer and Gatto 1984, 13, 157).

Steady work is far more productive than superhuman spurts. When I was twelve I lived with my uncle. He taught me to drive a car in the late 1940s because he wanted me to help him on long trips to Los Angeles, where he sold loads of used car batteries. He drove a 1936 Willys Overland coupé. Driving fast was out of the question. With the trunk loaded with several hundred pounds of batteries till the rear bumper almost scraped the road, we sped along the highway between Los Angeles and El Centro, California, at a breathtaking forty miles per hour. I noticed that many cars passed us several times during the drive. We saw them stopped at a filling station, then a café, then a scenic lookout. Later they would go around us again at seventy miles per hour. Often we reached Los Angeles about the same time as those cars that traveled at seventy. The tortoise and the hare.

After years of teaching, I have found that the same is true about steady workers and spurt workers in the arts (though this may not pertain to novelists). But the steady workers in the visual arts far outstrip the spurt workers in the amount of work completed, as well as in improvement. Spurt workers find that the time between spurts tends to get longer and longer. The nineteenth-century French novelist and critic Marie Stendhal recalled with regret that "I was waiting for genius to descend upon me so that I might write." But, she continued, "If I had spoke . . . of my plan to write, some sensible man would have told me, 'Write every day for an hour or two. Genius or no genius.' That advice would have made me use ten years of my life that I spent stupidly waiting for genius" (Guitton 1964, 54).

Expertise in art also requires discipline in many different guises. The most difficult of all, I believe, is the discipline of restraint. Artists must always restrain themselves from one thing or another. Some must restrain the impulse to plan too much, others to plan too little. Artists must restrain the impulse to take the line of least resistance; they are tempted to call a work finished when the primary image is good but several peripheral areas still need more work. They tend to settle for "pretty good" when they should be striving for damn good. When we review slide portfolios from artists who are

Artist and Artist's Image

applying for a teaching position, I can often look at the dates on the work and guess exactly the year that artist completed an M.F.A. It is common to see good work that suddenly plummets into mediocre work at a particular point, never to revive. My guess is that when they leave school they no longer have an instructor telling them to push that work further, so they quit too soon.

Painters who paint wet-into-wet must restrain the impulse to stir the paint too much. If they take a brush full of clean clear color and strike it once into another color, it may make a rich mixture of one color shooting through another. Take one more stroke across that mixture and it turns to crap (there's that technical term again).

Painters, especially, must restrain the impulse to spend all their time and effort working on (harassing) the objects in the painting (or what modernists called the "positive shapes"). They work and work to get the figure or the car or the animal just right, but they are satisfied with the skimpiest of backgrounds. But the best painters put a major portion of their effort into the background (negative shapes). Analogously, I have noticed that an attribute of some of the best actors is the way they are able to use silence. Many competent actors can render a competent believable performance, but many of them have *horror vacuii*—a fear of empty spaces.

Many actors, like many teachers (and many people in social settings), cannot stand to leave even a moment of silence. Somewhere in the back of their mind they harbor an inordinate fear that if they do not afford constant entertainment, the audience will rise en masse and leave the room. They think of silence as "dead air," in the same manner that many drawers and painters think of the area surrounding the principal image as dead space.

But the best actors know how to use a silence. They restrain themselves. They may stay dead silent at the most critical time in the plot. Such powerful silence can stack additional layers of contrast and suspense on the best of performances. Of course, those who do not understand the principle may impose silence at the wrong moment, or stretch it to unreasonable lengths, in which case it is dead air.

Similarly, I have also noticed that some of the best painters through history have spent more time on the background than on the figures and

objects. The figures or objects are often quickly and easily tossed off, while the background shows evidence of much care—painting and repainting.

Many artists, writers, and poets must constantly restrain the impulse to overdescribe. It is so common to see a young artist whip up a subtle elusive mysterious image, then look at it for a while, recognize that it is an excellent image, but decide that no one else will be perceptive enough to notice. So they "improve" the image: they outline it or they make the edges crisper; they make the image more recognizable.

The best thing about that image was its subtlety, and they destroyed that. They destroyed it because they underestimated their audience. Comedians do it. Writers do it. Poets do it. Artists do it. The problem with underestimating the audience is that some of the least literate and least perceptive viewers may like the well-defined image more, but these are the viewers that artists care the least about. The viewers we care most about are likely to be bored or even to resent this insult to their intelligence. The first thing any professional (writer, actor, artist, musician) must decide is this: who is my audience? That single decision will solve many problems.

The best viewers prefer the gestalt of making that closure themselves. When Picasso and his friends noted that viewers saw everything there was to see in Fernand Léger's paintings in the first two minutes, they did not intend this as a complement. This mistake alienates exactly those literate viewers that interest young artists the most. Never underestimate your audience— unless your primary motive is to make money. H. L. Mencken condescendingly observed: "No one ever went broke underestimating the taste of the American public."

A good rule of thumb is: the longer it takes to discover some aspect about a painting (an image, a metaphor, a relationship), the stronger that discovery will affect the viewer once it is found. Similarly, the longer it takes to catch on to a joke the funnier it will be, once understood. When we tell a joke and a listener does not get it, some are tempted to explain it. When we do explain a joke there can be only one response: an unenthusiastic "Oh. Yeah. I get it."

Do not tell them; let them figure it out for themselves.

I worked my way through high school in my uncle's tire business. We trav-

eled from car lot to car lot regrooving tires and replacing badly worn tires with retreads. While driving from one car lot to another one day in 1949, Uncle Vance started talking about his experiences in World War II: "The Germans had a little desert car that was air cooled," he told me, "and they carried a spare engine in the trunk like some cars carry a spare tire. It only took four bolts to change that little engine, so if it wore out, or overheated and seized up, they simply hopped out and put in the spare."

I told him that I found that hard to believe, but later in the day, on about the third car lot we worked, he was driving down the aisle between cars when he suddenly stopped. "By God, Bill! I think that's one of those little German cars over there now."

Sure enough, there was a funny looking little car sitting quietly among the great Fords, Chevys, and Chryslers. We got out and looked at the car. Vance went to the rear, turned the handle, and opened the trunk. Just as he had said, there was a small spare engine. For years I told my friends about that funny little German car that carried a spare engine in the trunk. The typical response was, "Come on, Bill. I don't believe that."

"It's true," I would swear. "I saw one in Long Beach, California." I finally learned not to tell people about that car. Then, thirty years later, after that experience had long slipped from my mind, I went out to tune up my car one Sunday. I walked around to the rear of my 1969 Volkswagen Beetle, grabbed the handle, and opened the engine compartment. Something about the day and the image suddenly popped Vance's joke into my mind. I laughed so hard I sat down in the middle of the driveway. I got up and went to the phone, dialed Vance's number, and when he answered I said: "Vance, that was a damn Volkswagen."

Vance knew immediately what I meant. He laughed so hard his wife had to take the phone till he could rejoin the conversation. The point here is that he showed remarkable restraint and, as was his habit, a remarkable confidence in me. He never explained his joke. He waited patiently for thirty years for me to make my own discovery, and I discovered it just in time. Two years later he died. I still cherish his confidence in me.

The viewers' right to make their own discoveries must be respected. Fail

to respect your viewers' potential, and you will do work they cannot respect. This closure is the contribution the audience makes to the work of art. R. G. Collingwood, one of the early writers about the linguistic aspects of art, insists that an artwork is complete only when an audience responds to it: "There will thus be something more than mere communication from artist to audience, there will be collaboration between audience and artist" (Collingwood 1961, 312). And the spokesman for the musical group The Neville Brothers, Cyril Neville, says that he and his three brothers refer to the audience as "the fifth Neville brother" (Neville 1994).

This idea of closure, the interaction between audience and artist, is one of the reasons that many artists do not like to talk about their work. When you listen to artists talk about their work, some of them may seem irreverent, almost insulting, in their refusal to explain what they are doing. Some talk about their lives but not their work. Some talk about technique. Some talk about the circumstances under which they made the work. But few will attempt to explain their work. There are three reasons for this refusal: (1) they do not want to explain their joke, (2) the best visual works cannot be adequately paraphrased verbally, and (3) they do not want to give the false impression that they have explained the work when they know they cannot do so.

The better an artwork is, the more history and tradition it has behind it. When I have an opening at an exhibition of my work and people ask me to tell them about it, I try to be polite. I try to talk about something related to the work, but what I want to say is: "I'll be happy to tell you about my work—if you have about three years." When an artist, who is probably far better at making art than at talking, spends two or three hours explaining just one work, the audience may leave thinking they understand that work (and perhaps bored as well). The artist, however, knows they do *not* understand that work. Most artists hate to give viewers the false impression that they have been told enough to understand the entire work. Because the important things in a work of art tend to be generated by the unconscious, the artists themselves do not fully understand their work.

When I am king of a university somewhere, I will require each department to offer a one-credit introductory course. In this course instructors will not

be allowed to require work within their discipline. Math instructors will not be allowed to require any addition, subtraction, multiplication, or algebra. Art teachers will teach no drawing or painting or history. Physics teachers will conduct no experiments. This single-credit course will be used only to explain to students what kinds of ideas their particular language (math, art, psychology) is intended to discuss.

My aptitude tests insisted that my strongest abilities were in math and science. Yet I performed poorly in math classes. I did, however, do well in plane geometry class, perhaps because Ms. Hammer explained that geometry teaches us to think efficiently. In hindsight I understand that I was not interested in other math classes because I did not know what that math was designed to do beyond checking the grocery bill or computing income tax or gas mileage. Quadratic equations were useless to me.

But I loved ideas, particularly those that expanded my view of reality. When I read in the paper something as simple as the fact that the tongue of a blue whale is larger than a large pregnant elephant, I practically had an aesthetic experience right there in the floor. If just one of my math teachers had explained that math is a language that can be used to discuss things that verbal language cannot attend, such as black holes in space, white holes, quasars, pulsars, star gates, space travel, and even time travel, I would have been extremely interested in those classes.

If you studied philosophy you would study the works of philosophers such as Plato, Spinoza, Kant, Peirce, Hegel, and Nietzsche. If you took writing classes you would learn to parse, construct a sentence, a paragraph, and an entire text; you would learn to carefully construct a thesis sentence and defend that thesis. After learning all of this, if you then went home and wrote about how much you loved your puppy, you would not be a philosopher. That would not be philosophy because that is not what philosophers write about. "How much you love your puppy" is not a topic in philosophy. Philosophers write about reality and its relationship to illusion and the human mind. Recent philosophers have attempted to examine how we understand reality through the mind's inherent ability to construct languages.

Similarly, if you study painting and learn to compose, adjust proportions,

render skillfully, and mix color expertly, and then you make paintings about cute puppies or beautiful landscapes, you are not an artist. Artists have traditionally examined the relationship between reality, illusion, and how the mind experiences these phenomena—the influence of human visual perception. In tune with recent philosophers, recent artists have focused on how language, or a mind that is constructed to invent and understand the world through language, influences our perception of reality.

If you are interested in such ideas and learn to discuss them through painting, *and you can still play,* you may well be a painter. The play is important. One of the most difficult ideas that I try to explain to the young artists I work with is that anything done well is play. The most successful financiers and gamblers do not care about the money: they love only the game. Money to them is simply a way to keep score.

The best artists and the best scientists are simply playing. This playful attitude is well demonstrated by Isaac Newton's often quoted disclaimer: "I do not know what I may appear to the world; but to myself I seem to have been only like a boy playing on the seashore, and diverting myself in now and then finding a smoother pebble or a prettier shell than ordinary."

It is difficult to explain to young artists that self-discipline and hard work are important, but, at the same time, they will work better if they don't give a damn. How does a beginner reconcile self-discipline and hard work with not giving a damn? How do you work your butt off and not give a damn? Children know how.

I have watched children play for hours. They play hard. They play so hard they are oblivious to the distractions around them. They will sit there and mess their pants to avoid having to stop their play. But they don't give a damn about doing it right. They may use toy cars as airplanes, or as dogs, or whatever comes to mind. When they play with blocks, they will not stack blocks the "right way."

When my oldest daughter was two, I spent an entire weekend in the shop making her a beautiful and elaborate set of blocks. I designed them, like Cuisenaire rods that are intended to give elementary school children a feel for math, in units of one to ten. To match the length of a ten-unit rod, she

would have to use perhaps two fives, or a five, a three, and a two. I hoped she would eventually develop an intuition for increment, proportion, and thus math, through playing with these blocks.

I made hundreds of these blocks. I remembered that when I was a child I never had enough blocks to build anything like what I had in mind, so I filled a large cardboard box with blocks. Stacey loved them. I watched her play with them for three weeks, and I kept my help and my opinions to myself. She actually played with them till she pooped her pants once—surely the mark of a successful toy.

But she played with them "wrong," I believed.

She did not build things with them. She did not stack them. She did not arrange them in rows. She did not impose any kind of order on them. She just seemed to stir them around like an old man shuffling dominoes. She would intermittently pick up one in each hand and bring them together in a collision, then let them fall to the floor. But I kept my nose out of it. I restrained myself to the full extent that my young self-discipline would allow.

Finally, one day when she was off doing something else, my restraint failed. I began to build an elaborate structure, my own small Xanadu. I was positive she would see the possibilities and begin to play "right." She came in when I was nearly through. She watched in fascination as I carefully placed the last few blocks in place. I stood up and stepped back, proud of my demonstration, certain she would now see the potential in those blocks. She walked straight to the palace I had built and kicked it down. She turned on her heel, left in disgust, and she has literally never, NEVER touched those damn blocks again to this day.

If you play, you will love your work; if you love your work, the self-discipline is not needed to keep you working. You may well find that you have to exert self-discipline to *stop* working.

When we try too hard at something we choke. We do not perform well. Basketball players who make almost all their free shots in practice will often miss during the game when it counts most. We have all seen figure skaters who perform well in practice but manage to fall at every important competition. The tendency to choke at the times that are most important to us,

when we are trying the hardest, is called "focal dystonia." On the other hand, no one performs well unless they have learned to concentrate, to focus—to shut out all other distractions.

How then do athletes or artists learn to focus, to concentrate, without trying too hard, without choking, without initiating focal dystonia? The Murphy's law of public performance is that when it is most important most athletes or artists will perform at the level of their worst practice session. The answer here is to practice more. Disciplined practice steadily raises the level of the worst performance.

There are tricks to help avoid focal dystonia. I tell beginning studio students that they will be graded more on quantity than quality—on effort rather than finished product. When they think they are not being graded on results they tend to relax more and do better. Some teachers, however, promise to grade on effort or on improvement, but in the end they give the high grades to the most finished, and often the most traditional, work. I often have beginners paint on unprepared butcher paper for the first quarter. I tell them the oil will rot the paper, so it will not last. Consequently, they are doing nothing more than a temporary exercise. When they do not believe they are creating a permanent work that they can keep, they relax, and experiment, and paint better, and learn faster.

Though it has been in print only since 1992, more people have bought Harvey Penick's book on how to play golf than any other book on sports in history. Harvey has coached most of the successful golfers in his day, but many of his readers care little about golf. Harvey is known as much for his wisdom as his coaching skills. He wrote that no golfer can see the club strike the ball. Still he continues to tell his students to keep their head down and watch the club strike the ball. He explains that "when I tell a student to keep his eye on the ball, it is usually to give him something to think about that won't do any harm" (Penick 1992, 28).

Tricks, if they work, are worthwhile. If students learn to work in a relaxed state from the first, and practice working in this state, they form good habits and they learn how it feels to work in a relaxed but intense state. Furthermore, this practice tends to teach them to focus more on process than on

Artist and Artist's Image

product, and I am convinced that the most widely shared attitude among the best artists of most times, most styles and schools, and most cultures is the tendency to prioritize the idea of art as an ongoing process, over the idea of art as product.

Certainly the best teaching and the best practice in any discipline concentrates on process as opposed to product. W. Edwards Deming is the world's best-known expert in quality management: he taught the Japanese to manage their businesses efficiently. He advises universities to stress processes, not outcomes, in all disciplines, including the evaluation of teachers and teaching methods. He insists that "if processes improve, outcomes will correspondingly improve" (Nielsen 1993, 3).

More than four centuries ago, for instance, Vasari recorded the story of an emissary sent by Pope Benedict through Sienna and Florence to find the best artist to execute paintings for St. Peter's. This emissary asked Giotto to furnish him with "a little drawing" to send to his holiness. Giotto, "who was a man of courteous manners, immediately took a sheet of paper, and with a pen dipped in red fixing his arm firmly against his side to make a compass of it, with a turn of his hand he made a circle so perfect that it was a marvel to see." The pope's emissary thought Giotto was making fun of him, but the pope understood the idea of discipline and process and "saw that Giotto must surpass greatly all the other painters of his time" (Vasari 1958, 8).

When he was more than seventy, the great Japanese artist Hokusai is purported to have said that he had now learned to hold a brush correctly. When he was past eighty he said that he could now paint one perfect character. He mused that he might be a good painter if he lived long enough. He was engaged in becoming an artist, not in producing art.

In 1967 Willem de Kooning was sixty-three and probably the best-known painter in the world—many would say the painter of the century. *Time* magazine noted that any painting he signed sold almost immediately for $12,000 to $55,000 dollars ($12,000 dollars was almost twice my annual salary as a university instructor at that time). De Kooning needed never paint another painting to attain either money or fame, yet he painted seven hours a day, seven days a week. When asked why he continued to work so hard, de

Kooning answered: "I am ambitious, ambitious to be a fantastic artist" (*Time* 1967, 88–89).

When Picasso was an old man he was asked: which painting do you think is your best?

"The next one," he answered immediately.

Even an artist with the mammoth modernist ego of a Picasso, who is reported to have signed and dated every doodle and every mark on a napkin because he believed he was such a genius that he had no right to throw anything away, understood the humility of process. ✐

The Color Monster

"I CAN'T PAINT BECAUSE I DON'T KNOW ENOUGH ABOUT COLOR."

"I'd use color on my sculpture, but I don't know enough."

"I wish I knew more about color for my photography."

"I wish I could take a course on color so I could make better art."

I often used to hear art students lamenting one variation or another of this complaint until I decided to teach a comprehensive class on color, both theory and practice. I investigated color from every perspective I could think of. I researched color as sign and color as illusion, the physics of color, the psychology of color, the history of color in art, color in television, color in photography, and the use of color in graphics (or commercial art).

All this research, after I had taught the class several times, led me to conclude four things: (1) art teachers and even the books were, in general, more than one hundred years behind in their knowledge of color theory; (2) only a few concepts or theories offered much help to young artists in their approach to color; (3) few artists in history have used color according to theory; and (4) the most important effect the color course had on young artists was that it removed an artificial monster of their creation and allowed them to relax in their work without being intimidated by their perceived lack of knowledge about color. That is, when they finished this course they felt they knew more about color than most successful painters have; consequently, they could never again blame the poor quality of their art on their lack of knowledge about color. That false monster had been destroyed. In short, they lost forever one more excuse for failure.

This creating artificial monsters in the mind, as a ready excuse for future failures, is a common device that haunts students in all disciplines, as well as in sports. I have seen many students, undergraduate and graduate, who cannot seem to work hard or try their best. Perhaps they think unconsciously

that if they really try and still fail, the failure will carry some meaning that they cannot face, but if they do not try their best and they fail, they can tell themselves it is okay because they did not really try; so the failure does not mean anything about their ability or their personal worth. It is as if they were saying to themselves: I'm probably going to fail and when I do, this will be my excuse.

This bad habit is as old as art. Sir Joshua Reynolds took notice of this in his discourses in the eighteenth century: "Such students are always talking of the prodigious progress they should make, if they could but have the advantage of being taught by some particular eminent master. To him they would wish to transfer that care, which they ought and must take of themselves" (Reynolds n.d., 326). Much of what teachers do is to remove, one by one, students' excuses for failure. *The Hustler,* starring Paul Newman and Jackie Gleason, is an excellent movie of 1961 built around exactly this thesis.

Most art books and art teachers still labor under Brewster's early nineteenth-century misapprehension that the primary colors are red, yellow, and blue. Even those who purport to follow the Munsell system often use the Brewster system. No other discipline in the twentieth century still uses this outdated color theory. As early as 1905, Munsell himself states: "There is a widely accepted error that red, yellow, and blue are 'primary,' although Brewster's theory was long ago dropped when the elements of color vision proved to be RED, GREEN AND VIOLET BLUE" (Munsell 1926, 49). (Violet-blue is accurately identified as ultramarine blue now.) Writers in physics, television, photography, and graphics have known since Young and Helmholtz's discoveries in the mid-nineteenth century that the primary colors are red, green, and blue (ultramarine). This version establishes magenta (a slightly maroonish red like alizarin crimson), cyan (like cerulean blue is easily mistaken for a light blue), and yellow as the secondary colors on the wheel.

Furthermore, secondary colors will mix subtractively to create a greater variety and a richer range of color than will primary colors. This is the reason that graphic artists (who clearly see the results and the advantages of mixing secondary colors when matching and reproducing color in the printing process) have traditionally mixed their color with these three secondaries: magenta, cyan, and yellow. The use of these colors has become so prevalent that they are

Color Monster

often called the "graphic arts primaries." (It is easy to see, though, that these three colors could be mistaken for red, blue, and yellow.)

But, for an artist's purposes, there is little reason to use either primary or secondary colors. Art teachers all over the nation are dutifully teaching their students about the (wrong) three primary colors, and students all over the nation are just as dutifully ignoring this information and choosing the tube that offers the color nearest to the one they want. They then change that color slightly to match what they have in mind. Few, if any, successful artists have mixed their color from primaries. Other than Cézanne, the impressionists, and the pointillists, few painters have been guided by theory in their use of color (except for the classic color theory: the Renaissance version of color perspective—warms advance and cools tend to recede into the distance).[1]

Two well-known color systems that are often mentioned but seldom understood or taught in detail by art teachers are the Ostwald and the Munsell systems. These are excellent three-dimensional—hue, chroma (or saturation), and value—systems for charting, describing, balancing, and naming color numerically and mechanically. Color can be named so accurately that a specific color can be phoned from one city to another. These systems are used, for instance, by antique bead dealers to establish the exact color of glass beads more accurately than it can be done by color photography. These two systems have also been the foundation and inspiration of the color mixing systems that commercial paint stores employ. But I do not believe any major artist has found much use for either system.

That exemplary problem finder Edwin Land was the author of the retinex color theory, the only twentieth century color theory that seems to hold much potential interest for artists.[2] A thoughtful reading of Land's theory. which he developed during investigations that led to his invention of the color Polaroid camera, is likely to persuade most artists that there is little reason to waste their time on theories of primary and secondary colors.

The following is a simplistic explanation of Land's theory. The retina itself

1. The impressionists and the pointillists were most influenced by Rood 1879 and by Chevreul's five Laws of Simultaneous Contrast (Chevreul 1890). For a complete explanation of the classic color theory, see Dunning 1991, 47–54.

2. See Land 1977, 108–28; see also Land,1983, 5163–69.

sees no color; it records only value information. Each range of cones is stimulated by only one particular wavelength of light, but those cones perceive the scene in a black and white interpretation only. The information that each set of cones sends to the cortex is like the information in a black and white photograph that has been taken through a color filter of a specific hue: the red cones record value information like the information recorded in a black and white photograph taken through a red filter; the green cones record information like that in a black and white photograph taken through a green filter, and so forth. Land offers the heuristic explanation that the process behaves as if the cones in the retina send hundreds of black and white photographs to the cortex; each of these photographs has been taken through a different colored filter. In addition, the rods send approximately accurate black and white information, as if that photograph were taken with no color filter involved.

Comparing the value information it receives in a series of black and white value impressions, the brain *computes* color. For instance, the brain analyzes the value information sent to it from the light reflecting off an apple: the red cones see the apple as a light value, the blue cones see it as a dark value, the green cones see it as a medium value, and the rods see it as a medium value. The cortex then compares (it does not average) this cumulative information and assigns the color red to the apple.[3] Furthermore, Land demonstrates that the brain can compute almost a full range of color with only two of these "photographs" (the red and the green, for example). The eye, echoing other redundancies in our physiological makeup, sends far more information to the brain than is necessary to compute color in a normal situation.

Color does not exist outside the brain. In the exterior world there are only different lengths of light waves, and humans have evolved the equipment to artificially distinguish between longwave and shortwave light by assigning different colors to different wavelengths.

But we do not perceive red only because of the red wavelengths of light that

3. Land's version of the relationship between the eye and the brain in the creation of color seems to me an elegant combination of the principal elements of the two most popular nineteenth-century color theories: the Young-Helmholtz physical theory of color (in the eye) and Hering's psychological theory of color (in the brain).

Color Monster

reflect off a surface. We perceive color owing to a combination of several phenomena, such as wavelength, context, and induction. For instance, it is possible to see red in an area where there are nothing but green wavelengths reflecting off that area. Bell Laboratories has a device that can fix an image on the retina so that its edges do not move even a cell width across the retina with the normal imperceptible quivering of the retina (50 to 150 movements per second). Because our vision is activated only when the edges of perceived objects move across the cells of the retina (perhaps only the width of a cell or two), any image that remains fixed immovably on the surface of the retina quickly becomes invisible. If all visual movement across the retina is halted, the subject loses any visual impression (is temporarily blind) within a few seconds.

In a well-known experiment, a man named Knapp at Bell Laboratories contrived a situation in which a large red circle surrounded a green circle that was less than half the diameter of the red, but the image of the smaller green circle was fixed immovably on the retina. The green circle disappeared! It could not be seen. It became invisible. Subjects saw only the larger circle, and they saw it as a solid uninterrupted red.

Consequently, Land asks: If the red we perceive as now occupying the area of the green circle is not caused by the wavelength of the light issuing from it, then perhaps the red we see in the larger red circle may also be caused by something other than the wavelength of the light it reflects.

In short, Land insists that color vision depends upon a series of related phenomena, and these phenomena are related to color as fire is related to smoke; even when we see the smoke the fire may be hard to locate (Land 1977, passim).

A thoughtful reading of Land's retinex color theory will persuade most artists that there are many possible primary colors for some purposes. Furthermore, there is little practical purpose in knowing or using a system of primaries or secondaries for anything other than reproducing color in a printing process. Any hue of pigment that is taken straight out of the tube will be richer and purer than the same pigment achieved through subtractive mixing, no matter how expertly conceived.

Experienced painters are likely to choose a basic palette that includes the six primary and secondary colors. They often choose a cool and a warm version

of each color. This creates a palette of sixteen basic colors when two blacks and two whites are included. Most will eventually find they do not use all these colors, and other colors will evolve to become their favorites. Thus they arrive at a palette through experience, by adding and deleting certain colors.

Painters will gradually learn more about the basic characteristics of the different variations of each color and its vehicle. For instance, ivory black is transparent, thus it is good for mixing rich tones but not for painting an area opaque black. Mars black is opaque, however, so it tends to work better for painting an area solid black, and it mixes excellent grays. Cadmium red and vermillion appear to be the same hue, but they act entirely differently: cadmium is opaque and is superior for painting a large area that color, while vermillion is transparent and does not cover well, but it is considerably cheaper, and it may mix to create different colors than its cadmium look-alike. After years of experience, each painter develops a unique and personal palette and specific empirical knowledge about the interaction of those colors.

Rembrandt used only black (sometimes a bluish black) and white with two other colors, red and yellow.[4] His apparently simple color schemes did not seem to impede his artistic potential. Furthermore, Cézanne, who was a fine colorist and color theorist, wrote to Emile Bernard (who had a tendency to obsess about theories in art) that it was not the color that was important, it was the art: "One can do good things without being very much of a harmonist or a colorist. It is sufficient to have a sense of art" (Chipp 1968, 20).

The two most important (but certainly not the only) things that artists need to know about color are value control and the semiotic properties of color. "Value" refers to how dark or light an area is, regardless of its hue. A black and white color photograph shows only the value of each hue: pure yellows tend to be light in value, pure blues tend to be dark, reds tend to be halftone.

If young artists understand two simple points of departure about color, they can learn to handle it well. First, the most personal color relationships tend to be established between colors of different hues but *similar* value. Because they are both stable on the retina, for instance, a slightly toned-down

4. An analysis of the colors used in the Night Watch includes a combination of inexpensive pigments that created yellow, blue, red, brown, and some green. Green was seldom long lasting, and his use of it is hardly apparent, while brown is usually either a dark yellow or a grayed-down red.

Color Monster

green and purple of exactly the same value can at first glance seem to be almost the same color.

Beginners often want to use broken color in an area, so they may drag a light color across a dark color. This creates too much value contrast and the surface often looks too broken up and too assertive for its context. More experienced artists will use two different colors of the same value, and be-cause they are similar values they will visually lock together (integrate) to produce one solid surface. Painters since at least the sixteenth century have used this method, particularly in their background areas. Painters such as Andrea del Sarto, Caravaggio, and David often wiped a warm (often burnt sienna, which is a toned-down red) over a cool (often a greenish gray) to create a rich background.

Second, with today's focus on semiotic properties in art, current artists would do well to consider what color can communicate beyond simply imitating the color of the objects we see in the real world. Color, it must be remembered, always establishes a connection with both illusion and the reality of the external world—that world outside the painting.

Because of the way the cones and rods in the human retina interact with the brain, the photopic (or cone) vision of the daytime world is immersed in color, but we see no color at night. The scotopic (or rod) vision of the night is black and white (with perhaps a slight blue or indigo shift).

No matter how carefully artists tried to remove all suggestions of the world outside the painting during the dominance of modern art, when art was supposed to be its own reality, color could not escape an identification with the external world. Jacques Derrida, who gave us deconstruction, the word and the strategy, insists "there always remains in a painting, however inventive and imaginative it may be, an irreducibly simple and real element—color" (Derrida 1978, 49). Hence, at some time in their careers, modernists such as Pollock, de Kooning, and Franz Kline chose to escape the last vestigial remnants of the external world by removing even a hint of color.

Postmodernists such as Anselm Kiefer, however, have sometimes limited their paintings to black and white for yet another reason: they wish to focus on myth, one of the principal characteristics of postmodernism. Kiefer's paintings focus on a more mythic reality, and the mythic world seems more at home at night than in the full light of day.

Advice to Young Artists

Furthermore, when modern artists used color, they usually sought unique and personal color through complex color mixtures: tints, shades, and tones. They often attempted to create colors that could not be tagged with simple names, such as red, purple, and green. Artists learn to mix such complex colors in three stages. Beginning artists start with very simple mixtures of color. The first stage is to lighten a color, so they add white. This creates what is called a "tint" or a "pastel." Beginners will often execute most of their works in tints, but tints and pastels do not usually work well in large areas because they tend to look dry and "chalky."

During the second stage, artists learn to gray their color down so it does not look so raw and garish. They first learn to add black to a hue, then they will learn to gray it by adding its complement, or an earth color. This creates a "shade." Shades usually look richer than tints, particularly in large areas.

The third stage is the discovery of tone. Artists will finally learn to lighten color with white, then gray it down with black, a complement, or an earth color. The combination of tint and shade creates a "tone," which is a much richer, more *attractive* color, easier to harmonize, than either tint or shade (but tones are not necessarily more expressive colors).

Postmodern artists, however, may not want "attractive" color. They may choose to use color as sign—the equivalent of a verbal referent. Hence they may limit their palette to the simplest of colors. Pure red, for instance, may signify such ideas as blood, violence, revolution, or the purification of society by fire, according to the context. Green easily suggests nature or the environment; caustic shades of green may suggest mortality, death, or corruption. Blue may refer to purity: water, sky, or spirituality.

In short, color may be used in many ways other than the simplistic harmonies that beginners often seek and teachers often encourage. The young artist's goal should be to become aware of the range of possibilities. Without such awareness, there is little chance of finding a viable direction. There is no right or wrong way to approach color; the only mistake is in failing to make a choice. Artists who are not aware of the choices often choose their colors for no reason other than that they harmonize; in other words, they pick colors that are "pretty." And pretty has been a swearword to artists of every period. �ló

Color Monster

7

Galleries, Portfolios, and Web Pages

THE ART WORLD IS FAR MORE COMPETITIVE now than it was at the height of modern art in the 1950s, when New York had just become its undisputed leader. It has been estimated that before World War II fewer than three hundred professional fine artists were living in New York. Richard Lindner remembers that when he first came to America in 1941, "there wasn't much of an art world. . . . There were two or three galleries, and nobody sold anything" (Gruen 1991, 93–94).

Two or three galleries!

But by 1950 well over ten thousand artists were registered in New York, when Pollock, Kline, and de Kooning reigned and Americans still labored under the modernist misapprehension that their country of 150 million individuals was a "melting pot" sharing a single monolithic belief system. During the 1950s a portfolio of a few slides, with a promise to produce more, landed many a young unproved artist (including myself) a spot in a group show or even a one-person show in a respectable gallery. No such easy access is likely today.

In the late 1950s, when I was taking my work around to the galleries in Los Angeles, which were mostly clustered around La Cienega Boulevard, I rarely saw other artists. Most galleries and collectors were still looking for "talent" and "temperament." They entertained romantic notions of finding their "eccentric genius."

Today, however, when I visit galleries, I see artists all over the place, standing on the street corners in the gallery district in Los Angeles or SoHo in New York. They seem to crawl out of the woodwork. I've seen artists with a portfolio under one arm and a guitar under the other, as if they were equally ready to paintcha, kiss ya, or sing you a ditty. The last U.S. census, in 1990, listed under the category of "Painters, Sculptors, Craft Artists, and Artist Printmakers" more than 13,000 artists (7,575 males and 5,590 females). This

includes only those who list "artist" as their principal job; it does not consider art faculty or those who hold jobs related to, or outside of, art.

Sophie Burnham records that by 1960 the number of New York dealers of all kinds of art had grown to 450; by 1970 they had increased to about 1,000. But about one-tenth of that number might be of interest to young artists with a timely image.

Nancy Jervis and Maureen Shild sent questionnaires to ninety-nine New York galleries in 1979 to determine whether artists were accepted or excluded on grounds of gender or race. An incidental discovery during their study indicated that about one hundred major Manhattan galleries handled contemporary artists. Each of these galleries handled about eighteen artists; hence there were about eighteen hundred possible berths for artists. These galleries had taken on 330 new artists in the typical two years from 1977 to 1979. Furthermore, not many of these galleries have the prestige to effectively launch an artist's career (Jervis and Shild 1979, A1).

Today's galleries look for professionalism in prospective artists. They want to see not just interesting work but they insist on a mature and disciplined "body of work." They hope to see a portfolio that demonstrates self-discipline, a professional work ethic, and persistence. A good response from a gallery today may be: "I like your work. I would like to see everything you do for the next two (or five) years." There are few easily won berths in galleries now. The dealer knows that a new artist may bring little profit to the gallery in the first three to five years of association.

This modern art market is a creation of capitalism. Furthermore, capitalism heavily influenced the very nature and form of the image in art. The concept of money has become more and more abstract: first the coin, then as the bank note in the fifteenth century, then as impersonal collectives in the nineteenth century, and finally money has become little more than numbers on computers to be transferred by modem from one multinational corporation to another (Dunning 1995, 42, 92–94). In response to this abstraction in the monetary system, along with other influences, art itself has responded by becoming more and more abstract (and finally more linguistic, perhaps partly in response to the signs that are used to keep track of the money) with each step. Certainly this abstraction and signing aspect of the monetary sys-

Galleries, Portfolios, and Web Pages

tem was only one of many cultural influences that pushed painting toward abstraction and linguistics.

By the end of the nineteenth century, it was assumed that the rich should collect art, and toward the end of the twentieth century, collectors have become investment-wise. They buy art for investment as other investors buy stocks and bonds. Sophy Burnham notes that in 1955 *Fortune* magazine published a two-part series, "The Great International Art Market," describing the pricing patterns of paintings by using the language of stocks and bonds (Burnham 1973, 32). Some painters, Cézanne, for instance, are considered "blue chip" investments. Young unproved painters deemed to have strong potential are considered speculative investments. There is a fortune to be made or lost in the trading of art. Marilyn Brown notes that this tradition was established as early as 1841 when Charles Roehn assured his readers that the art market, particularly the market in modern art, could be a source of quick wealth (Brown 1985, 10).

Burnham explains that by the 1960s art had come to be considered a hedge against inflation, and investors could not buy it fast enough. In its 1969 Christmas catalog, Sakowitz department store in Houston offered a membership in its "Masterpiece of the Month" club. For a million dollars they promised to deliver a painting by a different twentieth-century master every month for a year, which included works by Picasso, Chagall, and Matisse (Burnham 1973, 32). In 1982 one of the best-known art dealers in New York, Betty Parsons, observed that "art and real estate are the two things that have paid off best. They have held their values, and they will keep going up" (de Coppet and Jones 1984, 28). There has, however, been a recent downturn in the value of art, just as there are periodic downturns in the stock market. The investment letter *Bottom Line* notes that recent auctions indicate that the market for paintings in general is still depressed. It has not recovered from a few years ago during the 1980s when some painters, such as Chagall, Renoir, and Picasso, fell by half their value (*Bottom Line* 1994, 10).

In their study of artists' careers, Getzels and Csikszentmihalyi list four kinds of art shows that offer the least prestige and the most prestige and help for artists:

1. The first of the four kinds of art shows are sidewalk and shopping cen-

ter exhibitions (sometimes called "chicken-wire" shows). Exhibitors are often local amateurs. Serious artists ignore *most* of these shows. However, there are some very exceptional "art fairs" (the better ones usually have low entry fees). If such a show normally has substantial sales, the producers of these events do not need to charge the artist a lot of money for participation because they expect to make their money on commissions. These exceptional art fairs will have reputable artists acting as jurors for admission and awards.

Many young artists have done the art fair circuit early in their careers, and have been able to take in a thousand or more dollars in a weekend. But young artists must carefully weigh the advantages against the disadvantages of continuing to exhibit in such events. The awards and sales from these art fairs may pay the rent and buy more paint, but they will not further a career in the professional gallery world. In fact, it may be a hindrance. Ben Mahmoud is an artist I met through the Internet; he has been an excellent, successful painter for years, and he is a senior professor at a university near Chicago. He told of one well-established printmaker he knew who could not resist the "easy" money from an art fair. Ben was judging the slides for a particularly good art fair along with a man who owned the only gallery in Chicago that seriously dealt in contemporary prints. As they were viewing the slides, the work of this well-known printmaker was projected on the screen. Ben was aware that the printmaker was represented by the dealer sitting beside him. At lunch Ben asked the dealer what he thought about seeing the slides of that printmaker in the context of that fair. The dealer replied: "Oh, I voted him in the show, but I'll never represent him again." Perhaps this is not the way things "ought to be," but it *is* the way they *are.*

On the other hand, Ben assures me that in judging some pretty good art fairs, he has seen a few accomplished artists who were doing work that stood far above the usual fare. When he asked for their thoughts about art fair participation as opposed to gallery affiliation, they all seemed to maintain a similar position on three points: they felt the galleries took too high a commission, they were not interested in fame and notoriety, and they just wanted to do their art and make a living from it. Those who were most happy in this context had no illusions about the likelihood of their works hanging in museums. And some made a very good living.

Galleries, Portfolios, and Web Pages

But the downside is that in the art fair market, kitsch sells better than what is often called "high art"; so those who consider themselves serious fine artists may not be interested in that market.

2. The second of the four kinds of art shows are those staged by collectives or independents. Such shows have occasionally established or helped the reputation of young artists; the Paris Salon of Independents, for instance, launched the impressionists. Some artists, however, object to these collectives because they feel that they lose their autonomy and become identified with the image of the group.

Every art center has its own flavor of collective, or co-op, gallery scene. In New York the co-op galleries are not taken very seriously. The shows in such galleries never receive critical attention or reviews. Curators seriously shun them. However, Ben Mahmoud explains that Chicago has an entirely different attitude. The co-op galleries in Chicago have taken their style from two excellent women's co-op galleries that were formed in the late sixties: the ARC (Area Resident Artists) and the Artemesia galleries. These galleries were unusually well run with a high degree of sophistication and professionalism. The quality of the work they showed was their only priority. Besides shows that featured their members' works, they invited other nonaffiliated quality artists to show in these galleries.

After the success of these first two women's galleries, some very good co-op galleries formed in Chicago that still maintain that same tradition of professionalism and quality. As a result, that city's art reviewers often make the rounds of these spaces and sometimes review the work. But there is a built-in limit as to how influential even these better co-op galleries can be. When an artist begins to get media attention or has work purchased by an influential collector, an invitation from a commercial gallery may follow, and, of course, these galleries tend to lose their best artists in this manner.

3. The third of the four kinds of art shows are the juried exhibitions that are staged by art institutions. Shows that are organized by major museums and institutions "can bestow a great deal of legitimacy on an artist who is selected to exhibit in it" (Getzels and Csikszentmihalyi 1976, 188–89).

Though such exhibitions may build a very impressive résumé, they will likely be of little significance to the professional gallery. Mahmoud corrobo-

rates my experience when he tells me that young artists regularly show up at Sonia Zaks, his Chicago gallery, with very long résumés from such juried exhibitions. But dealers look only at the slides or photographs. If the dealer is interested, the interest will be in the work, not the résumé.

However, these regional and national competitions do serve a function. When universities began to form art departments some years ago, the question arose as to how the work of the art faculty would be evaluated. Other fields had their process of peer review, such as publishing in journals and invitations to present papers. So the model of the juried art competition was chosen as the proper venue to determine peer evaluation. The juries were usually composed of other artists, and as a result many colleges and universities established their own juried competitions. Young artists who wish to establish a career in academia might wish to enter their work in these juried competitions. Search committees are very sensitive to success in this arena because they consider it an honest peer review, and the opinion of their professional peers is exceedingly important to most university art departments; this is the reason for the emphasis on publishing in other fields. Published articles and books that are selected by their peers in "refereed" journals and presses are the ones that count most.

Small art centers and museums are often looking for exhibitions that might not cost them much money. The curators of these institutions are often hard pressed to mount interesting shows with their small budgets. A young artist has nothing to lose by sending some good slides and a cover letter suggesting an interest in an exhibition. It might be a good idea to allow them to keep the slides if they wish. Though they might not have an opening at the moment, they might find a spot a year or two down the road.

4. The most meaningful of the four kinds of art shows that Getzels and Csikszentmihalyi listed are shows in private galleries. These probably offer more help to an ambitious artist than any other avenue. In New York the galleries with the most prestige are in a few areas of Manhattan: on Fifty-seventh Street extending both ways from Fifth Avenue, SoHo (literally an abbreviation for South of Houston Street), and Madison Avenue between Fifty-seventh and Eighty-sixth Streets. Recently, several "good" galleries have relocated from SoHo to Chelsea, in the West twenties between Tenth and Eleventh Avenues.

The studio loft and the four listed kinds of art shows are intended to help artists land a gallery contract. But young artists should be aware that few galleries offer contracts in writing to unknown artists (Burnham 1973, 97). Contracts are generally offered only to "blue chip" artists. Furthermore, even if a young artist does have a favorable contract with the gallery, if the dealer abuses or even abrogates the terms of the contract, the artist still must decide whether to hold the dealer to the terms of the contract, which may jeopardize what could be a valuable relationship with the gallery.

A friend and former student, Bob Seng, who works for the Guggenheim Museum, tells me that one of the easiest and most accessible starting points for new artists in New York may be in shows staged by alternative spaces and underground organizations, which are usually financed by public and private grants. However, some of these operations have very clearly defined limits on whose work will be shown. For example, one space will show work only by artists living in New York City, and another will not show the work of any artist who has ever had a show in New York.

Another recent possibility for places young artists might be interested in exhibiting is in some noncommercial spaces, such as the Drawing Center, White Columns, and the Sculpture Center. These spaces have active programs for getting young artists' works before the public, and their shows are well attended and periodically reviewed.

A quick warning: do not fall for galleries that want you to pay for your show (other than perhaps to furnish your own brochures). Some questionable galleries may even want to charge for hanging the show, guarding the show, or simply for having someone sit there to keep the gallery open. No matter how much they flatter you—and some are good at convincing you that you are a genius, because that is their business—an exhibition in such a gallery means no more to artists than paying to publish your own book through a vanity press means to writers.

No serious painter, critic, or collector is likely to view work exhibited in such a vanity gallery, and such showings can cost a lot of money. In Hiram Williams's words: "Beware of the gallery you must hire for a showing"

(Williams 1963, 78). Getzels and Csikszentmihalyi note that some of these vanity galleries may ask for an exorbitant 80 percent of the money from the sale of the work. Some of them may take many months, or even years, to let artists know when work has sold, and even then artists may have difficulty collecting their share (Getzels and Csikszentmihalyi 1976, 190). But many reputable galleries may behave in the same way.

A studio in the right location may even serve as a gallery for artists who would rather sell their own work than deal with galleries. Many curators and buyers are searching for the "undiscovered," and they will visit lofts and studios. But this kind of space in the right location is often expensive. The art world is a small one, and those who live in it seem to know most of what is going on in their city. Thus, any young artist who has had works in major art centers has probably already been seen. Some years ago B. C. (Bud) Holland, one of the distinguished and highly successful gallery owners in Chicago, told several young professional artists that they should labor under no misconception: they had already been seen—and judged.

Getzels and Csikszentmihalyi explain that twenty years ago the average art gallery examined and gave serious consideration to only about 150 or 200 promising new artists each year; only one or two out of that number would ever be offered a spot in their stable (188–89). The best source for finding these galleries is *The Art in America Annual Guide to Galleries, Museums, and Artists*. The appendix lists the galleries according to state and city, with addresses, phone numbers, and the name of the director.

But this private gallery route also has its drawbacks. Getzels and Csikszentmihalyi argue that dealers often make demands on artists, whom they consider their "property." They may come to an artist's loft, look at the work, and shake their head. They may give unwanted advice on style, content, preferred media, and size, and they may set deadlines and production quotas. They may want to encourage public appearances, arrange profitable acquaintances, or influence an artist's life style or behavior (190). Michael Lewis insists that both artist and patron are "far more likely to be deceived by an art salesman than by a shoe salesman" or a used car salesman (Lewis 1994, 30). Burnham equates the honesty of dealers to that of horse traders

(Burnham 1973, 24, 91). Although this *may* be a *slight* exaggeration, young artists should be wary, but care should be taken to exercise this wariness without any show of hostility.

Any human activity in which much money changes hands does not long remain ethical or pure. Over many years I have known several artists who swear they have paid bribes to critics. These bribes may be as indirect as critics accepting an artwork after they write a glowing review for the artist (thus insuring a good review next time), or critics may accept (or even hint for) an artwork from an artist for whom they are about to write a review. The bribe, however, may be as direct as asking for money (or even sexual favors from either gender) to insure a good review. Some critics who are denied such a gratuity may still write a positive review, but it may occupy less space, feature fewer (or no) photographs, and worse, it may appear after the show is over—thus purposely stimulating no sales.

Sophy Burnham documents that this system of bribes is formalized and above board in Paris, where "critics are 'owned' by dealers." Because everyone knows about it, and because critics claim they would never accept a gratuity from an artist they did not respect, French critics do not consider this system unethical in the least. Artists in France receive positive reviews scaled in direct proportion to the price paid: in the early seventies, the price of a "luke-warm and short" review was $50 (128–29).

American critics, Burnham continues, laugh at this French posturing and state with assurance that such a custom could never gain a foothold in America. But New York artists also frequently give paintings to critics, and two major critics, Hilton Kramer (who had just laughed at a French critic for saying the same) and Lawrence Alloway, used exactly the same reasoning and words to defend the fact that they had accepted gifts from artists they had reviewed: (Kramer) "I'd never accept a painting from an artist I didn't like"; and (Alloway) "I'd never accept work from a painter I didn't respect." Furthermore, American galleries often pay a critic to review one of their artists, then advise the critic to sell that review to one of the major art magazines. Critics also write good reviews for artists who are close friends, artists they are sleeping with or married to, and artists whose work they collect (132–33, 136).

Some years ago the Chicago Museum of Contemporary Art mounted an exhibition from the collection of one of the city's influential critics. Artists who had "contributed" to the critics' collection may have felt that exposure on the museum walls and inclusion in the lavish catalog was ample compensation for the "gift" they had once made to that collector.

I think it is important for young artists to be aware of the possibility of such situations so they can decide beforehand how they will respond. I had two friends some years ago who were caught unaware by such propositions and, in knee-jerk responses to what they perceived as a major ethical breach, each refused a quid pro quo offer for a good review. Neither was ever offered another chance, and both, when they drank, could be heard to moan: "God! I should have taken the opportunity when I had the chance." Forewarned, young artists may perhaps decide beforehand what they plan to do, one way or the other, when such an occasion arises. Whether they choose to go along with it is their choice, but perhaps they will make a choice they can live with. The theme of this book, after all, is: knowledge enables artists to make choices.

Getzels and Csikszentmihalyi corroborate what most young artists know: an important step in acquiring a recognizable identity is to move to New York. Most artists feel that their status remains marginal until they are recognized in New York. "The power to confer legitimacy is more centralized in art than in almost any other field" (Getzels and Csikszentmihalyi 1976, 191).

The art world has always had a single center. In the early Renaissance the center was Florence, Rome in later years, and Paris for several centuries after that. Since early World War II, the undisputed center of the art world has been New York. In fact, many French have never forgiven New York for not ceding that position back to Paris when the war was over; this point is well argued in Serge Guilbaut's excellent book, *How New York Stole the Idea of Modern Art* (and Christmas?).

In their study of the Chicago art students, Getzels and Csikszentmihalyi found that five years after graduation four of the six most successful artists had already moved to New York, and the other two were planning to do so soon. All felt that their success depended on that move. They agreed on five central points: (1) new trends show up in New York at least six months before

they appear elsewhere; (2) these new trends are often foreshadowed by party gossip before they appear; (3) the city offers a superior art market; (4) they felt they had to go to New York even to attract serious attention from Chicago buyers and dealers; and (5) dealers and collectors consider such a move an important sign of young artists' commitment to their careers (191–92).

Peter Plagens insists that, even in the major art centers such as Chicago, the art school talk at the end of the year centers on who is relocating to New York and who is not. He notes that one New York art critic began his recent lecture at Yale art school by showing an aerial view of New York. When he pointed out Brooklyn, he told the audience that all of them would soon be moving to Brooklyn—because working spaces were cheaper there (Plagens 1994, 64).

Getzels and Csikszentmihalyi sum up by concisely defining the primary paradox involved in achieving success in art: To gain recognition artists must in turn recognize and work within the hierarchy of the social system, and artists typically find this arrangement disagreeable. Young artists are encouraged to be independent, but, at the same time, subtle forces tug at them to conform, and this conformity is "undefined, shifting, and seemingly devoid of justification" (Getzels and Csikszentmihalyi 1976, 192, 195).

For serious artists, the few alternatives to living in New York are to live in some of the older art colonies, such as Chicago, Los Angeles, New England, or the Southwest, or to take a position with a well-known university art department. The young artists in the study felt that alternative locations, such as Chicago, were not viable locations for them because they lacked the high stakes of New York and already hosted too many good artists with not enough recognition to go around (192–93).

Another and more recent opinion, however, is expressed by Ben Mahmoud. He insists that some of the artists that left Chicago for New York have returned recently. The downturn in the art market seems to have hit New York harder than Chicago. Chicago is not without damage, but it is an "easier," and a bit less expensive, city than New York.

Dealers know that collectors will often watch a young artist for two to five years before they buy. These collectors want to know if an artist will stick or perhaps just work for a short while and then quit. I have been told by dealers

Advice to Young Artists

that one of the most often asked questions by collectors is: is this artist a good investment? Such collectors and gallery owners are interested in staying power.

Walking into a gallery with a portfolio of slides is not the best approach. The discrimination study by Jervis and Shild demonstrated that of the seventy-five galleries that were willing to view slides from new artists, fifty had not chosen a new artist from slides alone in the past two years.

In fact, most dealers who will view the slides of "walk-in" artists admit that they do not do so to find new artists. The reasons these galleries agree to view the slides from walk-in artists varies. Some do it out of curiosity (to keep in touch with new work being done); some do it to be polite or because they feel that the viewing alone encourages young artists. Of the ninety-nine galleries that returned their questionnaire to Jervis and Shild, only twenty-two mentioned walk-ins as a *possible* source of new artist discoveries and only twelve said they found most of their new artists from viewing slides of walk-ins (Jervis and Shild 1979, A7).

By far the best method to approach a gallery is to be recommended to the dealer by an established artist or critic. Most galleries find their new artists through referrals from such respected artists, and it seems to make little difference whether the recommendation comes from an artist in their stable or an established and respected artist from another gallery. Some galleries find new artists through referrals from critics or other established members of the art network. Even classmates, art instructors, and some friends, if they are recognized members of the network, may be of some help (A7).

Sophy Burnham says that many galleries simply will not even look at slides from young artists unless they are recommended by an artist or someone they recognize (Burnham 1973, 100). Jervis and Shild conclude that access to galleries, and thus a successful career, depends heavily on the "old boy" network (now including "old girls") of those who have an established reputation, much like the old boy network that has governed success in other fields (Jervis and Shild 1979, A8).

If a young artist cannot find such a referral, it may then be worthwhile to approach galleries in other ways. Gallery owners like to feel that an artist has some sense of authentic interest in their specific gallery. One dealer once

explained to Ben Mahmoud how he would like young artists to behave in approaching his gallery. First, young artists should see some shows and have a good idea of the kind of work exhibited. They might make some comments to the dealer about any shows they feel are particularly good. They should come to openings, and in this manner show additional interest in the gallery and reveal that they can be supportive of other artists' works.

Artists who bring their own slides to such an event destroy any hope of developing a relationship with that gallery later. Don't do it!

After being seen in the gallery on several occasions, their faces will be known; then they will not be just a stranger walking in with slides. Furthermore, young artists who frequent a gallery will certainly meet the exhibiting artists. It is possible to establish a friendship and eventually arrange a studio visit from that artist. If such a successful artist has an interest in the young artist's work, this may result in an introduction to the dealer. However, such a routine cannot be easily carried out unless the young artist is living reasonably near the gallery. Though some artists have been known to drive 250 miles each way, on a regular basis, to visit galleries and attend openings, this method is clearly not for everyone.

A less satisfactory but perhaps workable alternative might be to consult the guide to galleries published each year by *Art in America*. This may help determine which galleries would have an interest in a specific kind of work. Then send the materials or visit. Some think that artists should become good self-promoters and more business oriented, but most artists do not have the kind of personality that makes it natural for them to deliberately and carefully research in this manner to avoid risks. Most are inclined to be impulsive.

Artists are also poor predictors as to how any particular gallery might respond to their work. They are often surprised that a gallery that seems to handle work that seems like their own in timeliness and concept will show little interest. For instance, during a period when I was experimenting with some airbrush work in my painting, I approached a dealer who glanced at my portfolio and quickly told me: "I already have an airbrush artist." The fact that my work at the time was abstract and with a minimal use of airbrush, while the other was a near photo realist who used all airbrush, did not seem

to register with her. Young artists are also surprised that some galleries that seem to exhibit no work that is like their own will respond enthusiastically to their work.

Those who visit galleries will often notice that some of them seem to exhibit a variety of artists, some of whom may share few obvious similarities. This is especially true in this age of pluralism. How, then, could artists, who are not likely to have an objective point of view about their work, predict which galleries will like their work and which will not? I have noticed that most artists refuse to categorize their work, no matter how obvious the connection may be, as an example of any movement or style. I have seen artists whose work was typical funk, abstract expressionism, or surrealism outraged when someone labeled them as such. Something there is about an artist that does not like to be categorized. They all believe they are unique. How then, if they cannot perceive similarities, could they possibly determine which galleries are prone to handle work like theirs? Hell! Try them all—when you are ready.

I suggest that young artists should present their work to all the galleries that handle contemporary art in which they would like to show their work. Start with the best galleries first. Why get locked into a lesser gallery when one of the better ones might have been interested?

If you must walk into a gallery "naked" (with slides only), the only way the dealer is likely to see them while you are there is for him to hold them at arm's length in the general direction of some available light source or toss them onto a light table. A few might stick them into a slide viewer. No artist wants to be viewed in this manner. Few dealers will drop everything in the middle of a business day, haul out and set up a projector, then look at the slides in the manner they deserve to be seen. Artists never want their work viewed in this manner. That's one of the reasons they should make an appointment if possible.

If you ask artists or galleries how work should be presented, most of the artists and almost all of the galleries will say, "Slides." But that is not necessarily true. The fact that most people do not know what they want accounts for many unhappy marriages and the popularity and persistence of the adage: "Be careful what you ask for; you might get your wish." For the young artists

with large works that must be represented by photographs who go in person to present their work to dealers, I suggest setting up a portfolio of color prints, 5" x 7" or 8" x 10". Photographic prints in transparent folders in a loose-leaf notebook makes an acceptable presentation, but these prints should be as good a quality as the artist can manage.[1]

For paintings, I suggest arranging the notebook so that when it is opened, a color print of the entire painting is on the left and an 8" x 10" black and white glossy detail of an area that shows the best paint handling or the most interesting detail is on the right. The black and white detail is especially applicable to "retinal" artists, painterly artists, or artists who have a lot of small well-painted detail. Black and white prints show the thickness, quality, and consistency of the paint far better than do color prints. You should also have available black and white 8" x 10" glossies of entire paintings for some of your best works, specifically those that carry well in black and white. Anytime you need to print black and white brochures, or you have a chance to receive some publicity (in a newspaper or book, for instance), you will need black and white glossies for reproduction. For the best color reproductions 4" x 5" transparencies taken with a view camera or even with an old press camera are best. If you do have such ideal transparencies made of your work, they make excellent color prints.

Showing prints rather than slides gives artists some control as to how their work is first viewed in gallery visits, and photographic prints show the work to better advantage in quick viewings. I have had good responses to this method, and student after student has returned to tell me that dealers, even when they did not particularly like the work, have often said that this is the right way to show your work.

In the painting department where I work, my colleague and I have always suggested that those who were going to New York start with Ivan Karp's gallery.

1. Cibachrome prints are very good, but these do not come cheap. The Hollywood film industry has produced a very good quality film: Asa 400 for processing sfw-xl. This film is available from: Seattle Filmworks, Elliot Bay at Pier 89, P.O. Box 34056, Seattle, WA 98124-9956.

The film is processed as a negative, and slides can be made from this negative; then both negatives and slides will be returned. The advantages are: duplicates can be made without any loss of quality; some color correction can be made in the process; and these negatives will produce excellent prints. The downside is that this film may not have as fine a grain when slides are projected. Almost any photography magazine carries ads for this film.

Advice to Young Artists

He is an astute viewer and exceedingly knowledgeable about the gallery scene in New York. Burnham notes that many credit Ivan Karp's astute eye for Leo Castelli's astounding success with pop art during the 1960s when Karp worked there (Burnham 1976, 36). Even if Karp is not interested in handling that work, he often gives excellent advice and he sometimes steers artists to galleries that he thinks might respond to their work.

One of my colleagues went to New York a few years ago. In line with our own advice she started with Ivan Karp at his O. K. Harris Gallery in SoHo. She showed him a portfolio that was set up as I previously suggested, with excellent 8" x 10" color prints. He loved the portfolio. He called several of his staff out to see it. He asked her if she was famous in the Northwest where she came from. Then, after all the attention she had received partly *because* of the portfolio, as she was leaving he casually mentioned that she should really use slides.

With all due respect to Mr. Karp, I do not believe it.

Always have two or more slide portfolios with you. Some galleries will not have time to look at the prints while you are there, some may prefer slides, or they may look at the prints and want more time to assess the work, or they may wish to compare your work with other current applicants. They might ask you to leave slides. In this case then, they may take the time to project the slides and view them appropriately, though most galleries only use light tables now (a most inappropriate method for careful scrutiny). This is why some artists use 4" x 5" transparencies taken with a view camera.

Never offer a gallery an unsolicited written statement of your goals, intentions, or aesthetic concerns. In all the work I have viewed from applicants for graduate school, I have never seen a statement of purpose that helped the work. All the statements I have seen have trivialized the work they were intended to support. When one of the graduate students here sent a nationwide questionnaire about what kind of portfolio to present to galleries, Ivan Karp put it in writing succinctly: "Never include a statement of your aesthetic intent unless you intend it solely for the amusement of the gallery staff."

If an artist cannot go to the galleries in person, it is sometimes possible to do it by mail. I have gotten excellent responses from galleries by sending a portfolio of slides (in response to a previous query letter). The mailed portfolio should include what writers call SASE, a self-addressed, stamped, return

Galleries, Portfolios, and Web Pages

envelope. Sending the slides by mail allows dealers to set up the projector and view them in a leisurely manner at their convenience—when they are in the mood. Many young artists will also find this to be a far less humiliating method than going to the galleries in person.

But artists should understand that New York galleries do sometimes require the artists they handle to live there in the city. Some will not represent a young artist who will not live there.

Most dealers, in my experience, have been very professional and as sensitive, or at least courteous, as time and pragmatism allows, but several, as in any other occupation, will show all the sensitivity of a rhinoceros in heat. Every artist who has made the rounds of the galleries can tell stories of gross rudeness. I believe that artists are obligated not to accept such treatment in a docile manner: it just encourages them.

Many dealers are more likely to take the time to look at your work if you write or phone for an appointment ahead of time. If you do make an appointment, be on time; you are unlikely to impress a future business partner by demonstrating how flaky and inconsiderate of them you can be. If you have trouble accepting courteous, or even abrupt, rejection, you might be better off to mail the slides. But try to avoid showing your work to anyone at the gallery other than the dealer until the dealer has seen your work. Subordinates and secretaries can discourage you or hurt your chances, but they can seldom help.

The importance of a gallery to an artist's career is demonstrated by the fact that about two-thirds of the artists selected for the Whitney Biennial come from New York galleries (Jervis and Shild 1979, A9). If most of the remaining one-third of the artists came from galleries in other cities, there would appear to be little room at the Whitney (and that goes for most major museums) for artists who represent themselves. In my experience, the art magazines also find their selections through galleries. Where else would they look to find many examples of many different artists' work?

Being a successful artist takes more than just the ability to make art. My experience as a teacher and as an artist tells me that success in art takes four equally important elements of character: ability, self-discipline, the hide of a rhinoceros, and persistence. If you are sensitive to rejection, if you believe

each rejection means something about you or your work, you might be better off in another field. I have watched several excellent young artists finally drop out of the field because they simply could not abide the criticism.

A young artist must learn to view the opinions of dealers as nothing more than the suggestions of a business manager. That is the function of the gallery: nothing but your business agent. You must be the final arbiter of your own aesthetic. All you are asking of the gallery is whether they believe they can market your work. If they do not believe in you, you should not want them to represent you, even if you *could* talk them into it. The odds may seem discouraging at first glance, but young artists should keep in mind that the number of rejections, no matter how many, has absolutely no meaning.

It takes only one acceptance to bring success.

"Success" may not mean that young artists can quit their day jobs. Ten paintings a year for $5,000 each doesn't go far; after the dealer takes 50 percent (and some collectors are given discounts of 15 percent or greater), the artist's share of the remainder is not enough to live on, much less afford the necessaries for making art. And few artists ever sell that much work.

To understand this you must first understand how many small galleries come into being. First, even though a few gallery owners may be quite astute and may know something about what they are doing, understand that there is no training required to open a gallery. No gallery owner is required to pass a test. They are not licensed as competent in the field. Anyone with money can open a gallery. As Gerald Broomier and Joseph Gatto put it, to open a gallery "all one needs is a rented space and a sales permit" (Brommer and Gatto 1984, 200).

Edmund Feldman explains that many small galleries often operate essentially as art boutiques—small shops in exclusive neighborhoods (Feldman 1982, 199). Running a small gallery is often more an exercise in salesmanship than in aesthetics.

Some of the better galleries, however, can be a real help to artists. Feldman notes that some of the best dealers—such as "Durand-Ruel, Vollard, Kahnweiler, and others—have been more than business managers" (191). The dealers frequently act as patron and friend, and he cites John Russel as describing the dealer as performing the services of estate agent, employment agency,

Galleries, Portfolios, and Web Pages

pimp, social secretary, and investment counselor (Feldman 1982, 26).

Dealers habitually encounter scores of young artists, many of whom are badly trained and as ego-needy as some of the dealers. Many of these needy young artists demand more than a reasonable amount of time. Some want stroking and flattery rather than a quick honest opinion. Galleries report that 50 to 150 artists per week ask for viewings. Coping with prima donna behavior quickly grows tiresome. Dealers can often tell in two minutes if they are not interested in seeing more of an artist's work, but if they say so in that short amount of time, some artists complain that they have not had a fair viewing. They insist that their brilliant work cannot possibly be "understood" in such a short time. But dealers may feel they do not have the time for such cosseting, and thus they may learn to evade the viewing of artists' work.

With this in mind, I have found that a viable approach to a gallery is a fast approach, one that immediately lets them know you are not a person who demands two hours of attention. If you must be a walk-in "naked," you might approach the dealer with portfolio in hand and say: Do you have a couple of minutes to look at my portfolio? This lets them know you will be satisfied with a reasonable amount of attention, and you do not expect them to hold your hand afterward.

You must keep in mind that dealers have seen much work. They can decide quite quickly whether they might be interested in seeing the real work. Remember: your portfolio is not the work. Photographs are merely an attempt to describe the original. They offer a better description than most could do verbally, but the portfolio has only one function: it allows dealers to decide, with the least trouble possible, whether they are interested in seeing the actual work. This saves you, as well as them, needless work and embarrassment: loading your work, dragging it into the gallery, then reloading it to return to your studio.

Remember: galleries are not (or should not be) passing judgment on the quality of your work. They are not qualified to pass such judgments. Their only legitimate function is to decide whether they might be able to sell your work. That's why they often insist on the opinion of artists or critics whom they respect.

Young artists should also be aware that most galleries keep from 33 to 66

Advice to Young Artists

percent of the sales price of each artwork (commonly 50 percent now). This percentage is also owed on any work that artists might sell in that entire geographic region, even though the sale was made at the artist's studio and the gallery may have had nothing to do with it in any way.

The art world is a small place, and news travels fast. Anyone who has received a discount on an artist's work will brag to friends. Those friends may easily mention it to dealers when they are bargaining with them, and news travels fast. Should artists think they might hold back a commission on a sale from their studio, they risk losing a hard-won gallery relationship.

Some galleries may even demand a larger commission from young artists. If they do, they should offer something extra in return, as some of my galleries have done, such as advertising well beyond the normal, assuming responsibility for taking works to exhibitions, framing or even stretching the canvas if it is sent rolled up, assisting the artist to get into meaningful exhibitions in museums, or arranging the placement of articles about the artist in art publications. These are valuable contributions and may well be worth the extra cost. All this is negotiable, however; once artists become well known or begin to sell exceptionally well, they are sometimes in a position to negotiate. The mistake that many young artists make is to feed their pride at the expense of their business relationship. I have seen young artists who are selling very little lose their relationship with galleries by making unreasonable demands or throwing tantrums over some inconsequential thing the dealer has done.

Young artists, especially painters, should learn to take good slides and photographs. Photographing paintings is not like photographing anything three-dimensional. Even some good photographers have problems photographing flat paintings; they often don't know how do deal with the glare. Buy a single-lens reflex camera; most of them are good nowadays. Here is a general method that will work for most artists. Set up a black background as a place for your work to be photographed. Paint a wall flat black for large work, or if you want a completely black background, invest in a piece of black velvet large enough for a background for your work. Photograph your work in front of this black wall or fabric. This effectively crops the slide to the edges of the work and eliminates the mistake of taking slides that show all the clutter of the studio surrounding the work. An alternative to this is to mask, very care-

Galleries, Portfolios, and Web Pages

fully, the image with silver "chart" tape. The silver side of the tape should face the projector bulb to reflect the heat of the lamp. When the work occupies only a small area in the middle of the slide, viewers find it hard to see the work, and the work itself suffers. The work should occupy most of the area of the film so that it is the only thing noticeable. The work should not have to compete with clutter for attention.

If you photograph outside in daylight, buy good daylight film. If you photograph inside, buy film that is adjusted to tungsten light, and light your work obliquely from the sides so light will not reflect directly back and produce hot spots and glare; this is especially important for photographing paintings. Use two or more five hundred-watt halogen *photographic* lights that are balanced at thirty-two hundred to thirty-four hundred kelvin for the first part of their life. After they drop in their kelvin rating to about twenty-nine hundred, you can use them for studio lights.

You will need to bracket your camera settings at first: one shot at the correct light reading, one at a higher reading, and one at a lower reading. After some practice you will probably not need to bracket any longer. Some artists will find that taking a close-up light reading directly off a Kodak gray card placed on the surface of the painting will produce consistently better exposures than taking the reading directly off the work.

Some artists like to use a camera without a built-in light meter but with a very good lens; in this case then they can purchase a good spot meter, which will result in better and more consistent metering, especially if the metering is done from a Kodak gray card that is hung in front of the painting. The only drawback to this is that if you decide to use a polarized filter to reduce glare in spots, it is impossible to get an accurate light reading with a detached light meter because with each slight turn of a polarized filter the light reading is changed considerably. But this is not necessary except when photographing paintings that tend to have problems with glare, and this can often be worked out with lighting.

Once able to take consistently good photographs without the need to bracket, you will want to take several slides at one time, a minimum of five to eight shots at each setup. These slides are generally cheaper and better than having to send off for duplicates when you need more—which you will.

Buy a tripod. Few can hold a camera, even with high ASA film, steady enough for professional quality resolution.

Frame the work so that it fills most of the camera's viewfinder, and thus most of the slide. Nothing looks more amateurish than a photograph of a work that occupies only a tiny area in the center of the slide. And make certain that the work is square in the viewer, not at an angle to the camera. If you are using a view camera (or press camera), it is best to use a ground glass screen with ruled lines on it. The works can then be more easily lined up in the viewer. Remember that when someone whose opinion you value is viewing your slides, those slides are the only reality at that instant.

Some photographers might correctly offer much more elaborate advice about photographing work, but most artists are not looking for a job as a photographer. The advice above is about the most simple way I have found to generate consistently acceptable photographs of your work.

The most critical advice to a young artist regarding a career as a "gallery artist" might be to develop a plan, or rather plans. First a realistic short range plan: How am I going to get by? How am I going to develop my strategy of approaching galleries? How can I develop and mature in my work? and most important: when will my work be ready to show? In some cities it might not be critical if artists expose their work before it matures. Dealers there have little memory. New York seems to be such a place. Many dealers in Chicago, Los Angeles, and San Francisco, however, have long memories. If young artists expose their work before it is mature and strong, that first, and poor, impression will remain a ghost haunting the rest of their career in that city.

Many artists now maintain a home page on the Internet featuring reproductions of their work, so that others may easily get some idea as to what their work looks like. I was curious as to whether maintaining a home page was a good marketing device. So I asked several artists who kept home pages and I queried art discussion groups on the Internet. The consensus was that there was little likelihood of making any direct sales on the Internet, but some felt it was a valuable adjunct to other marketing means.

Several also reported that their web site may have resulted in an inquiry about them having a show at one place or another, and perhaps an inquiry about a purchase.

Galleries, Portfolios, and Web Pages

Ben Mahmoud says he has never made a sale on the Internet and he did not expect to. He feels that his web page serves as an introduction, and he reports that several people have seen the web page and then gone to Zaks Gallery in Chicago to see his work.

One respondent said he knew a professional photographer who had excitedly launched a page; he paid $900 to have it designed, then $600 a year for "processing purposes." In two years he had received a couple of inquiries but had sold nothing.

All those who responded said they did not think the Internet was a good place to market work, but many felt they got other satisfactions and sometimes a few leads or interesting inquiries from their site.

Mahmoud has maintained a web page for years (at http://sun.soci.niu.edu/~benm/), and he offers the following advice: Some artists pay large sums of money to organizations or businesses that will digitize their work and place it on a web page host. In some cases, the costs can reach $300 or more for the initial site construction and a hefty fee for annual maintenance. The problem is that I know of no artist who has ever made a sale directly from a web page site. It is unlikely that those who are interested in collecting art would purchase work based on images that are presented on the "web" unless perhaps someone were selling computer printouts of the images shown.

The basic problem with home-page images is that they tend to be low resolution. Even if they were high-resolution images, the flickering image on the monitor does not present the real thing, and collectors are almost always interested in "the real thing." So, if artists invest money in a web site with the hope of returns on that investment, they will likely be disappointed. However, there are advantages to having work mounted on a web page. There are times when someone will express an interest in the work. Artists do not always have reproductions to hand out, but if they have a web site, it will be easy to hand out their URL (their WWW address). This may be particularly handy for artists who "converse" with other artists on the Internet, or on listserv discussion groups.

And possible clients, if their interest is genuine, will take the time to view the site so that they can glean some idea of what the work looks like. If the client's interest is stimulated, they may visit the gallery that shows the artist's work.

Advice to Young Artists

The web page can function as an adjunct to exibiting work. It may be used to announce exhibitions, to keep previous buyers up to date on studio developments, and to exchange images with other artists. To do this, artists need not spend great sums of money. Most graduate students have access to high-powered computers, digitizing equipment, and programs that can lead to the construction and placement of a web page. But if they do not have a rather powerful computer with image manipulation capabilities, it might be necessary to hire someone to do that work.

A number of programs make constructing a web page very simple. Some are shareware programs that are inexpensive and can be downloaded from the web. "HTML Writer" is one such program; "Web-It" is another. Both facilitate the construction of a web page, demanding no knowledge of "html code."

Images on a web page must be digitized. Many service bureaus do this, but the means to digitize images can usually can be found on the campus of most colleges and universities. At this point, a decision must be made about the size and resolution of an image before digitizing. Artists might be tempted to want high-resolution images, which look great on the screen; however, such high-resolution images make for large files. Large files make for slow downloading. More often than not, a slow download will discourage viewers, and they will be tempted to terminate before the download is finished.

A file with a resolution of seventy-two dpi (dots per inch) provides adequate resolution for most viewers, and it is probably a good idea to use images that will not extend beyond the edges of most screens. I have found that a horizontal image of 5" in width is appropriate, and a vertical image of 3½" in height seems to fit most screens. My experience indicates that the best images are created by using a "jpg" or "jpeg" format with a "less than average" image quality. This produces a file that will download quickly and look good on most monitors.

Now comes the problem of placing the constructed web page on the World Wide Web itself. There is one site that provides disk space at no charge, Geocities at: http://www.geocities.com

This address offers directions for finding a space to upload your web page. The simple directions explain an easy process, and the page can be edited with relative ease. This means that you can, from time to time, delete old

Galleries, Portfolios, and Web Pages

images and place new ones, assuming that you have a computer and access to the web through a server, which can be a university server or a commercial server such as America On Line. Geocities permits up to two megabytes of material for each site. This is a generous limit and a number of images and texts can be placed on such a site. The next step is making sure your web page is known to most of the "search engines," such as Yahoo, Alta Vista, Excite, Infoseek, and others.

Perhaps someday soon when critics review an artist's work, especially in newspapers and publications where they have no chance for good illustrations, they will include at the start of the review the URL for that artist's web page, and interested readers may click in to see what the critic is writing about.

As an artist, the adage that insists "you are what you eat" is no longer true. Artists are what their slides show—or their web page. Furthermore, always think like a professional: never leave town without a copy of your portfolio. You never know when you might wish you had it with you. ✨

Jobs for Young Artists

ART OFFERS FEW OPPORTUNITIES FOR FINANCIAL SUCCESS. The serious young recent graduate needs to find some method to earn a living wage that still allows for enough time to do artwork. Earning a living from art alone is not an easy task. It is impossible to sell enough serious, main line art in a small town to come close to making enough to live on and still buy the necessary materials for making art. People in small towns seldom spend much money on art, and when they do, it tends to be representational work, such as portraits, still lifes, and landscapes. Even the smaller cities offer little opportunity for selling enough serious art to afford a living. Small cities do not have as many collectors per capita, and those who do live there usually buy their art from larger cities, especially New York.

To earn a living by selling serious work, an artist must move into, or at least close to, one of the major cities: New York, Chicago, or Los Angeles. But because the two-story Los Angeles sprawls all over southern California, living close to Los Angeles means living in it, for all practical purposes.

Many galleries in San Francisco are more sympathetic to what is called "corporate art"—decorative art done in excellent taste but with little aesthetic risk or strong personal message. Houston, Texas, has also been known to buy some serious art in good times, but I am not quite certain what level or quality; Houston has not had good times in the 1990s. Edmund Feldman guessed in 1982 that perhaps two or three hundred artists live by the sale of their work, and that perhaps half of those live well (Feldman 1982, 192). Feldman's is the most conservative estimate I have found.

With the recent changes in artistic attitude, it is possible that the art economy might begin to support more artists at a moderate level, as opposed to lavishing opulence on a few. The moderns believed in genius. They believed that each century produced only a handful of "real" artists, and this attitude

generated a market in which figuratively there were only a few Rolls-Royces and a Lamborghini here and there. All the other artworks were considered junkers. That is, there were a select few artists who sold everything they executed for wildly exorbitant prices, while thousands more produced excellent work that was considered practically worthless. Many excellent artists could hardly give their work away, much less sell it.

When I was in art school in the 1950s everyone knew the same small handful of modern artists: giants such as de Kooning, Kline, and Pollack. That attitude, however, is inconsistent with today's art. Today's art students may know a few postmodern artists, but each student may well have heard of an entirely different set of artists. The artists that one student names may well be entirely unfamiliar to another. There are few postmodern artists, outside of Anselm Kiefer, that I can count on most my undergraduate students, or new graduate students, knowing about. And some haven't heard of Kiefer.

The postmodern image of the artist is closer to that of the medieval artist than the Renaissance artist. Unlike Renaissance artists such as Michelangelo, who was called divine by his contemporaries, medieval artists were near anonymous. Today's art students, most of whom know many Renaissance artists, have a difficult time naming even one medieval artist. Postmodern theory revolves around the assumption that artworks are generated by the culture and the times, not by individual genius. If Monet or Freud hadn't come along, they reason, someone very much like them would have appeared to organize, in a similar manner, the ideas that their culture had generated.

As we come closer and closer to Andy Warhol's prediction that "someday everybody will be famous for fifteen minutes," the postmodern image of the artist is rapidly approaching the medieval image of anonymity. Any "fame" that is experienced by "everybody," after all, is near anonymity. This anonymity may be good for young artists in some ways: it creates a market that does not revolve only around Rolls-Royces and Lamborghinis—a market in which Fords, Toyotas, Hyundais, and Dodges may finally be valued reasonably.

In the light of these changing attitudes, the odds for "eking" out a living selling artworks may turn out to be better for young artists today than during the modern period. But the odds are still not in their favor by any means.

Advice to Young Artists

I agree with Edmund Feldman that there are thousands of excellent and talented artists working today who enjoy little financial success, and that the success of the artist, like the success of the movie star, is dependent upon the whims and caprice of the system. "It is the system," Feldman states, "that discerns the real or potential needs of the market and selects individuals who can be molded to fit those needs" (193). This is the same system that generates the notion that only a few good artists are working at any one time in society. "That notion is widespread even though it is a 'myth'" (198).

Teaching at the college or university level is one method that many artists choose to support themselves. A teaching position offers the advantage of allowing artists to work in any direction they deem worthwhile without having to worry about tailoring their direction to match the demands of the marketplace. But teaching also poses several problems. Jobs are exceedingly competitive. *More* than four hundred qualified applicants with M.F.A.'s are likely to send portfolios when any college teaching job in the popular studio areas, such as drawing and painting, sculpture, design, photography, or ceramics, is advertised. (There may be fewer than twenty applicants for a position in a field such as metalsmithing.) Peter Plagens estimates that more than 170 art schools and university art departments crank out about a thousand M.F.A.'s each year. He seems to agree with advanced art students when they estimate that "maybe 1 percent of the M.F.A.s will make it as artists, 2 percent as [college or university] teachers" (Plagens 1994, 64, 65).

Those with a Ph.D. in art history, however, still find it much easier to find a position: most will find a position in a college somewhere. In fact, many small colleges have a hard time hiring and keeping art history teachers with doctorates. But recently that too has become more competitive. Ten or more years ago when we advertised a position in art history, we were lucky to get one Ph.D. candidate, and that one was weak; recently when we have advertised such a position we have received more than twenty well-qualified applicants with at least some publications. Still not nearly as competitive as one of the major studio fields.

During the early 1990s, studio artists have had a far more difficult time finding college teaching positions than has been normal in the recent past.

Jobs for Young Artists

The national economic scene has been so desperate that colleges and universities throughout the nation have been cutting their programs and their faculty; reports indicate that California cut their university system by 30 percent in the two years after 1991. But in the late nineties, with many of the faculty who were hired during the boom times of the sixties and seventies retiring, the odds have improved immensely for recent applicants.

William Bowen and Julie Sosa have attempted to consider an immense amount of pertinent data and possible circumstances to calculate the demands for college and university faculty in the humanities and social sciences in the United States for the next ten years. They conclude that the demand will increase substantially from 1997 to 2002.[1] My recent experience seems to indicate that they are right. The best place to find listings of college and university teaching positions (or museum positions) is *The College Art Association's Listing of Positions.* The newspaper *Chronicle on Higher Education* (available in most university libraries) is another good source.

College and university art departments usually pick the candidates they intend to hire primarily by the quality of their portfolios for two reasons: evaluating teaching performance is even more difficult than evaluating artwork and they nurture the belief that excellent artists are excellent teachers. Therefore, any artist seeking employment in colleges must have an excellent slide portfolio. The second most important aspect is often the curriculum vitae, especially the listing of exhibits entered and awards won. Being somewhat uncertain of their ability to judge, most departments, like high school students picking a date, do like to think that others admire the young artists they hire. Remember that selecting the best portfolio is a personal and subjective choice. Again, rejection does not mean your work is bad and acceptance does not necessarily mean it is good.

Selecting candidates by portfolio sometimes creates a serious problem.

1. The lowest and highest predictions respectively were: 11,890 (low), 22,983 (high), total positions (new positions plus replacements) for 1992–97; and 18,521 (low), 20,215 (high), total positions for 1997–2002 (Bowen and Sosa 1989, table D.8, p. 213, and table D.11, p. 216).

Compare these numbers with the predicted number of serious qualified applicants with terminal degrees in the humanities and social sciences: 13,633 total applicants in 1992–97, and 13,460 for 1997–2002. Bowen and Sosa expect the odds to be somewhat better in the future than they are now (table D.7, p. 212).

Advice to Young Artists

Colleges and universities often hire teachers with excellent portfolios who have little interest in teaching. Their primary interest is often focused on their own work; they are just using the teaching position to support themselves as "artists in residence." Furthermore, universities often reward only professional success (publish or perish) and ignore teaching quality. This generates the familiar university situation in which students are often lucky to see their instructors ten minutes a week. But with the new "accountability" interests in the universities, many universities are starting to require their instructors to submit to "course critiques" from the students in every class every semester. Though the forms used for these course critiques are needlessly long and contain many irrelevant questions, many hope that it will eventually start to place some emphasis on good teaching.

Some community colleges and small colleges, however, try to pick candidates primarily on their teaching ability, but this method poses its own peculiar problems. There is little valid and established method for evaluating teaching performance before hiring a candidate. When candidates apply for a position, they select colleagues who are their friends or allies to write their recommendations; therefore, most recommendations make candidates sound as if they could walk on water. Moreover, an undesirable candidate's colleagues will sometimes write flattering recommendations in the hope they will move to another school. Furthermore, most colleges are slow to let teachers go once they are hired, unless they create trouble or they are good enough and arrogant enough to generate jealousy. (I have seen more young teachers fired for being too good than for being bad.)

If, however, a department should succeed in picking candidates who are exemplary teachers, but who fail to establish competencies in their subject, they end up with instructors who do an excellent job of misteaching—teaching all the wrong things but teaching them well. A well-mistaught student may take years to overcome the misconceptions and faulty practices learned during early training.

It is a rare art department that succeeds in consistently hiring candidates who are highly competent in their subject and also interested in teaching. But the departments that do so can offer much help to young students. The worst

Jobs for Young Artists

teachers I have met were either not competent and not up to date in their discipline or they cared little about teaching. I have never met a teacher who was well prepared, highly competent, timely in knowledge of the discipline, and interested in teaching who did not do an adequate teaching job.

A master of fine arts degree (M.F.A.) in the chosen area is the required "ticket" for teaching at a college or a university and at most community colleges. Because galleries had never seemed to be much interested in the fact that I had an M.F.A., I used to tell my students that if they were certain they would never want to teach, they did not need that piece of paper, the M.F.A. But several students returned to tell me I was wrong. Perhaps galleries are not much impressed if you have the degree, but many of them do seem uncomfortable if you do not. They may find the lack of a terminal degree to be an impediment in trying to sell an artist's work.

I have also come to feel that the M.F.A. is worth working for if only in terms of what young artists may learn from their instructors, and, more important, from the other graduate students, if they can pick and get accepted to a good program. There are a few prestige graduate programs: Yale has long been acknowledged as the prestige leader, and recently they have probably even deserved this, but prestige does not necessarily mean the school is currently a good one. It takes twenty to forty years for the reputation of a school to grow to common knowledge, and by that time the instructors who earned the reputation are all gone. They may or may not have been replaced with instructors of equal quality.

The best way to pick a school is to ask around, and then visit the school. While there, speak to the teachers in your area, and, more important, talk to the other graduate students in your area. Notice whether the teachers and students are helpful. Ask and notice whether there is a graceful working alliance between the students. It is far more difficult to learn in a department that is full of jealousies and students who resent and envy one another than in a department where the students share information and support one another's success. Throughout my teaching career, I worked on that aspect of student relationships as hard as I did on the teaching of subject. I wanted them to learn from one another.

Advice to Young Artists

Well-meaning teachers outside the art department often tell young artists early in their undergraduate studies that they must take education courses, leading to a teaching credential, if they want to teach; this is true only if they plan to teach in public schools, elementary through high school. No teaching credentials or education courses are required to teach at the community college level or above. In fact, many search committees may be prejudiced against candidates who have taken classes in teaching methods. Right or wrong, they often consider such a choice a mark of poor priorities by one who is more serious about getting a job than about their art.

Spending time in education courses, they reason, robs too much time away from art courses and studio work and thus makes it far more difficult to achieve the expected level of excellence in a studio area. Furthermore, most students I have spoken to who have taken education (or teaching methods) courses feel they learned very little in these courses in proportion to the time spent.

Several studies indicate that the ability to teach a subject improves in direct proportion to the number of classes the teacher took in his specialty (painting, photography, literature, etc.). For instance, as early as 1968 Joan Harris conducted a study of English teachers in Illinois public high schools. The teachers who commented on their teacher preparation felt that the "study of grammar, linguistics, and language theory had been neglected" and "suggested that more courses in composition and teaching writing should be available to English teachers" (Harris 1968, 5). None suggested that they needed more classes in teaching methods. Obviously, when the teaching credential demands a minimum of thirty semester hours (forty-five quarter hours) of education classes, that replaces a large chunk of subject matter that cannot be taken in the relevant discipline. Furthermore, some studies even indicate that the more education classes teachers have had, the weaker their teaching is.

With the exception of New York University, which offers a Ph.D. in studio arts, I am aware of no active doctoral degree in the studio arts. Consequently, the "terminal" degree in studio art is the M.F.A. A few other universities have offered doctorates in studio arts in the past, notably Ohio State University, but these universities have either discontinued their degrees or quit accepting candidates.

Jobs for Young Artists

The typical M.F.A. is two or three years beyond the M.A. or the bachelor of fine arts degree (which is a five-year degree at many universities). Most universities do, however, accept strong candidates with a B.A. in art into their M.F.A. programs. Some universities (the one I teach in, for instance) will even accept candidates with a B.A. in a field other than art *if* a candidate can *demonstrate* competency in a studio area or the relevance of the previous degree to a studio area (physics, for example).

The principal advantage that teaching offers is that it is a valuable learning opportunity for the teacher. I believe young artists learn more in the first two years of teaching than in any four years of painting—as a student or on their own. When new teachers explain to their students something they thought they understood, and those students begin to question them, the young teachers will be pressed to think, rethink, and reevaluate all their previous ideas and positions. In doing so they will crystallize ideas and concepts that they previously held only in foggy awareness. I would suggest that most young artists will reap heavy benefits from up to five years of teaching experience.

There are, however, two major disadvantages to teaching: it occupies much time that young artists might otherwise have devoted to their own work and teaching often drains good teachers of their own ideas and creative energies.

Time is used up, not only in the time spent teaching but also in preparing for class, grading, giving outside help to students, and—even worse—in meaningless and useless bureaucratic activities such as department meetings, committee meetings, filling out forms, and seriously negative internecine political activities. After his first year teaching at a university, Henry Kissinger's comment was: "University politics are so vicious because the stakes are so low." Teachers in some departments spend their time and energies like a band of howler monkeys, alternately defending their territory and threatening the territory of others. My advice is to ignore departmental and university politics no matter how righteous or important an issue may seem at the time. Such politics will screw up your priorities and they can easily compromise your integrity far more seriously than the old fear of prostituting your work.

Teaching may drain teachers of their ideas if they are generous with the

suggestions and ideas they offer their students, and serious teachers are oblig-
ated to such generosity. When teachers offer good ideas to their students, they
soon see them carried to fruition, sometimes better than they could have
done it themselves; they may then have little need to execute that idea them-
selves. Offering these ideas uses up creative energies that their own work may
have profited from. But the positive side of this generosity is that sharing
teachers develop in concept more rapidly than they might have on their own
because they see their see their ideas come to fruition much faster than they
could do on their own. Furthermore, imagination and creativity, like mus-
cles, grow stronger with use.

Serious young artists who do not wish to teach may decide to move to one
of the three major cities to have better access to the art world. They might work
at any job, full- or part-time, to support their tenure in the city and maintain
the necessary loft studio. They might work at corporations such as IBM,
Vickers, Remington Rand, Xerox, insurance companies, or any of the compa-
nies that look for humanities graduates; but the better the position, the more
time it tends to occupy beyond the normal eight hours a day. And the more
success you have on that job, the less need you may have to obsess on art.

The study done by Getzels and Csikszentmihalyi indicates that many of
the more serious young artists are likely to seek part-time employment per-
forming art-related activities, such as "constructing models for architects,
dressing department store windows, casting toy statues, selling art supplies,
teaching art in summer camps, conducting museum tours and so on"
(Getzels and Csikszentmihalyi 1976, 218).

The most coveted positions, however, are jobs in art galleries, museums,
and companies that crate, store, and deliver art for galleries and museums.
While young artists are crating and uncrating paintings, they learn the work-
ings of the art world from behind the scenes. They may meet dealers, spon-
sors, critics, and future customers. The knowledge they gain can also be
disillusioning; young artists see practices that they may feel are in direct
opposition to their own integrity. Still, the willingness to accept the venal
aspects of the art world is another factor in determining who will continue
in the field. Several gifted students "left the field because they were averse to

the self-promotion, 'gallery-fawning,' and occasional duplicities involved in developing a clientele" (217).

The Visual Artist Information Hotline is a toll-free information service for visual artists; it is a program of the New York Foundation for the Arts (NYFA) in New York City, and you can call them at 1-800-232-2789. They will try to help you with any questions you may have. They will attempt to answer questions from fine artists in any of the visual arts—painting, sculpture, drawing, crafts, photography, and mixed media, as well as film or video or both.

The hotline operates in all fifty states, the District of Columbia, Puerto Rico, and the Virgin Islands. Artists may speak directly with the hotline staff between 2:00 and 5:00 P.M. eastern time, Monday through Friday, or they can leave a voice mail message anytime. They provide information on organizations at the national, regional, state, and local levels that will support individual visual artists. Some of these organizations may offer either direct support (cash grants, for example), indirect support (workshops and slide registries, for example), or, in some cases, both types of support. For grants and fellowships, the hotline can send detailed profiles of each program, including eligibility requirements, the amount of money awarded, the application and selections process, and deadline information.

Artists must then contact each organization directly for application forms and complete guidelines. Students are not eligible for most of these programs, but the hotline does offer suggestions on how to research scholarship information. They also provide information on various other topics, including emergency funding, health and safety, insurance, artist communities, international opportunities, public art programs, studio space programs in New York City, legal information, and publications. Even when a topic falls outside the scope of the hotline, they attempt to provide some suggestion on how to search for information on the topic. In five years of operation, the hotline responded to more than twenty thousand calls. It can be a valuable resource for artists.

I have seen a few young artists seek positions as art therapists, but I have never seen this function as a viable profession.

Art as therapy is an outdated concept.

In *Careers in Art* Gerald Brommer and Joseph Gatto explain that "art therapists use art as a vehicle for positive human change. They use drawing,

painting, and other forms of art work in diagnosis, treatment, rehabilitation and education" (Brommer and Gatto 1984, 213). Mental illness, however, is coming more and more to be perceived as an imbalance in blood chemistry, and psychiatrists are moving rapidly toward drugs, rather than psychoanalysis, as the preferred treatment.

Larissa MacFarquhar tells us that psychoanalytical methods dominated American psychiatry thirty years ago. Most of the psychiatry departments in medical schools were headed by psychoanalysts and stressed Freudian methods. But now it is difficult to think of more than four departments in America that are still guided by analysts. One of the last holdouts was Cornell, and they recently replaced their chair with a neuropsychopharmacologist. Mac-Farquhar believes that psychoanalysis is not far from being thrown out of medical schools entirely (MacFarquhar 1994, 20). Roy Porter argues convincingly that "psychoanalysis will come to be seen less as the authentic science of the psyche than as one of many late-Victorian quests for identity" (Porter 1994, 39). I have given that statement much thought and I have come to believe it is a profound insight.

Several past students have asked me about the possibility of becoming art therapists. My views on the subject discouraged all but four of them from pursuing that direction. I have always believed that art at the superficial level it is customarily introduced to clients in therapy situations has little or no value. I believe that any conscientious therapist would find insufficient satisfaction in the method to sustain legitimate enthusiasm for an extended period.

The four students who were not dissuaded studied at two of the best-known centers for art therapy. I asked all four of them to let me know after five years in the field if they still felt that art therapy was a legitimate field. All four eventually contacted me. Three said they had left the field after less than three years. The fourth was happy with his position. But he was not treating psychological abnormalities; he was working with older patients who used drawing and painting as physical exercise designed to work the arms and maintain flexibility in the joints. This seems to be a legitimate function for such a hobby approach to art. But it might be difficult for a serious artist to sustain much enthusiasm for teaching this over a long period.

I do not argue that verbal interaction between counselor and patient has

Jobs for Young Artists

no place. Those who find themselves in untenable situations that they do not know how to cope with may find that an insightful counselor can offer "coping strategies" they would never invent if left to their own devices. Others who did not learn how to handle anger as children may have developed deeply ingrained habits of violence, abuse, or self-destructive behaviors. A good counselor may sometimes be an invaluable help to such people. But, in an age when serious mental illnesses, such as depression, schizophrenia, paranoia, and obsessive-compulsive disorders, are treated more successfully by fine-tuning the electro-chemical system with chemicals than through counseling, the concept of art as therapy appears to be more and more an anachronism, out of tune and touch with our age.

Perhaps the principal fallacy in such a strategy is the word "art" attached to therapy. The low expectations inherent in such therapy programs might be more aptly named "activity therapy," "exercise therapy," or "movement therapy." Serious art as a hobby or an activity taken lightly is an oxymoron. Art is an obsessive activity that demands a lifetime commitment. When the term "art" is used with "therapy" it conjures up false hopes and expectations, which lead to inevitable disillusionment and frustration, which must only compound the original problem.

I do not mean to imply that art taught in a serious and competent manner cannot affect positive changes in young artists. Some of the best art instructors I have met have been excellent art therapists, though they would never have called themselves that nor perhaps even thought about it. One of the reasons I enjoy teaching is that I can show young artists how to learn those things necessary to becoming good at art (or anything else for that matter), and, consequently, they begin to realize that they can and will become very good at this profession.

With the realization that they can be of value comes a feeling of personal value and sometimes an almost abrupt change in countenance and personality. Many of us have, after all, been trained to believe that we are what we do. I have seen young people who once habitually hung their head and avoided looking anyone in the eye straighten up and begin to look self-assured. I have seen those who had habitually sought destructive relation-

ships in which they were abused suddenly realize that they did not deserve to be treated badly and reject abusive acquaintances. I am sometimes amazed at how much a person's opinion of themselves improves once they begin to *earn* approval from their instructors and peers. But I have also seen others who did not undergo such positive changes.

The first two to five years in art are painful, frustrating, and often exact a toll on the self-esteem of beginners, particularly beginners who have emotional problems to begin with and are not equipped to commit the time, discipline, and energy to the field that it demands. Finally, even the suggestion of art as therapy trivializes the discipline and demeans serious practitioners in both art and psychology.

Of course, most will have to work at jobs that are unrelated to art. This is perhaps the biggest challenge a young artist will face. It will demand all the self-discipline, perseverance, and good work habits they can muster. This is the winnowing field, and most will fall along the way at this stage. If young artists work hard every day in school, while they have lots of encouragement and do not have to work, that may not mean much in the long run. But if they can work a job all day, then come home to lonely quarters in the evening and still manage to work some every day when no one seems to care a whit, and if they can keep this up for years, then that probably means they are the genuine article: a real artist.

Done well, art can be of constant interest and unpredictability—something to build a life around. But as a superficial activity designed to "treat" those with emotional problems, it is, in my opinion, a failure. Certainly art did little to solve the emotional problems of painters such as Caravaggio (who spent his life on the run from one criminal assault after another), or van Gogh, or even Mark Rothko, who, it can be argued, painted multitudes of the most successful spiritual images in history, then killed himself. In the words of Willem de Kooning, in the opinion of many the best artist of the twentieth century, "Art never seemed to make me peaceful or pure." ⌐

Jobs for Young Artists

Working Spaces

I HAVE SEEN SEVERAL YOUNG ARTISTS make fundamental mistakes when they choose or build a studio. They may, for instance, build their studio too far from their living quarters. My studio is just eleven feet from my back door, and over many years I have found even this to be too far in the winter of eastern Washington state. If I had it to do again I would have it as a part of my living quarters. I often think of some small change I want to make in my painting, but, living in the North, the studio is too cold for a quick trip, or I do not want to put on heavy shoes to wade through the snow to make a simple change—which often ends up being a major project once I start.

On the other hand, my computer is here in the house with me, and I often get up from reading—or in the middle of a television program, or in the middle of the night when I have an idea and cannot sleep—to make changes or to type out sudden ideas. Had I built my studio as part of the house, I would have the same convenient access to painting at any hour. If I do not make changes when I think of them, I often do not remember it quite right later on. I can make notes to remind me of ideas that I hope to express in words, yet even then some of my more complex ideas suffer; but, when I have a visual image in my mind, sketches are often insufficient to bring it back the way I first envisioned. Furthermore, if my studio were in my living quarters, my work would be constantly in sight to keep the unconscious working far better than when it is removed from view. Out of sight, out of mind.

Furthermore, spending several hours each day in a studio separated from everyone else is an extremely solitary activity. I have met several young artists with ability and potential who worked well in art school when they had others around, but find after they leave school that they do not have the

reclusive personality necessary to sustain the cloistered atmosphere they encounter after school. They might feel less cruelly isolated if they shared a working space with other artists, or if their working space were in their living quarters, within sight and hearing of those they live with. That could easily become a deciding factor in the staying power, success, or failure of some individuals. Writing is somehow never the solitary occupation that visual art is, perhaps because there are more interested and knowledgeable people who are capable of understanding and sharing verbal ideas.

If, however, you find a real bargain on a working space, do not hesitate to rent it. In the older sections of many towns or cities, there are often warehouses or loft spaces above downtown businesses that are inexpensive to rent. In many cities groups of artists band together and collectively buy or rent old buildings or warehouses, then divide up the space between them. Sometimes, depending on local ordinances, they build their own living and working quarters within these buildings. The ones I have seen make ideal studios and even living quarters if the area is zoned for that.

Young artists just out of graduate school might consider that it would be very economical to move to a small town that has a deserted downtown area with lots of available space at reasonable cost. This might be an excellent short-term solution in the early part of an artist's career. When they first finish school might be the right time for many young artists to bury themselves in their work and strive for maturity in their work. It is an error to present work to others, who may remember it later, before the work is ready. It is likely that finishing graduate school is not coincidental with the maturity of an artist's work. However, despite the economics, to settle permanently in the comfort of a small town where rent is cheap, parking is plentiful, and a trip to the hardware store is simply a twenty-minute event will not help a budding career.

Almost anything will do as a working space when you live in a warm climate like California. But it is not a good idea to use primitive quarters in the North where the climate is cold much of the year. If your studio is not comfortable, you are less likely to spend time there. I know several artists in Washington state who thought it was romantic to work in ramshackle quarters with perhaps nothing but a woodstove for heating. Most of them do not

work regularly. They may soon come to dread going out to a cold studio, laying and lighting a wood fire, then waiting for the place to heat up. Trying to work with jacket and gloves on is like washing your feet with your socks on, to use an old expression.

Artists must think of the convenience a particular studio offers over a long period. Convenience contributes to good work habits. At the age of forty or fifty—a prime age for artists—you finally become the cumulative result of all the habits and patterns you established when you were young. Occasional activities, good or bad, seldom have much importance in the end. You need only be concerned with patterns, habitual behaviors.

One thing I did right when I had my studio built was to place a switch for the studio heat inside the house where I live. When I get up in the morning, I flip the switch; by the time I am ready to work, the studio is warm and inviting. Furthermore, even if my resolve to work fades before I get there, I feel obligated to work anyway because I have already paid to heat the studio.

Artists who maintain studios far away from their living quarters, and also have primitive heat or toilet facilities, start each morning with two speed bumps to slow them down and discourage them from working—not an insurmountable obstacle but an obstacle nevertheless.

And obstacles accumulate.

Another mistake I have seen many artists make is to decide to build their own studio. They may plan to spend only two years in the building, but time passes; it has a way of creeping past before you notice it. In every case but one that I have seen, the artist spent five years or *more* building the studio. That is five years in which they do not make art. Five years may be more than a tenth of their professional life.

Unless you are an experienced builder, I suggest you either rent or float a mortgage and have the studio built. Or, until you can afford a better studio, make do temporarily by converting a large room or a garage to a studio; that can usually be done—even by those who cannot walk and chew gum at the same time—in less than a week and will probably accommodate most kinds of artwork.

Most young artists in the beginning will simply have to make do with converting some existing space to a studio. Often this can be done quite easily. I

could make specific recommendations, but it is quite logical and straightforward. And different artists will prefer entirely different kinds of environments. If your work is small, often all you need is a spare bedroom. You can install the lighting and the workbenches that you need, and you are ready to begin work. If you work large, you may need a larger space. You may want to look for something with ceilings higher than those of the postwar house, which are just under eight feet high.

Many artists simply convert a garage to a studio. When I did this, the garage just had exposed studs, so because I am a painter I "wallboarded" them with half-inch plywood. This offers good purchase for nails or hangers to hang paintings on while you work. It also offers the opportunity for hanging tools, and tracing around each tool on its hanger with felt-tip markers, so that it is easy to know where each tool goes. I find that if I can find my tools easily, I save much time, which is always precious to the working artist.

At some point, some artists may be fortunate enough to afford to construct the studio of their dreams. In doing so, dreams can become nightmares. The artist finds that the demands of local building codes may drive the cost of the building up immensely. Many communities will not allow the construction of a commercial building (and a studio is a commercial building) in an area that is not zoned for it. The building codes for commercial space require, for example, exit lights with battery backups. Sprinkler systems may be required in the area where the water heater and furnace are located. Paved parking space may even be required for the building. Site plans done by a civil engineer are sometimes required, and water drainage and storm water retention can be considerations. It can be frustrating to find that in a commercial space you are not allowed to do your own wiring or plumbing unless you are a licensed contractor. That is often forbidden by local codes, even though you may have all the knowledge and skill for the job. One strategy is to hire contractors who will allow you to work with them. Maybe the electrician will allow you to install the boxes that hold the outlets and switches, and maybe you can drill the holes where the wires will run; this should reduce the bill some.

Building permits are usually required even if you plan to remodel an existing space. The people in the code enforcement departments are usually

friendly and helpful in explaining the requirements and codes. It would be a serious mistake to undertake a major remodeling without a permit. One complaint will bring the inspectors to your space. There may be serious fines, and everything constructed without a permit might have to be removed.

Health considerations are important too. Clearly, it is best not to eat in the studio, so that you don't end up ingesting toxic art materials. And smokers should never light up in the studio. Smoking causes some materials that are already somewhat harmful to become extremely hazardous. Proper ventilation should be an important consideration. Artists who spray material in closed spaces are inviting serious physical problems, especially liver problems.

Our bodies successfully withstand occasional exposure to many different substances that are unhealthy. But many artists tend to live, day in and day out, with the materials of their art. This constant exposure can be disastrous without the proper care and protection. One item that should be in every single studio is a U.S. Mine–approved organic particle filter mask. These can be purchased at most hardware stores. They should be stored in an airtight container to make the filter last as long as possible. When odors can be smelled with the mask on, it is time to buy a replacement filter for the mask.

When I had my studio built in 1964 I had many callow theories about function and lighting that did not wear well over the years. Most experienced painters are familiar with Leonardo's advice to choose a studio with north light. The reasons are obvious. When you depend on the sun for light, north light is more constant. The sun rarely shines directly through north windows (especially in northern locales) but it shines directly through south, east, or west windows much of each day. When the sun shines directly into a room, the portion in direct sunlight is so bright it hurts your eyes, while the part that is not in direct light offers poor visibility to eyes with pupils focused down to accommodate the large areas of brilliant light.

Furthermore, the brightly lit areas move noticeably across the room throughout the day, constantly changing the light. North light, however, remains fairly constant all day. This was exceedingly important in Leonardo's day, when artists painted from models and mock-ups in their studios and attempted to mimic the lights and darks they observed on objects to achieve

an illusion of volume. This may not be so important for the artists today who do not have such priorities, but they still do not want the sun shining directly on their work during only a part of the day.

Because I was a painter I placed a premium on wall space. I built a studio with three full unbroken walls of working space (except for necessity of the double-door entry because of the size of the canvases I often painted). Leonardo had touted north light because natural light was much better than candles, which were the principal source of artificial light available then. Knowing this, I decided that north light was not important in this age when paintings are seldom seen under natural light. Most galleries and museums are lighted exclusively by electric light now.

If paintings were destined to be seen under artificial light, I reasoned, why not paint them under that same artificial light? All these were good simplistic logical considerations. I did not realize at the time that, unlike art schools (which usually use cheap fluorescent lights), galleries and museums do not use just any kind of artificial light. They use a kind of lighting balanced to a specific color temperature, about twenty-nine hundred kelvin.

The only windows in my studio extended only two feet down from a ten-foot ceiling on the north wall, leaving another eight-foot high expanse of wall space to hang paintings. I found after working in this studio for a year or two that the lack of windows made it a dreary cell-like place to be alone in—another small obstacle to steady work. I now suggest that young artists should make the studio a pleasant, as well as an efficient, place to work; they may then be more anxious to start work each day. It is better to have to discipline yourself to stop work each day than to have to discipline yourself to start work each day.

The small high windows on the north side, of course, offered little light, so I had to rely on electric light. I used five hundred-watt floodlights. Most incandescent lights, I later discovered, are too warm; they strengthen the warm colors in an artwork and change the overall proportion between warm and cool areas; they also make the cools look cadaverous. And warm light at low levels is psychologically disturbing; our image of Hell is a place lighted by open fires: a low-level, warm, reddish light.

Working Spaces

Fluorescent lights, on the other hand, strengthen cool colors and change the warm/cool balance the other way. They deaden the warms, leaving them looking corrupt and putrefied. And blue light is disturbing at high levels. Consequently, the industrial world has millions of workers who perform eight hours or more each day under this kind of bright, psychologically disturbing fluorescent lighting.

The lighting companies continue to flood the market with these "cool white" fluorescents, and institutions, including art schools, use them because, unfortunately, they are much cheaper than other lights. "Warm white" and "daylight" fluorescents are closer to daylight with kelvin temperatures of four thousand and forty-eight hundred respectively, but they still do not cover the spectrum evenly. And the kelvin temperature is too high for lighting artwork.

A carefully balanced combination of fluorescent and standard incandescent might help fill in both the warm and cool areas, and this might be an acceptable economic solution if one or the other were already in place.

The simplest and best lighting I have found comes from the five hundred-watt halogen lamps that are sold in most discount stores. The inexpensive, short tabletop version (as opposed to the standing floor version) is simply a reflective fixture covered with a glass filter and a wire cage (halogen bulbs can pop and spray glass if they are not covered, and the glass filters out the harmful ultraviolet) with a simple stand that allows the fixture to sit on a flat surface. Or you can screw the stand to the wall or ceiling. These sell for ten or twelve dollars each in any discount store; that price includes the five dollar bulb.

These lamps are *very* bright; they will furnish more than adequate light for any activity. Aimed straight up toward the ceiling, the reflected light is bright enough to read by, easily and bright enough for most studio work. Pointed directly at the work, they are bright enough for any work. Some people assume that standard halogens are balanced at about thirty-two hundred to thirty-four hundred kelvin like the photographic halogens, but this is not true. I talked to Paul Morantz of Fisher, Morantz, Renfro, Stone in New York, probably the best-known museum and gallery lighting company in North America. This company has designed the lighting systems for numerous

major museums and galleries from coast to coast. Morantz insists that when common long-life halogen lamps are metered for temperature, they register twenty-eight hundred to twenty-nine hundred kelvin. Only the photographic version of this bulb registers the thirty-two hundred to thirty-four hundred kelvin. The photographic version is often used as photographic studio lighting to accommodate film that is balanced to tungsten light.

Morantz tells me the ideal museum and gallery lighting process is complex and combines some fluorescent with halogen lighting, but most artists have little reason to be concerned with the subtleties. I will simplify. According to Morantz, museums and galleries try for an average temperature of about twenty-nine hundred kelvin for most artwork; prints are often illuminated with slightly warmer light. Some museums do use daylight in varying amounts (about five thousand kelvin at high noon, the higher the number the cooler the temperature), which cools the temperature of the halogen lamps until late afternoon. Daylight turns considerably warmer in the late afternoon because it is forced to travel a longer distance through the atmosphere. The longer the distance sunlight travels, the more blue light is scattered out by the atmosphere, finally creating a strong red cast to the light at sunset.

Consequently, in conjunction with any available natural light, the normal long-life halogens are a simple, effective, and inexpensive choice for studio lighting for most artists. They produce a light that is much like the lighting under which artwork will be viewed in most galleries and museums. Artists who wish to supplement the cooler areas of the spectrum where halogen light is weak can install triphosphor fluorescents with a color rendering index (C.R.I.) about eighty-four or eighty-five. Halogens and triphospors in concert make excellent lighting for artwork.

I will briefly mention the proper use of an easel for painters. I see so many young artists now that do not seem to know the fundamentals. I have watched young artists who have transferred from other schools complain about the glare on their paintings. They invariably have the painting directly facing a window or slanted back or both to rest at the most stable position for the easel. Easels are built to adjust the angle between the painting and the floor. Because most light comes from above, when paintings are slanted back

even slightly, they tend to accumulate glare, and they are hard to see clearly.

Frank Lloyd Wright planned the walls of the Guggenheim Museum to slant back slightly because he said that was the angle at which the artists saw the paintings on their easels. He must have visited a class of painting students who did not know how to adjust their easels properly and thus had their paintings at the wrong angle.[1]

But the Guggenheim staff correctly hangs paintings vertically; they do not exhibit them at the angle of the wall as Wright intended. Furthermore, professional artists seldom use easels. Most hang their paintings flat on the wall because this offers a sturdier surface to work on and a good angle to avoid glare. The wall also steadies and stabilizes much larger paintings than an easel can, which is especially important for painters who apply paint in a vigorous physical manner.

When working on an easel and troubled by glare, adjust the easel until the top of the painting is slightly ahead (forward) of the bottom, and glare will disappear. That is why easels have that adjustable block with a lip on it, toward the top, to keep the painting upright when it is leaning slightly forward. You may need to put additional weight on the base of the easel to keep it from falling forward; sandbags work well. Reposition the painting so that it is almost perpendicular with the windows so that the light rakes across the painting from the side, rather than shining directly on the painting to reflect straight back into your eyes. Artificial lights (if not bounced off the ceiling) should be almost over the painting (perhaps a foot from the wall), or well to the side, so that the light will hit the surface of the painting then reflect away from your eyes. With a few simple facts and ideas in mind it is easy to set up a good working space.

The artist's studio serves yet another important, pragmatic, but little-known function. This function may be the most important element in the eventual success or failure of a young exhibiting artist. In their seminal study of young artists at the Chicago Art Institute, Getzels and Csikszentmihalyi

1. Several artists, including de Kooning and Kline, signed a letter of protest about the design of the Guggenheim, arguing that the "curvilinear slope . . . indicates a callous disregard for the fundamental rectilinear frame of reference." Wright answered in his customary arrogance: "There *is* no such frame of reference, except one raised by callous disregard of nature, all too common in your art'" (Plagens 1996, 69).

note that none of the unsuccessful artists had done this one thing; further more, all six of the young artists who achieved the highest levels of success *had* done this one thing: *All* six successful artists had all rented lofts in downtown Chicago!

Some had done so even before they finished school. Some shared the loft with another artist. Many of the unsuccessful artists continued to work hard at their discipline, and many of them were producing quality work, but *none* of them had rented a loft. Consequently, they were known to only a few close friends (Getzels and Csikszentmihalyi 1976, 187).

And this "political" function of the studio is also important in Los Angeles and San Francisco—and doubly important in New York.

These "opportunity" lofts are even expected to have a certain look. Finished work should be stacked against the walls, and work in progress should be easily visible. The successful artists, in the previously mentioned study, hosted parties nearly once a week, and the more memorable the parties were, the more likely the young artist would gain recognition. They also attended openings and parties hosted by other artists. I might note here that Getzels and Csikszentmihalyi discovered that even though some of the successful artists did use a little (but not much) marijuana, they rarely used any hard drugs, and they all insisted that drugs were of absolutely no help in their work (217).

The loft is considered an important and virtually required step because it is believed to indicate (whether right or wrong) that a young artist is genuinely committed to the profession (187).

Establishing and maintaining these lofts requires behavior that most artists consider unnatural or even repugnant. To maintain such an "opportunity" loft, young artists—who are usually withdrawn, self-sufficient, and introverted—must be businesslike, masters of ceremonies, caterers, and public-relations experts. This paradox was both obvious and unsettling to most of the artists in the study. They were *all* uncomfortable with the contradiction between their personal need for solitude to practice their art versus the pragmatic need for sociability to advance their careers (187).

After gaining some success, the two most successful artists moved to sim-

Working Spaces

pler studios, but they clearly understood that they did so with considerable risk. For those who do not already have good gallery contacts and a committed following of buyers, this kind of move can mean the end of a career. Many gifted students do not understand the need to rent and use a downtown loft, and, consequently, many of them fail. Others who may realize this is the price for success may choose not to endure the hypocrisy and "therefore fail even the first step toward their intended career" (188).

My intention in this section was not to advocate one behavior or another. I simply want to make certain that young artists are aware of the behaviors that may be required of them so that they can make informed decisions. It saddens me to meet accomplished but unsuccessful artists in their forties and fifties who were never aware of the realities and prerequisites for success and thus were never allowed to choose. Success eludes them.

And they do not know why.

And they never had a choice. ✐

Records and Taxes
Ben Mahmoud

THE PROFESSIONAL ARTIST MUST SPEND TIME ON THE "BUSINESS."[1]
There are application forms for grants, as well as exhibition and competition
forms, to be filled out. There are letters to galleries, curators, and even crit-
ics, to write. There are slides to label.

And there is the biggest headache of all: taxes.

One artist told me: "I find that I spend an obscene amount of time on the
business part of being an artist." One goal of the professional artist is to keep
this "obscene amount of time" to a minimum. This can be accomplished by
logical and accurate record keeping. Matters are so much more simple if one
does not have to jump up and dig out the actual painting to get the dimen-
sions for an entry form. Beginning artists do not have to remember much
about their work; they do not yet have too many completed paintings. But
the professional artist soon finds that the almost countless paintings, draw-
ings, prints, or sculptures they have produced boggles the memory. Where is
that painting now? In what year did I do it? What size was that drawing I sent
out six months ago? Who owns it now? It is impossible to remember such a
mountain of information.

The first record-keeping habit a young artist should develop is a journal of
completed work. If you don't have and use a computer, and make backups reli-
giously, I recommend a simple journal book, about 5" x 7". List each work as it
is completed, two to a page. This will leave room below each entry to record the
exhibitions and shows the work has been in. And when the work sells, it is a
good idea to list the name and address of the buyer. Artists often find it neces-

1. Ben Mahmound has been a successful painter for decades, and he has learned well how
to keep efficient records and how to prepare tax returns. His wife, Wendy, is a CPA who
teaches at Northern Illinois University. He is far better equipped to instruct in this area
than I, and he was kind enough to write this section and allow me to include it as a service
to those who are interested.

sary to borrow works from collectors for a major show, and, without records, it could be an undertaking of major proportions to bring together the names of the works with the names and addresses of the collectors.

The first item in each entry might be the title of the work, then the medium and size. Then enter the date of completion. It is a good idea to indicate in this journal whether the works have been photographed. I indicate whether there is a slide, a 4" x 5" transparency, or a black and white negative or both. This journal should be a sturdy book because it will get much use for a long time. Every time I fill out a form that requires the size, date, or some other detail of a work, I simply open the journal. Often the works are not in my possession; they may be in the gallery or they may have been sold. This makes labeling slides so much easier and less time consuming.

Another important record is the documentation of professional activity. The artist is called on many times for a "résumé" of professional activity. Frequently a generic résumé will not work, and a new one has to be tailored for the immediate purpose. Creating such a résumé is most easily accomplished if artists keep a journal of all of the shows, awards, public collections, publications, reviews, and catalogs. It may be a good idea to divide this journal into several sections: one for exhibitions, one for awards, one for collections, and one for reviews and catalogs.

It is important to comment here on the listing of collections in a résumé. It is the mark of less-than-professional artists to list the works they have in private collections. These collections are, by definition, private, and some collectors resent having their ownership advertised. Unless the collection is significant, such as the Satchii Collection or a major curator's collection, it is wise not to list private collections on a résumé. Public collections are a different matter. These can and should be listed.

Put the date of each entry in the margin and then list the item or event. There should be some consistency of form. For example, it is a good idea to begin exhibition listings with a term that explains the kind of exhibition: invitational, national competitive, one-person, etc. Again, this should be a sturdy book because it will be heavily used during a successful career.

Although it takes time to organize, the time spent on this task is an invest-

ment; it *will* draw interest. The more efficiently artists are organized, the less time they will ultimately spend on such trivia. Some successful artists find that putting together an application for a grant or proposal for a show is a two-day event. They hate it. More organized artists can do the same thing in an hour or two. They may not like it any better but they will not have to suffer as long.

The obligatory record keeping produces records that are needed for taxes. When being an artist becomes a business, a Schedule C must be filed with the income tax return. This schedule is the profit or loss statement for a business. If artists generate any income with their work, they must file such a return and pay the taxes required. If they incur a loss in the business, they may file a Schedule C and use the loss to offset other income.

There are many rumors about how often an artist can file a loss and still be considered a business. If you never show a profit, the IRS will treat the "business" as a "hobby," and the costs of conducting a hobby are not deductible. Rumor sometimes has it that an artist must make a profit in one out of three years or in five years. That test, however, is just *one* of the tests used by the IRS to discriminate between "business" and "hobby." A more fundamental test is whether one can demonstrate an *intent to make a profit*.

Making a profit demonstrates that intent very well. However, artists can show a loss year after year if they conduct themselves in a businesslike manner, which includes keeping accurate and proper records. Artists must demonstrate a consistent effort to place their work in situations where sales might be likely. This may include exhibitions, competitions (awards are income), art fairs, and private showings. This demonstrates the importance of record keeping, because such records can demonstrate an attempt to sell the work.

So, assume the decision has been made to file a Schedule C with the next year's tax return. What records need be kept? What items must be saved? The simple answer is: record everything; keep everything. It is vital that any and all income be recorded. But which expenses should be recorded and accompanied by receipts? All expenses of doing business should be recorded and documented. This means the cost of supplies: rent for the studio, utilities for the studio, frames, art magazine subscriptions, postage, the cost of equip-

ment (though there are special regulations for deducting the cost of equipment, which will be covered later), insurance on the tools, work, or property, and business-related telephone calls. The cost of your home phone may not be deducted, but business-related long distance calls can be.

The cost of business-related services can also be deducted. These might include photography, shipping, or printing. Any advertising expenses are deductible, and any fees paid are also deductions. Commissions paid to dealers or brokers are legitimate deductions. Business-related auto mileage is deductible, which includes trips from your studio to the hardware store or the art supply store, and mileage to and from your place of employment, or from your place of employment, to your studio if careful mileage records are kept; but it does not include the mileage from your residence to the studio.

If you deliver a painting to a gallery, and you must pay tolls on the highway, this should be recorded. The parking fee should also be recorded. A small pad in the car or truck will serve as a record-keeping journal for your mileage. If you are away from home on business for more than a day, you may deduct the cost of accommodations and food. If you entertain a potential patron or dealer, these costs can be deducted, but care and discretion should be exercised in this category. Entertainment expenses are looked at very carefully by the IRS.

Keep a separate bank account for the income and expenses related to your studio business; besides looking more businesslike, it makes record keeping more efficient. Keep all receipts relating to business expenses. All these records should be retained for at least three years after the year they are filed. If you have not been audited within three years of the filing deadline, you probably will not be audited for that year unless the IRS suspects fraud. Canceled checks may sometimes not be considered receipts by the IRS. It is important that receipts be kept besides the canceled checks.

Should artists find it necessary to both live and work in the same building, there are additional tax considerations. They must be careful if they declare art is their business and file a Schedule C. If they live and work in the same space (and this is broadly defined as the same location), the area considered "working space" must be separate and exclusively devoted to artwork.

One artist's deductions for studio costs were disallowed at an office audit, so the artist asked for a field audit. The IRS agent came to her studio; in one room that was used for matting and preparing work for exhibit, a room that was kept relatively free of the dirt and debris of her art making, stood an ironing board. The IRS agent asked what role the ironing board played in making her work. She replied that it played no role. The space was disallowed—the entire room.

Any space used for work and subsequently used to generate a business deduction must be used solely and entirely for that business. If a photographer were to use the bathroom as a darkroom, that room could not legitimately be deducted as a business expense. It should be noted that presently, it is very difficult to get a deduction for an in-home business. Recent court rulings have not been favorable for such deductions, and the IRS looks very carefully at any return that took an in-home business deduction.

If you hire someone to help you in the studio, this may pose a special problem. If that person is your employee, by the IRS definition, you have to pay employment tax and issue a W-4 form to your employee at the end of the year. On the other hand, if personnel are contracted to do work for you, they are considered "independent contractors" and are held responsible for their own taxes and insurance. The conditions that make a person an independent contractor rather than an employee are: contractors decide how and when the work will be done, they use written contracts for the work, they are paid by the job, not by the hour, they have their own tools, and they set up their own work schedule.

It is easy to incur a devastating hospital bill if someone working for you as an employee (but not an independent contractor) gets hurt in your studio. If the injured person is an independent contractor, you will not have that responsibility. If you do hire an independent contractor, IRS form 1099 must be issued to the contractor and sent to the IRS at the end of the taxable year and before January 31.

With regard to deducting equipment, a business can generally deduct the cost of the equipment in the year it was purchased, up to $17,500—so long as the expense does not create a loss against all earned income that year, after

all other business expenses are deducted. This requires a section 179 election on IRS form 4562. However, if greater income is expected in future years, it may be wiser to depreciate the equipment over its statutory life. The IRS has a publication that explains depreciation; it is called, most originally, *Depreciation*. Once the statutory term of depreciation has been reached, the artist should stop listing that equipment on Schedule C.

If an artist makes an error in the section 179 election to depreciate, the error cannot be amended. Once you elect to depreciate equipment, you cannot change your mind. If you begin to deduct the expense of the equipment on the original return (when you begin to depreciate the equipment), you cannot go back and elect section 179. When dealing with an expensive piece of equipment, it is wise to have the professional advice of a good CPA or enrolled agent.

Successful artists may find themselves earning a profit in a taxable year. In this case they incur self-employment tax liability. This tax is calculated by multiplying the net profit on Schedule C by .9235, and then multiplying that product by .153. Self-employment tax is a social security tax and Medicare tax. It is possible that the artist might owe self-employment tax and not owe income tax, because income can be offset by the standard deduction or by itemized deductions and exemptions. This could reduce the income tax to zero. But these deductions have no bearing on the self-employment tax.

The nature of many artists often works against the procedures of a businesslike practice, and the duties of record keeping are onerous. To avoid them is simply to put off the inevitable and to compound the work when it must be done. Because there never seems enough time for artists to be engaged in their creative pursuits, it is easy to procrastinate or avoid the organization of the business. But denial is not a river in Egypt and will cost the artist again and again in extra time and trouble. ⌒·

11

Blind Dancers

THE AESTHETIC EXPERIENCE IS A POLAR OPPOSITE to the complex intel-
lectual experience, but I believe they are the two most important experiences
in art. The first, the aesthetic experience, often generates common and gross
misunderstandings on two levels.

The first misunderstanding is that some artists, teachers, and critics—after
a lifetime in the field—still fail to understand that such an experience exists.
And those who have not tasted the experience often find it impossible to com-
prehend or sincerely acknowledge it. Many are simply not open to such an
experience for one reason or another, while others have been "raised" on slides
and reproductions alone, and this experience is not attainable through pho-
tographs of artworks. Because such an experience often depends on the rela-
tionship between illusion and the reality of the work itself, the added illusion
that a photograph must intrude negates the original relationship entirely.

Barnett Newman is one of the most important of the post-Rothko tran-
scendental painters, and he is that rare find, a genuine artist who writes well.
He explains that "unless I have seen the original work so that a photograph
can remind me of my own real experience, photographs and slides have little
interest for me. It seems to me that an art education based on this material
is nothing but a mirage" (Newman 1990a, 6).

On the other hand, the second misunderstanding is that some viewers and
professionals who are aware of the esthetic experience, or have experienced
it themselves, believe it is the only important experience in art. They do not
understand that a complex intellectual experience, entirely unrelated to the
unified aesthetic experience, can be just as important and just as moving, but
in a different manner. Furthermore, these two separate experiences, one
purely intellectual and the other apparently sensuous, can meld into one uni-

fied experience: intellectual analysis is fully capable of generating the aesthetic experience itself.

Arthur Koestler, the self-professed "atheist mystic," says he was introduced to the experience while waiting for execution by firing squad. He noticed the symbol for infinity drawn on the wall of his cell, and, to take his mind off his imminent execution, Koestler focused his entire concentration on the idea of infinity. His immersion in a notion that resides eternally outside human ken or experience generated his first mystical experience.

Other common mistakes are: some have heard so much hyperbole about art that they come to believe there is no such legitimate experience, some confuse it with an erotic response, some confuse it with having had a vision or a hallucination, others believe that such enlightenment generates in the beholder some kind of preternatural power. They may believe that such enlightened people are never petty, selfish, afraid, or materialistic. But none of these impressions is true. Contrary to popular opinion, jerks remain jerks, before or after such experiences. Materialists do not lose their interest in possessions. Observe the behavior of some of the world's mystic leaders. When mystics from India or the Middle East come to Europe or the United States, many of them become surprisingly acquisitive: they collect properties, Rolls-Royces, or gold bullion. None of this behavior is related, one way or the other, to the aesthetic experience.

Nevertheless, such an experience does exist.

In fact, those who experience the aesthetic find it is as real an experience as any other phenomenon, such as the experience of a chair, a table, or pain. The aesthetic experience is closely related to life, death, and divinity. Some call it a religious experience; some call it a death experience. Such an experience does offer two things to the recipient: it stops the fear of *being dead* (but not necessarily the fear of dying or the fear of pain) and it tends to connect all things and all knowledge. That is, such an experience generates an awareness that everything in the world and everything in the mind is connected to everything else.

All disciplines, for instance, are but different routes to the same goal: the experience is customarily courted through such disparate disciplines as reli-

gion, science, mathematics, philosophy, and the arts. Hence, what you learn in physics should in some manner relate to art, philosophy, and psychology—if you are able to make the connections. After an aesthetic experience, learning (or rather understanding) becomes much more efficient because there is no longer any need to relearn the same ideas anew in each discipline; the understandings of reality that are gained through physics should cross over and relate to art, psychology, and philosophy.

Those who consider this experience the most important in art (or any discipline) are called "transcendentalists," and the modern philosophical understanding of transcendentalism is based primarily on the ideas of the eighteenth-century philosopher Immanuel Kant. He believed that humans know nature only through perceptions, which they experience by means of their senses; he separated these perceptions into several different categories, such as cause and effect, quality, quantity, necessity, actuality, possibility, and modality.

Kant argued that because the mind begins with perceptions and not with things in themselves, we can never entirely understand either phenomena or the world. Therefore, our *separate* senses can never perceive God. But the mind's integrated intuitive faculties can transcend mere sensuous perceptions. The intuition can suspend these categories of the individual senses as separate, unrelated entities and experience them all together as a single unified totality; in this manner, we can know the experience of God.

Ecstasy, presence, numinous presence, epiphany, mystical experience, ultimate reality, immanence, cosmic unity, religious experience, the spiritual, the eschatological, the infinite, revelation, revealed truth, enlightenment, transformation, transcendental, vitalism, peak experience, pragmatism, meditational, the sublime, a state of grace, the universal pool of consciousness, Bernard Berenson's "ideated sensation," Roger Fry's "disinterested intensity of contemplation," and Susanne Langer's "symbolic form" are just twenty-seven of the terms beyond record or number that have been used to describe the transcendental experience in art, which I shall call the "aesthetic experience."

The aesthetic experience is alluded to or mentioned in brief paragraphs here and there. Some may write at length about the phenomena that surround or influence it. But the experience itself is seldom addressed *directly*

at any length by artists or writers because such experiences are, by the nature of our language, ineffable. We can talk around such an experience but not directly to it. Barnett Newman explains that "the spiritual content of a work of art, if it has not been ignored, has as a rule been taken for granted" (Newman 1990b, 151). Newman also argues that this experience of the sublime has often been confused with "beauty," and he insists that some American painters (including himself) were beginning to find "the answer, by completely denying that art has any concern with the problem of beauty" (Newman 1990c, 173).

Some writers and artists may feel that their credibility is particularly vulnerable when they attempt to write about or talk about a phenomenon that can sound so personal, so subjective, perhaps even ridiculous—as if they were defending the existence of flying saucers or reincarnation. But William C. Seitz believes that aesthetic experiences, "though they approach mysticism and cannot be fully explained, should not be pushed aside as poetic extravagance. They are irreducible facts of creative experience, and intrinsic data concerning works of art" (Seitz 1963, 54).

I am fully aware of the problems that exist when writers attempt to describe the essence of this experience to the uninitiated. The one definitive aspect of the aesthetic about which all who write on the subject agree is its ineffability, its ability to slip through the verbal fingers of those who try to explain it.

The difficulty encountered when explaining such an experience stems from the fact that our verbal language is designed to express emotion and to communicate one experience in terms of, and analogous to, other similar experiences. Verbal languages are not designed to describe entirely new experiences. Linguists such as Benjamin Whorf explain that language does not explain new experiences or concepts so much as it articulates the world in terms of experiences we hold in common (Whorf 1956b, 233–45; 1956a, 233–45). A speaker, for instance, can often accurately describe the experience of falling a great distance because we have all experienced some kind of fall. Our minor falling experiences are different from falling off a house, or out of an airplane, only in degree; they are not different in kind.

Advice to Young Artists

Contemporary philosophy has often been accused of pursuing semantics at the expense of metaphysics, but Alfred North Whitehead, one of the best-known twentieth-century American philosophers, is immune to such a charge and insists that "it is true that the general agreement of mankind as to experienced facts is best expressed in language. But the language of literature breaks down precisely at the task of expressing in explicit form the larger generalities—the very generalities which metaphysics seeks to express" (Whitehead 1978, 11).

Linguistic difficulties arise when a writer attempts to relate an experience that is unlike any the reader has ever had. For instance, how would we explain sight or color to one born blind? Hans Selye cites a parable from India that illustrates the difficulty in explaining something like color to the blind:

> A blind beggar asked his friend, "Tell me, what do they mean by white? What is white like?"
>
> "White is a color," he was told. "It is like the snow on the mountains."
>
> "I see," the blind man said. "It is a cold and soft color."
>
> "No, not always; paper is white too."
>
> "It is a thin and fragile color, then?"
> "It need not be. Milk is also white."
>
> "Is it fluid and nourishing?" the blind man asked, somewhat bewildered.
>
> "Not necessarily," his friend explained. "All sorts of things are white: clouds, teeth, an old man's beard—your eyes are white, too, that is why you cannot see through them."
>
> "Oh, never mind!" the blind man sighed. "It is a cruel color. Perhaps it's just as well if I don't try to understand it." (Selye 1964, 268).

Or if someone stumbled upon a mythical Shangri-la, where everything, including air, water, shade, and objects maintained a constant temperature above eighty-five degrees, how might they describe the sensation of cold to one of the indigenous inhabitants who had never experienced it? If cold were

accurately described as the absence of heat, an indigenous listener would think the experience must become more and more pleasant as the temperature grew colder because that would be consistent with previous experience. It would also be difficult to explain to those who had never touched dry ice (which seems to burn, rather than chill, the finger that touches it) how opposites such as heat and cold can become indistinguishable from each other.

Like color to the blind, the mystical experience is unlike any other experience. Consequently, religious mystics, as well as artists, throughout history have seldom spoken directly about the experience itself. Instead, most religious leaders and artists have spoken only of the road that leads to such an experience. That road has traditionally consisted of removing disciples from their worldly concerns to learn a disciplined attentiveness. This self-discipline often takes the form of advocating restraint toward worldly things, sometimes even to the point of rigorous asceticism. Those who have had no glimpse of the true goal, therefore, are often doomed to perceive such instructions as moral rules. But morality has little (though I would not say nothing) to do with the mystical experience.

Some initiates, however, have spoken directly (though perhaps briefly) about the experience itself, and I will focus on these brief comments that attempt to communicate the experience directly. Because my explanations are remarkably like bits and pieces voiced by many other writers and artists, I think it is necessary to corroborate my ideas with quotes from other sources to demonstrate that these are not just my own personal or eccentric responses. Though it is timeless and global, the aesthetic experience is so difficult to explain that I will rely on a collective explanation composed of examples from those who have attempted to write about it directly.

Because I cannot establish a simple analogy between the mystical experience and any other experience, I cannot describe it; therefore I will first describe what it is not. Walter T. Stace, a former professor of philosophy at Princeton University, has written influential books on Greek philosophy, the philosophy of Hegel, and aesthetic problems. He explains that the mystical experience is not foggy, vague, sloppy, or misty (Stace 1969, 10). (The similarity in the sound of the words "misty" and "mystical" has no relevance whatsoever.) The experience under discussion is absolutely not related to

occult or parapsychological phenomena such as telepathy, telekinesis, clairvoyance, or precognition (10).

Hallucinations and visions, either visual or audible, are no more related to this experience than is the size of one's nose. Both large-nosed and small-nosed people have experienced the aesthetic; likewise, those who have had visions, as well as those who have not, have enjoyed aesthetic experiences. But the experience itself is unrelated to visions.

Some mystics did have visions, but they did not regard these visions as mystical experiences. St. Teresa of Avila, for instance, often had visions, but she knew they were not the experiences she sought. She thought God sent some of them to encourage her to pursue the mystical consciousness. But she believed the devil might have sent other visions "in order to confuse her and distract her from the true mystic quest" (11).

Contrary to common opinion, the aesthetic experience is not subjective. The ability or inability to communicate an incident or a sensation efficiently has nothing to do with its subjective or objective qualities. Both cold and color are real experiences whether or not they can be explained to persons who have not experienced them. Neither is the universality of an experience any indication as to its objectivity. Walking on the moon, though it has been done by few, is nevertheless an objective experience. The aesthetic experience itself is just as objective as cold, color, or walking on the moon. It is a real phenomenon. But the causes and interpretations of the experience may well be subjective, and this may lead to misunderstanding.

Stace explains that if, on a dark night, three people see something glimmering white, one may think it a ghost, one may see it as a sheet on a clothes line, and the third may insist it is a rock painted white. This is a single real experience with three different interpretations. An interpretation may be either true or false. To gain an understanding of mysticism, it is necessary to distinguish the difference between the mystical experience itself and the various interpretations that such an experience may generate in either mystics or nonmystics (10). The experience itself is formless, so it may lend itself to many interpretations. Furthermore, it may generate "a *bona fide* conversion to practically any creed, Christianity, Buddhism, or Fireworship" (231).

I intend to focus on the milder of two recognized categories of the mystical

Blind Dancers

experience. The aesthetic experience in art is what Stace calls an "extrovertive" mystical experience.[1] This experience may be initiated by some external object such as painting, sculpture, photography, or a tree in the moonlight. Though the introvertive experience may be the more important in the history of mysticism and human thought, the extrovertive is far more important and relevant to the arts—almost to the exclusion of the introvertive.

Not only art objects trigger this response; certain experiences in nature can also trigger the experience in receptive persons. Just the experience of walking alone in the evening elicited this response from Bede Griffiths: "It is as though a veil has been lifted and we see for the first time behind the façade which the world has built around us. Suddenly we know that we belong to another world, that there is another dimension to existence" (Griffiths 1994, 84).

John Dewey is one of America's most respected philosophers. His *Art as Experience* has had a lasting effect on the view that critics and artists hold about the relationship between art and the aesthetic experience. Dewey likens the aesthetic experience to confronting a divine presence. He cites the experience of acacia trees in the moonlight, as related to him by a friend, to demonstrate the close relationship between a religious "ecstatic communion" and an "acute aesthetic surrender":

> The loose feathery foliage on moonlight nights had a peculiar hoary aspect that made this tree seem more intensely alive than others, more conscious of me and my presence. . . . Similar to a feeling a person would have if visited by a supernatural being if he was perfectly convinced that [the being] was there in his presence, albeit silent and unseen, intently regarding him and divining every thought in his mind. (Dewey 1934, 28)

One of the best of the geometric painters in the 1930s, Joseph Stella, described his experience with a painting in remarkably similar terms to those

1. "There appear to be two main distinguishable types of mystical experience. . . . One may be called extrovertive mystical experience, the other introvertive mystical experience. Both are apprehensions of the One, but they reach it in different ways. The extrovertive way looks outward and through the physical senses into the external world and finds the One there. The introvertive way turns inward, introspectively, and finds the One at the bottom of the self, at the bottom of the human personality" (Stace 1969, 15).

used by Dewey's friend. Stella said he "felt deeply moved, as if on the threshold of a new religion or in the presence of a new Divinity" (Ashton 1985, 105). Malevich claimed he saw the face of God in his black square (Gablik 1984, 21). And Mircea Eliade writes: "But for those to whom a stone reveals itself as sacred, its immediate reality is transmuted into a supernatural reality. In other words, for those who have a religious experience all nature is capable of revealing itself as cosmic sacrality."[2]

Charles Morgan, who knows the theater well, tells us that "every playgoer has been made aware now and then of the existence in the theatre of a supreme unity, a mysterious power, a transcendent and urgent illusion, which so to speak, floats above the stage action and above the spectator . . . endowing him with a vision, a sense of translation and ecstasy, alien to his common knowledge of himself" (Langer 398, 63). Clive Bell often mentions the aesthetic experience and he too equates it with religion, as had those who wrote about aesthetics from Gautier to Wilde and Whistler: "The physical and material, for artists and mystics alike, served only as a 'means to ecstasy'" (Twitchell 1987, 81).

Paul Tillich is the most influential of the modern neoorthodox, philosophical theologians who have attempted an alliance of faith with a depth of reason. He has written extensively on aesthetics and specifically on the aesthetic experience as evidenced in the arts. He asserts that we encounter this experience in Chinese landscapes, in the background of Asiatic and Western paintings, and it is the primary element in the impressionist dissolution of particulars into a continuum of light and color. He insists this quality has been carried through into nonobjective painting, and the work of the 1950s was dominated by it. (This is even more true of the work of the 1960s.) "Of course," Tillich reasons, "one cannot show ultimate reality directly, but one can use basic structural elements of reality like line, cubes, planes, colors, as symbols for that which transcends all reality—and this is what the nonobjective artists have done" (Tillich 1984, 227).

Three bodies of work that I believe are the most efficient in stimulating the aesthetic response are Gothic cathedrals and the paintings of El Greco and

2. Eliade 1975, 141.

Mark Rothko. I use the term "efficient" because more people seem to be sensitive to these examples than to any other. Gothic cathedrals were intentionally designed to create what Christian worshipers would interpret as a Christian religious experience. These cathedrals are much larger inside than Americans can easily understand. Though we have enclosed large functional spaces for sports, Americans have never enclosed large spaces for purely aesthetic reasons. We insist that our space be mostly functional. Americans, given the chance, would quickly cut up all the "useless space" of a Gothic cathedral into hundreds of condominium apartments, offices, or small shops.

These European cathedrals are so large that birds live in many of their interiors—permanently. The interiors rise in one uninterrupted gesture straight up from the floor, as high as thirteen stories. The first six or seven stories are rather dark, affording little opportunity for light to enter. Then, suddenly, delicate structural supports allow the enormous curtain walls of stained glass to enclose almost all the upper stories. Many varieties of colored light enter these upper stories where it mingles and mixes to form one giant ball of light.

When the light is just right it forms a near palpable ball of light hovering far above the tiny mortals standing in the aisle. A luminous living entity. It can, and was intended to, become a facsimile of divinity, the very simulacrum of God.

Working in tandem with this heavenly light show are several tricks of perspective that further disorient the viewer from visual reality. For example, the side walls do not rise straight toward the roof in exact parallels as we would expect. The walls are slightly farther apart at the top than they are at the bottom. This reverse perspective eliminates the expected convergence that is normally caused by linear perspective. This not only disorients the viewer from the normal perspective of visual reality but at the same time it also creates the sensation that the viewer, now a participator, is much smaller than usual. Hence the participator feels astronomically insignificant in relation to this house that is visibly inhabited by God—the entity of light hovering above.

This feeling of insignificance often generates a sensation of unity with the universe. Participators sense that they are insignificant but eternal atoms in

the abiding tapestry of the universe—at once indispensable, yet indistinguishable from all other atoms. This sense of cosmic unity and insignificance is like the feeling some have when looking up at a blanket of stars on a clear night far away from the city, but such a sensation indoors is unexpected and even more disorienting. These cathedrals were designed to give the worshiper a religious experience, a genuine sense that they were standing in the presence of a living loving God, and they were exceedingly efficient in the service of this purpose.

The aesthetic experience that has been discussed so far is the strongest version of all extrovertive alternatives—the realization of and communion with the reality of a powerful universal consciousness or divine being. But the experience does exist in different strengths and varying degrees. It extends from this zenith, which leaves no doubt as to its truth or its reality, to, at the opposite end, a gentle glimmer of awareness, which may be so subtle as to make the viewer question whether it has happened. Some viewers may be left wondering, in retrospect, whether they have had a legitimate response or if they have only imagined it.

At this ephemeral and delicate state of the aesthetic, artworks are often described as meditative. Rene Parola, for instance, writes that minimal artworks "demand a viewer who wants to take the time to contemplate and be rewarded with a quiet depth of feeling that *borders on* the mystic" [emphasis mine] (Parola 1969, 130).

The next step up might be described as the decided sensation that a work of art is "alive." Viewers may feel what is often described as a sense of living presence in the work. The painter Frank Stella explains that this sensation "occurs in the unrecoverable moment when the artist looks at what he has made and sees it as alive. This assertion will no doubt be dismissed as a delusion; but remember that it is the mechanism of art that is being described here, and this mechanism successfully accounts for what exists and what endures" (Stella 1986, 126).

Closely related to this sensation is the conviction that the work is a living entity, an undeniable presence like that of another person. Such works may seem to have their own "territorial imperative," and it may even seem that a

violation of that territory would be insensitive, like standing too close to another person—in effect, violating their psychological territory. Hiram Williams explains that some paintings confront the viewer; the image is a presence, "a personage, almost a creature looking at the viewer. Stand before a Rothko [many who write about this aspect of art mention Rothko] or a Rembrandt portrait, and I think you'll find that they have this in common" (Williams 1963, 50). And Rothko told Murray Israel that "he wanted [to create] a presence, so when you turned your back to the painting, you would feel that presence the way you feel the sun on your back" (Breslin 1993, 275). The ceramist Cecilia Cunningham feels that "the life of art is not only a quest but a communication about the process of the quest for that deeper feeling of presence" (Cunningham 1984, 11).

John Dewey tells us the aesthetic experience is global: "the aesthetic quality is the same for the Greek, Chinese and American" (Dewey 1934, 331). Early in its history, Dewey also says, the Catholic Church noticed there was little difference between the aesthetic experience and the religious experience, and it used the aesthetic experience pervasively to strengthen the faith of Christians: "sculpture, painting, music, letters were found in the place where worship was performed." (329). He reasons that "because of the aesthetic strand, religious teachings were the more readily conveyed and their effect was the more lasting. By the art in them, they were changed from doctrines into living experiences" (329). The fact that "the church was fully conscious of this extra-esthetic effect of art is evident in the care it took to regulate the arts" (329).

Mark Rothko's mature work is the second of the more easily achieved aesthetics in art. His series of paintings feature little more than a few blurry soft rectangles, and they have probably actuated more aesthetic experiences than any Western painter since El Greco. It is worth noting that both El Greco and Rothko used the same successful format—as have many others.

El Greco often painted two semirectangular scenes: one "real" earthly scene occupying the bottom of the painting and another heavenly or visionary scene occupying the top half of the painting. Each scene appears to be viewed from a different angle: the bottom scene is viewed at eye-level, while the upper scene

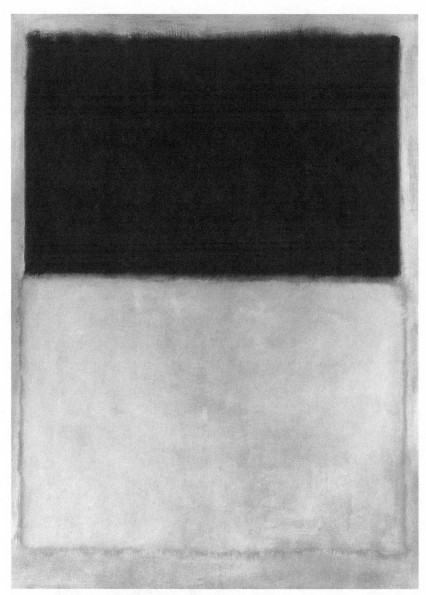

Mark Rothko, b. Dvinks, Russia, 1903, New York, N.Y., 1970. *Green and Tangerine on Red,* 1956. Acquired 1960. Oil on canvas 93½ x 69⅛". Signed and dated on reverse. Acquired 1960, the Phillips collection, Washington, D.C.

Blind Dancers

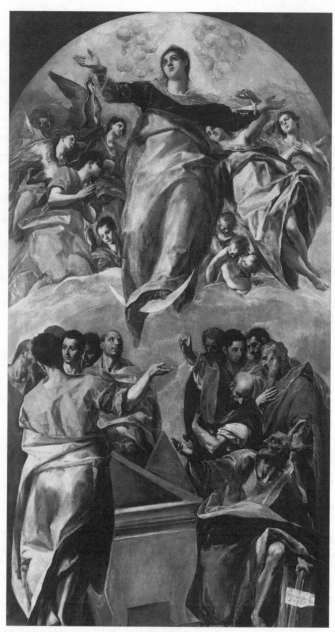

Domenico Theotokópoulos, called El Greco. Spanish, 1541–1614.
The Assumption of the Virgin, oil on canvas, 1577, 401.4 x 228.7 cm.
Gift of Nancy Atwood Sprague in memory of Albert Arnold Sprague, 1906.99.

Advice to Young Artists

is represented in worm's-eye view. The top rectangle hovers above the viewer and moves back and forth in space according to the viewer's interpretation of the scale. That is, the figures may be read as small figures in front of the picture plane, life-size figures on a plane with the earthly scene, or as giant immortals who are positioned far in the distance. This image was supplemented by the silvery moonlight quality that El Greco created by shading from pure hue in the shadows to tints in the highlights, and in his later paintings, by the consistency of the archetypal flame-like schema with which he often represented hands, figures, and other images in his paintings.

To avoid a fundamental solipsism, I will not list categories of effects that create the aesthetic, partly because I don't think I could and partly because I would not want to dissect and explain it to the point that all the magic was removed. Furthermore, I want to make it absolutely clear that this experience cannot be explained or *understood* intellectually any more than sexual congress can be explained to, or understood by, a prepubescent child who has had no sexual urge or experience.

I hope to accomplish two things in this chapter: to corroborate its existence to those who may have had a similar experience and to explain what it is not to those who have not had such an experience. Otherwise, many who have had such an experience but have met no one else who understands it may come to doubt their own reality if they have no one to discuss it with. And some may mistake another experience for the aesthetic.

My purpose here is not to explain this ineffable experience. But I will go so far as to venture that such an aesthetic in Western society often (but not always) seems to be actuated by a spatial illusion of some kind, particularly an illusion that disorients viewers from everyday reality.

Susanne Langer contends that "there are dance forms that serve mainly to sever the bonds of actuality and establish the 'otherworldly' atmosphere in which illusory forces operate" (Langer 1953, 192). Later she continues: "In the early stage of human thought when symbol and import are apprehended as one reality, this image [of a world of vital forces] is the realm of holiness; in later stages it is recognized as the work of art, the expressive form which it really is" (193).

Blind Dancers

Sir Herbert Read writes that Western society's consuming interest in space is a result of their search for transcendence, and humankind could only have developed a sensibility for space as a result of its many creative activities. He insists that the consciousness of space was a by-product of a numinous awareness. But what is it in the creative process, Read asks, that "leads on the one hand to an ethical immanence, a *place* sensibility, and on the other hand to a religious transcendence, a *space* sensibility?" (Read 1955, 64).

Sometimes illusion functions to spatially disorient the participator from reality. In Gablik's words: "The new role of the artist demands that he construct perceptual fields which offer a disorienting experience to the perceiver" (Gablik 1977, 157). This disorientation sometimes creates a feeling that solid objects are disembodied. In this mode art often makes an apparently solid mass appear elusive and ephemeral. This can sometimes be done in craft or sculpture as well as in painting.

Sometimes the aesthetic is due to an apparent spatial hovering (I don't know how else to explain it), the illusion that a mass tends to hover back and forth in space, as the upper part of some of the El Greco and the Rothko paintings do. Eliade explains: "For religious man, space is not homogeneous; he experiences interruptions, breaks in it; some parts of space are qualitatively different from others" (Eliade 1975, 143).

Mark Rothko uses all three previously mentioned devices in his paintings: disorientation, disembodiment, and spatial hovering. William C. Seitz, who combined the sensibilities of an excellent practicing artist with the discipline and rigor of an art historian, knew Rothko well. He interprets Rothko's paintings as fulfilling at least two of these criteria. He explains that the pictorial space in these paintings extends deep into the background. For the first time in modern nonrepresentational art, Rothko does not block off recession into depth. Relinquishing both flatness and depth as an overt aim creates a new quality of space: color areas are free to move into pictorial depth unimpeded; they may even leave the surface and advance:

> Thus the picture plane cannot be seen as a simple equivalent of
> the canvas surface, though intermittently one or more of the areas
> appear strikingly dense and impenetrable as a mass of concrete; but

as the eye moves upward or downward—the only directions that the balanced format will permit—the spatial and the physical effects shift, and what was mass becomes mist. (Seitz 1983, 53)

Seitz has offered an excellent description of spatial hovering. This is the way James Breslin explained the work titled *Number 10* (1950) in his recent biography of Rothko:

> At first we are drawn to the dramatic yellow rectangle—by its intense, glowing color, its greater size, its dominant position. The rectangle contains—nothing—and so, weightless, it rises and floats out from the picture plane toward the viewer. Yet its golden surface is also translucent and we look into this spacious rectangle—like looking into the sun. (Breslin 1993, 277)

Breslin has just described the disembodiment of material shapes. He ends two pages of such description with the observation that "the opposition between flatness and depth, like that between substance and void, collapses in an ambiguous space where shapes cannot be firmly bound, easily located, or securely identified" (278).

Writers have often commented on the fact that so many viewers insist they have felt "confronted" by Rothko's painting: many viewers have even been known to break down and cry in the presence of these paintings. When Selden Rodman asked about this phenomenon, Rothko replied: "The people who weep before my pictures are having the same religious experience I had when I painted them. And if you, as you say, are moved only by their color relationships, then you miss the point!" (Rodman 1961, 93–94). And to Robert Motherwell he argued that "ecstacy alone was it; art is ecstatic or it's nothing" (Breslin 1993, 333).

Though he arbitrarily chooses to assign an ethnic flavor to the experience, John A. Walker says that Barnett Newman's paintings also have this quality, "no matter how 'minimal' or 'abstract' his paintings may appear they are always suffused with content; in particular with notions of the sublime and with Jewish mysticism" (Walker 1975, 5).

Hiram Williams notes insightfully, however, that Rothko can have no rec-

ognized followers in painting because his "is a single, pure idea, completed, realized" (Williams 1963, 67). I would extend this sense of realized completeness to each of his paintings and suggest that in continuing to produce similar images, Rothko, in a sense, became his own follower. His direction and image are difficult to explore further; because he knew only one way to elicit this mystical response, he must have felt as if he were painting the same painting again and again with little more than changes in color scheme.

Gottlieb also used a similar formula adapted to a horizontal image, a longer horizontal canvas with a neatly contained circular shape on one half and a loosely painted rough approximation of a circle on the other. He must have felt the same sense of repetition. Barnett Newman and Jules Olitski extended the atmospheric qualities and possibilities of Rothko's image, and they must also have been familiar with this sense of redundant frustration. El Greco, however, painted entirely different arrangements of figures within the bounds of his formula. Furthermore, his later flame-like images did not depend on this formula. Hence, he was free to paint entirely different paintings each time he picked up a brush.

A few artists after 1980—even though art in general has changed its primary direction, emphasis, and structure—still continue to pursue the aesthetic experience. Julian Schnabel, when talking about his intentions, said he wanted to generate a feeling of God in his work. And Suzi Gablik, even from her Marxist perspective, while still questioning Schnabel's spiritual integrity, grudgingly admits that his work does seem "to aspire to a numinous dimension" (Gablik 1984, 90–91). From her Marxist point of view, Gablik defines "spiritual" art as that which improves society; hence she has decided that the works of transcendental artists such as Helen Frankenthaler, Morris Louis, Kenneth Noland, and Jules Olitski "are *only* aesthetic" (22). But even Gablik admits to the importance and the permanence of the mystical aspect of art: "The kind of sacramental vision to which I am referring is not that of routine church-going or religious dogma as such, but a mode of perception which converges on the power of the divine. . . . However much we ignore, camouflage, or degrade art's "sacred elements," they still survive in the unconscious," (92–93).

I perceive this aesthetic quality in the work of many of the best artists, par-

ticularly in those retinal artists who work in the tradition that extends from the Italian Renaissance through impressionism to modern art. Postmodern signing artists, however, are descended more from the medieval and Dutch line in art.[3] Italian artists sought the aesthetic experience through the elements of illusion, perception, and divine beauty, but medieval, Dutch, and postmodern artists often focused on iconic signs, the Apocalypse, Hell, ugliness, and death. On the first page of the first chapter of his seminal book *The Postmodern Turn*, Ihab Hassan (whom Lyotard gives credit for coining the word "postmodern,") tells us that an important characteristic of postmodernism is "the voice of the apocalypse" (Hassan 1987, 3).

I do not perceive a numinous presence in most of even the best of the retinal artists' work. I detect it in only a few pieces. But I am not certain whether this is due more to my own receptivity at the time of viewing or to the potential of the painting. It is also true that no artist succeeds in capturing this quality in every painting. Many artists may capture it in only a few paintings. Some artists, Rothko for instance, find only one way to approach the experience, and their work may become repetitive.

Artists often show certain works just because they are fine paintings in some other sense, even if they do not achieve this aesthetic quality. The aesthetic experience is one of the most important and lasting elements in art, but it is not the only important or lasting element. Signing artists often ignore the aesthetic effect to pursue other avenues, and many of them intend to be judged more on a literary basis, as Hogarth did, than on a retinal or aesthetic basis, but in some of the best art in any period there is some implication of the aesthetic experience. Even some of the postmodern signing painters achieve this quality. Anselm Kiefer's work, for instance, sometimes captures this quality.

Several writers believe that tribal societies once lived in a constant "state of grace." This awareness of unity with the world was lost when humans grew out of their tribal societies and gained individual consciousness (which Americans celebrate).[4] David Cooper explains that "the origin of human consciousness is often described as the inception of ego awareness. And ego,

3. For a complete explanation of this idea, see Dunning 1995.
4. See chaps. 11 and 12 in Dunning 1955.

by definition, was constructed by erecting presumed boundaries between the self and all that was not self. This artificial boundary leads to a sense of duality and separateness" (Cooper 1994, 7).

We live in a fractured world of separateness, but tribal societies lived in a unified world. When Columbus first met the indigenous peoples of the Americas, he described them as a gentle "people living in a state of grace." This sense of ourselves as separate individuals that we gained with the advent of "civilization" is what tends to separate us from the experience of unity with the world around us. Art is one of many paths to the rediscovery of that archetypal unity.

The ability to respond to this quality in painting is not given to every civilized human, though I believe most can be trained to it through one discipline or another. Eliade contends that "after the 'second fall' (which corresponds to the death of God as proclaimed by Nietzsche) modern man has lost the possibility of experiencing the sacred at the conscious level, but he continues to be nourished and guided by his unconscious" (Eliade 1985, 82–83).

I find that most serious art students, after three or four years of competent discipline and training, do become aware of this quality, even when it is fairly weak, though they tend to be more certain of it in others' work than in their own. Perhaps the most important thing in the training of this awareness is to develop the full intellectual and intuitive understanding of the entire painting as an image (even if it is a fragmented image), as opposed to seeing separate images *in* the painting. Beginning viewers and painters tend to see separate images in the painting as if the painting were a photograph of interesting objects; they focus on the objects, not the photograph.

The development of this aesthetic awareness can also be achieved through structural competencies, self-discipline, and the efficient training of sensitivities to formalist elements such as proportion and pictorial space. John Dewey holds that the enemies of the aesthetic are not the practical nor the intellectual concerns, as many believe. The real enemies are "the humdrum; slackness of loose ends; submission to convention in practice and intellectual procedure. Rigid abstinence, coerced submission, tightness on one side and dissipation, incoherence and aimless indulgence on the other, are deviations in opposite directions from the unity of an experience" (Dewey 1934, 40).

Advice to Young Artists

Even when viewers are aware of, and sensitive to, the aesthetic experience, they may seldom encounter it. They may well be able to sense it in some kinds of paintings and not in others. They may be able to achieve the experience in the presence of a particular painting one time, yet not be able to do so a day or a week later with the same painting. Not only may it take years of interest and participation in a discipline for some people to achieve this sensitivity, but it sometimes also requires some kind of preparation immediately before the confrontation.

The kind of preliminaries that I find most efficient are those that tend to make viewers more passive and less preconceived in their expectations. When viewers bring their own expectations to a painting, they short-circuit the aesthetic process. If they are judgmental in their primary encounter with the work, they are likely to perceive only what they expect to see. For instance, if they believe all good painting is well composed in dark and light, they will come to the painting looking only for this and will not then be able to respond to any experience that is not structured in this manner.

Richard Egenter, in *The Desecration of Christ*, explains that even those who are receptive to religious ecstacy may search for another interpretation, Freudian for instance, and thus block the aesthetic experience before it has a chance to assert itself (Egenter 1967, 28). Consequently, viewers, as well as artists, must learn to approach art with the courage of a blind dancer, willing to follow where the art leads them, undaunted by the discoveries and the obstacles they might encounter.

Perhaps the most common and the worst of all the preconceptions and prejudices that block the aesthetic experience is the attitude that anything worthwhile must demonstrate skill in execution and difficulty of technique. This attitude nullifies the artist's intention to make the difficult appear to be spontaneous and easily done. Nijinsky leapt as no one else has leapt, but he made it look so easy that viewers believed they could do it too.

The focused conscious mind has a low threshold for boredom. Any sustained effort at analytical activity that intensely focuses the conscious mind, such as chess, math, or simply hours of analyzing paintings, tends to exhaust the mind's ability to continue to do so. Perhaps it was no accident that Duchamp was a chess master. Because chess is an intensely focused logical

activity, several hours of chess fatigues the conscious mind and leaves the unconscious in control.

Experiments with air traffic controllers indicate that only the first half hour or forty-five minutes of watching the radar scope is dominated by focused conscious (or left brain) mental activity. After that, the conscious abdicates to the unconscious unfocused mind (the right brain). The peripheral or unfocused mind is not susceptible to fatigue. It remains active even when we sleep. When the ability to concentrate is worked to the point of exhaustion, the unconscious takes charge, and the viewer is left passive and susceptible.

Analysis can be a handy weapon in the artist's arsenal. Too many artists condemn the logical and the analytical with one blanket prejudice. Once the nonanalytic, visual determination is made that a work is unsuccessful, an artist can then analyze what might be done to improve it. But the initial judgment must be made visually, not analytically. Analysis must be the servant, not the master. The Ex-Lax theory of art is: If it moves you, it's working. If an artwork moves the viewer it is foolish to charge compositional weakness or lack of cohesiveness.

Perhaps my account might be of service at this point. When I was in graduate school working on my second master of fine arts degree, I went to Chicago to interview for a university teaching position. The interview was over by nine o'clock, and my train would not leave for Champaign-Urbana until eight that evening. I decided to spend the day at the museum at the Chicago Art Institute. An exhibit of Young American Painters hung there at the time, and I decided to spend the entire day with those paintings.

I had learned to respond strongly against what I considered "gushing" about art—meaningless rhetoric designed more to impress the listener with the speaker's sensitivity than to communicate any real insight. I avoided those who spoke of art in the manner that wine tasters speak of wine: "Umm, nice nose. I'm titillated by its coquettishness, but I'm angered by its arrogance." As the poet Llewelyn Powys advised his young friend, "Do not talk nonsense about 'inspiration'" (Powys 1969, 26). I wanted to talk about reality in art the way physicists speak of reality in science. A trained formalist at the time, I believed that if an artwork was successful, the qualities that made it so could be explained if the speaker were competent.

I went through the exhibition at the museum that day in Chicago analyzing each painting as I came to it. Like a well-trained formalist, I analyzed each in terms of pictorial space, dark-light composition, spatial composition, proportion, multiplicity and unity, value control, sensuosity of surface, painterliness versus linearity, and so forth.

Each time I came to Rothko's painting I looked at it briefly, found nothing I was predisposed to find, dismissed it, and went quickly to the next painting. I had previously seen many reproductions of Mark Rothko's paintings, but I had never before seen one "in person," so to speak. When students showed me reproductions of Mark Rothko's paintings and asked what I thought of them, I explained, with all the hubris of youth, that they were decorative, nothing more than furniture. They would go nicely, I explained with a cruel critic's wit, in a roomful of Danish modern furniture.

I examined each painting in the exhibit with the same expectations, looking for the same set of criteria. I did not understand at the time that I was, in a sense, judging these paintings on craftsmanship. I judged them as to how well they fulfilled a preconceived (and arbitrary, I later came to realize) set of standards. Like all good modernists at the time, I believed these standards to be timeless and "universally" applicable to all art. It is especially this claim to universality that postmodernists most dislike about the modern point of view.

I analyzed paintings till noon. My head literally hurt. I could hardly think anymore. I went to the cafeteria in the basement, had lunch, and relaxed for half an hour. Then I went back to the exhibit and started analyzing again. The more fatigued my mind became, the more I disciplined myself to continue analyzing. Finally, after more than six hours of rigorous analysis, my conscious mind (or left brain, or focused attention, whatever you want to label it) was entirely fatigued. It literally felt flabby and unresponsive. Like a muscle pushed past exhaustion, my mind refused to respond to directions. But I believe in periods of acute immersion and wanted to continue. I decided to just stand passively in front of each painting, without thinking, and see if any of them would "do something" to me.

I stood in front of several paintings, one after the other. Perhaps I felt something from two of them that I had not felt before, but the sensations were subtle. Probably my active imagination, I decided.

Blind Dancers

Then I stood in front of the Rothko.

All my previous preconceptions and expected criteria were gone now. I stood for the first time as a totally passive viewer, experiencing an artwork entirely visually and unconsciously rather than searching for the elements that I believed all art possessed.

I literally felt the presence of God.

Though I am (and was then) in no sense a Christian, that presence was as real an experience as my experience of any other phenomenon, a table, a woman, or pain. The experience was not in the least visual: I saw no glow, no hovering persona, no induced intense color. The experience was quite calm, even mild. But for the first time I understood that God, if it existed, was no person. God was an awareness, an enlightenment. The question as to the gender of God had absolutely no relevance. God was no longer a big white-haired Santa Claus father figure in the sky somewhere. Perhaps this is why some religions frown on speaking the name of God; to name is to personify and to personify is to be deceived. On Mount Sinai, when Moses asked God what he should tell his people when they asked for the name of God, God said: "I AM THAT I AM." God then told Moses to tell his people that "I AM hath sent me to you" (Exod. 3:14).

In Rothko's painting I sensed the presence of the consciousness of all the other people in the world, alive and dead, all mixed into one giant nonegotistical blend—like blended fruit juices wherein the taste of no specific juice can be identified out of the overall flavor. This experience, I later found, has no geographic or chronological boundaries. It is often described as "a universal pool of consciousness." Furthermore, I think this experience is perhaps the source of the modernists' belief that there is such a thing as a universal aesthetic. Perhaps what they miss is the fact that persons in different cultures may be stimulated to this experience through entirely different means.

The best analogy for this universal pool of consciousness that I can come up with is that of a lit match: If I light a match it gives off heat. When I blow the match out, that heat does not disappear; it dissipates but the heat still exists. The heat is then spread over so large an area that I can no longer find it nor distinguish it from its environment. Still it exists. But in a match-lighting ceremony, when tens of thousands of matches are lighted, perhaps, after

Advice to Young Artists

all the matches are extinguished, some may be able to sense the existence of a collective pool of energy.

Perhaps as an explanatory heuristic device (not as truth) I can assume that our consciousness is like this. While we live we create energy. The source of this energy is in one spot and easy to detect, even though it is constantly being dispersed into the atmosphere. Once entirely dispersed and mingled with the energy of all others, the energy or consciousness from any single person, living or dead, is impossible to detect. But if we become sensitized to the collective energy of the billions that have lived on earth, it may be possible to become aware of it.

Raised a Southern Baptist, I had moved away from religion. I had become an avowed atheist, as certain of this as I was of the effability of art. Perhaps I interpreted the Rothko experience as God because of my early training and my expectations. Remember: Walter Stace has told us that even though this experience is objective, the interpretation of the experience is entirely subjective, and, furthermore, such an experience will convince anyone of the existence of their particular God, whether they are Christian or fireworshiper. I returned to church. I decided that perhaps I had missed the message when I attended at a younger age. I visited several different churches and several different denominations, but I soon learned that they did not in any way seem to acknowledge the experience that interested me.

I think it is useful to examine how this happened to me on that day. It happened only after several years of discipline and years of training my visual sensitivity. Furthermore, it happened after hours of straining, draining, and fatiguing the left brain—the part of the brain that is responsible for daytime consciousness. The left brain handles such things as linear time awareness, verbal activity, reason, and logic. This part of the brain is more active in the daytime.

The right side handles such activities as the awareness of the body in space, music, poetry, and art. Perhaps this explains why many artists prefer to work later in the day and evening, even through the night, when the left brain is less active. (The art building where I teach is nearly empty in the mornings on weekends, but it is active through most of every night.)

Intense conscious analytical mental activity tires the left brain and leaves

Blind Dancers

the right in control. I have at times had long analytical discussions or played chess for several hours before painting. When I do so, my sense of time seems to disappear when I paint, and interesting images seem to appear in my paintings by accident far more often than they do normally. This preparation by fatiguing the left brain perhaps made me so susceptible to Rothko's painting on that day. I have seen a few paintings by him after this. Some of them seemed to generate a subtle glimmer of that first experience. Some of them did nothing. I do not know whether this is because some of his paintings are less successful at generating this response than other paintings are, or because I have not been so receptive since. Perhaps some of both.

That was the most powerful experience of that kind I have ever had, though I have felt varying degrees of it with other artworks, and with two phenomena in nature: Mount Rainier above Paradise lodge and the Grand Canyon. But the number of experiences seems to be unimportant. I do not crave repetitions of the experience. The aesthetic has a sense of the eternal about it. Once is enough.

Ric Dragon is a friend that I met on the Internet, a painter who lives in Chichester, New York. After reading this chapter he sent me the following note through E-mail.

> When I was studying with Nicolas Marsicano at State University of New York at Purchase, I was obsessed with "presence" in painting. One day at the MoMA, I stood and looked at some of Rothko's paintings in an insistent attempt to "get it." Finally it hit me; but it was like someone grabbing me by the scruff and holding me against the wall. I rushed out of the Rothko room back to the Matisse room. Ah! Soothing. Back to the Rothkos. I repeated the process a couple of times for good measure.
>
> Marsicano was old, and was to die only a couple of years later, but he had known Rothko back in the 40's and 50's. When I saw him the next day, I said: "Isn't it wonderful what these Rothkos do!? Why don't the Matisses do it?"
>
> He replied: "Sometimes you ask questions you've got no right to ask!" ⟡

Advice to Young Artists

Bibliography

Adler, Judith E. 1979. *Artists in Offices: An Ethnography of an Academic Art Scene.* New Brunswick, N.J.: Transaction Books.

Albers, Josef. 1963. *Interaction of Color* (text volume). New Haven, Conn.: Yale Univ. Press.

Arnheim, Rudolf. 1989. *Thoughts on Art Education.* Los Angeles: Getty Center for Education in the Arts.

Arvey, Richard D., et al. 1994. "Mainstream Science on Intelligence." *The Wall Street Journal.* Dec. 13, A18.

Ashton, Dore. 1985. *Twentieth-Century Artists on Art.* New York: Pantheon.

*Best, Steven, and Douglas Kellner. 1991. *Postmodern Theory: Critical Interrogations.* New York: Guilford Press. This is the best and most elaborately summarized review of postmodern authors and ideas that I have found. It condenses and surveys what the best of the poststructuralists have written and what that writing means.

Blackmore, R.L. 1969. In his footnotes to *Advice to a Young Poet: The Correspondence Between Llewelyn Powys and Kenneth Hopkins.* By Llewelyn Powys. Edited by, R.L. Blackmore. Cranbury, N.J.: Associated Univ. Presses.

Bottom Line: Personal. 1994. 15, no. 14 (July 15): 11.

Bowen, William G., and Julie Ann Sosa. 1989. *Prospects for Faculty in the Arts and Sciences: A Study of Factors Affecting Demand and Supply, 1987 to 2012.* Princeton, N.J.: Princeton Univ. Press.

Breslin, James E.B. 1993. *Mark Rothko: A Biography.* Chicago: Univ. of Chicago Press.

Brommer, Gerald F., and Joseph A. Gatto. 1984. *Careers in Art: An Illustrated Guide.* Worcester, Mass.: Davis Publications.

Brown, Marilyn R. 1985. *Gypsies and Other Bohemians: The Myth of the Artist in Nineteenth-Century France.* Ann Arbor, Mich.: UMI Research Press.

Bryson, Norman. 1981. *Word and Image: French Painting of the Ancien Régime.* London: Cambridge Univ. Press.

Entries marked with an asterisk (*) stress concept and idea; entries marked with a dagger (†) deal with the realities of the world.

†Burnham, Sophy. 1973. *The Art Crowd.* New York: McKay. This book demonstrates the realities of the art world and gallery scene more completely and forthrightly than any other I have read. I found the following chapters particularly interesting: "Dealers of Art," "The Marketplace," "On Reputations: Relations with the Artist," "Critics of Art," "Do Critics Deal."

Chevreul, M.E. 1890. *The Principles of Harmony and Contrast of Colours.* 3d ed. Translated by Charles Martel. London: Bull.

*Collingwood, R.G. 1961. *The Principles of Art.* New York: Oxford Univ. Press. An excellent early (1938) non-Saussurean yet linguistic approach to art in the tradition of Benedetto Croce. Most of the concerns that Collingwood examines in this early book, written long before the term postmodernism had been coined, are relevant to the concerns of postmodernism.

Cooper, David A. 1994. "Invitation to the Soul." *Parabola: The Magazine of Myth and Tradition* 19, no. 1 (Feb.): 7.

†Crawford, Tad. 1981. *The Visual Artist's Guide to the New Copyright Law.* New York: Graphic Artists Guild (30 East Twentieth Street, New York, N.Y. 10003). This book will answer all your questions as to how to copyright your work and the necessity of doing so.

*Culler, Jonathan. 1986. *Ferdinand de Saussure.* Ithaca, N.Y.: Cornell Univ. Press. Saussure is the father of modern linguistics, and his ideas are the foundation of the postmodern concern with linguistics that forms the basis of all the new critical strategies: structuralism, poststructuralism, deconstruction, revisionism, and semiotics. You may find it difficult to make sense out of many of the current writings in art if you are not familiar with Saussure's ideas, and this book is the best introduction to his ideas.

Cunningham, Cecilia Davis. 1984. "Craft: Making and Being." In *Art, Creativity, and the Sacred: An Anthology in Religion and Art,* edited by Diane Apostolos-Cappadona. New York: Crossroad.

Dhanens, Elisabeth. 1973. *Van Eyck: The Ghent Altarpiece.* Edited by John Fleming and Hugh Honour. New York: Viking.

De Coppet, Laura, and Alan Jones. 1984. *The Art Dealers.* New York: Clarkson N. Potter.

Dewdney, A.K. 1985. "Computer Recreations." *Scientific American* 253, no. 2 (Aug.): 16–21.

Dewey, John. 1934. *Art as Experience.* New York: Minton.

*Dunning, William V. 1991. *Changing Images of Pictorial Space: A History of Spatial Illusion in Painting.* Syracuse, N.Y.: Syracuse Univ. Press. This book might well have been titled *The Roots of Modern Art.* Selected by *Choice* magazine as one of the outstanding academic books for 1992, this is a history of the illusion-

istic aspects of painting from the Greco-Roman period through modern art. It traces the six major elements of illusion over two thousand years and demonstrates how periodic changes in society's priorities affect science, philosophy, and the image of pictorial space in painting. It demonstrates that modern art was an extension of the painterly concepts and topics of interest that were initiated in Greco-Roman art and further developed during the Italian Renaissance and impressionism. This book is an explanation of the formal elements in painting and a history of their development and influence. It is a history of the relationship between painting and reason.

*———. 1995. *Roots of Postmodernism.* Englewood Cliffs, N.J.: Prentice-Hall. This book is the exact opposite perspective of *Changing Images of Pictorial Space.* This is a history of the linguistic aspects of painting, and it demonstrates that postmodern art was an extension of the concepts and topics of interest that were initiated in the Middle Ages and further developed in Dutch painting, expressionism, surrealism, and in artists such as Duchamp and Dubuffet. This book is a history of the relationship between painting and the irrational.

In tandem, the two books demonstrate that modernism and postmodernism are not just recent styles in art; rather they are recent manifestations of two opposing traditions that have been with us since the beginning of history. Both of these books are unusual in that they are well-documented art history books intended as much for an audience of artists as for art historians. I believe they will both be of more interest to artists than will most art history books.

Efland, Arthur D. 1990. *A History of Art Education: Intellectual and Social Currents in Teaching the Visual Arts.* New York: Teachers College Press, Columbia Univ.

Egenter, Richard. 1967. *The Desecration of Christ.* Translated by Burns and Oates Ltd., 1959. Chicago: Franciscan.

Eliade, Mircea. 1975. *Myths, Rites, Symbols.* Vol. 1. New York: Harper and Row.

———. 1985. *Symbolism, the Sacred, and the Arts: An Anthology of Religion and Theology.* Edited by Diane Apostolos-Cappadona. New York: Crossroad.

Feldman, Edmund Burke. 1982. *The Artist.* Englewood Cliffs, N.J.: Prentice-Hall.

Freud, Sigmund. 1947. *Leonardo da Vinci: A Study in Psychosexuality.* New York: Random House.

Gablik, Suzi. 1977. *Progress in Art.* New York: Rizzoli.

———. 1984. *Has Modernism Failed.* New York: Thames.

Gardner, Howard. 1983. *Frames of Mind: The Theory of Multiple Intelligences.* New York: Basic Books.

Gauguin, Paul. 1978. *The Writing of a Savage.* Translated by Eleanor Levieux. Edited by Daniel Guérin. New York: Viking.

Bibliography

*Gerritsen, Frans. 1983. *Theory and Practice of Color.* 1975. Rev. 2d ed. Translated by Ruth de Vriendt. New York: Van Nostrand. This is the best all-around book on color I have found. It is scientifically solid, and it clearly explains and demonstrates, with both photographs and overlapping transparencies, everything most artists will ever need to know about the additive, partitive, and subtractive mixing of color. It explains the theory and the anomalous departures from the theories (especially for the color yellow).

*Getzels, Jacob W., and Mihaly Csikszentmihalyi. 1976. *The Creative Vision: A Longitudinal Study of Problem Finding in Art.* New York: John Wiley. This is a unique long-term study of artists from the sophomore and junior class of the Chicago Art Institute. These students participated in an elaborate set of tests while still in school, then the authors followed their careers for seven years to observe who achieved success and what background, abilities, or character traits seemed to be associated with success in the art field. The first half of the book is quite technical with lengthy explanations of study controls and testing methods, but any young artist will find the observations starting at page 159 exceedingly interesting.

Gilmore, Roger. 1991. "The Evolution of Education for Visual Intelligence." *Design for Arts in Education* 92, no. 6 (July-Aug.):

*Gilmour, John. 1990. *Fire on the Earth: Anselm Kiefer and the Postmodern World.* Philadelphia: Temple Univ. Press. This is an excellent critical examination of the "old master" of postmodernism, Anselm Kiefer.

Grampp, William D. 1989. *Pricing the Priceless: Art, Artists, and Economics.* New York: Basic Books.

Griffiths, Bede. 1994. "Winding the Golden String." *Parabola: The Magazine of Myth and Tradition* 19, no. 1 (Feb. 1994): 84.

Grossen, Bonnie. 1996. "Making Research Serve the Profession." *American Educator* 20, no. 3 (Fall 1996): 7–8, 22–27.

Gruen, John. 1991. *The Artist Observed: Twenty-eight Interviews with Contemporary Artists.* Chicago: a cappella Books.

Guitton, Jean. 1964. *A Student's Guide to Intellectual Work.* Translated by Adrienne Foulke. Notre Dame, Ind.: Univ. of Notre Dame Press, 1964.

Haas, Howard G. 1994. "Lessons in Leadership." *Bottom Line: Personal* 15, no. 8 (Apr. 15): 11–12.

Harris, Joan. 1968. "Report on the Teaching of English in Illinois Public High Schools." In *Current Research in English Teacher Preparation: A First Report* (from the summaries and conclusions of completed special research studies of the Illinois State-Wide Curriculum Study Center in the preparation of

secondary school English teachers), edited by Raymond D. Crisp, 5–6. Urbana: Univ. of Illinois Press.

Hassan, Ihab. 1987. *The Postmodern Turn: Essays in Postmodern Theory and Culture.* Columbus: Ohio State Univ. Press.

Henri, Robert. 1951. *The Art Spirit.* New York: J.B. Lippincott.

Israel, Paul. 1994. "Life Lessons from Thomas Alva Edison." *Bottom Line: Personal* 15, no. 8 (Apr. 15): 13–14.

Jervis, Nancy, and Maureen Shild. 1979. "Survey of NYC Galleries Finds Discrimination." *Artworkers News.* Apr.

Kapleau, Phillip. 1980. *The Three Pillars of Zen.* Garden City, N.Y.: Doubleday.

Kushel, Gerald. 1994. "Peak Performers." *Bottom Line: Personal* 15, no. 6 (Mar. 15): 1.

Land, Edwin H. 1977. "The Retinex Theory of Color Vision." *Scientific American* 237, no. 6 (Dec.): 108–28.

———. 1983. "Recent Advances in Retinex Theory and Some Implications for Cortical Computations: Color Vision and the Natural Image." *Procedures of the National Academy of Science USA* 80 (Aug.): 5163–69.

Langer, Susanne K. 1953. *Feeling and Form: A Theory of Art.* New York: Charles Scribner's Sons.

Lewis, Michael. 1994. "Paint by Numbers: The hype and hypocrisy of the Art Market." *New Republic* 210, no. 17. (Apr. 25): 27–34.

MacFarquhar, Larissa. 1994. "The Department Department." *Lingua Franca: The Review of Academic Life* 4, no. 2 (Jan.-Feb. 1994): 20.

Madoff, Stephen Henry. 1978. "Anselm Kiefer a Call to Memory." *Artnews* 86, no. 9 (Oct. 1987): 125–30.

Medawar, Peter B. 1979. *Advice to a Young Scientist.* New York: Harper and Row.

†Michels, Caroll. 1983. *How to Survive and Prosper as an Artist: A Complete Guide to Career Management.* Rev. ed. New York: Henry Holt and Company. This book offers helpful advice on managing your career. Chapter 5 is the most valuable section; it offers advice about galleries and dealers, and what they may think about you. It also has a good chapter on grants.

Mozart, Wolfgang Amadeus. 1961. "A Letter." In *The Creative Process: A Symposium.* Ed. Brewster Ghiselin, 34–35. New York: New American Library, 1961.

Neville, Cyril. 1994. *Today Show.* June 9.

Newman, Barnett. 1990a. "In Front of the Real Thing." In *Barnett Newman: Selected Writings and Interviews*, edited by John P. O'Neil. Text notes and commentary by Richard Shiff, 195–96. New York: Alfred A. Knopf. First printed in Artnews 68, no. 9 (Jan. 1970): 6.

———. 1990b. "The Plasmic Image" (1945). In *Barnett Newman: Selected Writings*

and Interviews, edited by John P. O'Neil. Text notes and commentary by Richard Shiff, 138–55. New York: Alfred A. Knopf.

———. 1990c. "The Sublime Is Now" (1948). In *Barnett Newman: Selected Writings and Interviews*, edited by John P. O'Neil. Text notes and commentary by Richard Shiff, 170–73. New York: Alfred A. Knopf.

Nielsen, Dennis N. 1993. "A Deming Approach to Promotion and Tenure." Paper presented at the 100th annual meeting of the American Association of Engineering Education, session 2275 (June). Urbana, Ill.: Program Proceedings.

Parola, Rene. 1969. *Optical Art Theory and Practice.* New York: Reinhold.

Penick, Harvey. 1992. *Harvey Penick's Little Red Book: Lessons and Teachings from a Lifetime in Golf.* New York: Simon and Schuster.

"Perspectives." 1994. *Newsweek* 123, no. 11 (Mar. 14): 18–19.

Plagens, Peter. 1994. "School Is Out, Far Out." *Newsweek* (Jan. 24): 64–65.

———. 1996. "Abstract Slant." *Newsweek* (Mar. 4): 68–69.

Porter, Roy. 1994. "Fear and Loathing in Vienna." *The New Republic* 210:8 (Feb. 21, 1994): 39.

*Poster, Mark. 1989. *Critical Theory and Poststructuralism: In Search of a Context.* Ithaca, N.Y.: Cornell Univ. Press. Read chapters 1, 2, 3, 4, 6. This book offers the clearest and most understandable explanation of the importance of the exemplary poststructuralist Michele Foucault, and the evolution and influence of his ideas.

Powys, Llewelyn. 1969. *Advice to a Young Poet: The Correspondence Between Llewelyn Powys and Kenneth Hopkins.* Edited by R.L. Blackmore. Cranbury, N.J.: Associated Univ. Presses.

Preston, John Hyde. 1961. "A Conversation with Gertrude Stein." In *The Creative Process: A Symposium,* edited by Brewster Ghiselin, 164–72. New York: New American Library.

Read, Herbert. 1955. *Icon and Idea.* Cambridge, Mass.: Harvard Univ. Press.

Reynolds, Sir Joshua. n.d. "The First Discourse." In *Discourses Delivered to the Students of the Royal Academy.* Intro. Roger Fry, 5–14. New York: E.P. Dutton.

Rilke, Rainer Maria. 1954. *Letters to a Young Poet.* Rev. ed. Translated by M.D. Herter Norton. New York: W.W. Norton.

Risenhoover, Morris, and Robert T. Blackburn. 1976. *Artists as Professors: Conversations with Musicians, Painters, Sculptors.* Chicago: Univ. of Illinois Press.

Rood, Ogden. 1879. *Modern Chromatics.* New York: Appleton.

Rose, Barbara. 1987. *Robert Rauschenberg: An Interview with Robert Rauschenberg.* New York: Random House.

*Rosenau, Pauline Marie. 1992. *Post-modernism and the Social Sciences: Insights, Inroads, and Intrusions.* Princeton, N.J.: Princeton Univ. Press, 1992. This book presents a view of postmodernism with more clarity than most. It explains the reasoning, the strong points, and the weak points. No need to read the last half of each chapter unless you are interested in the application of postmodernism to sociology.

Seitz, William C. 1983. *Abstract Expressionist Painting in America.* Cambridge, Mass.: Harvard Univ. Press.

———. 1963. *Hans Hofmann.* Garden City, N.Y.: Doubleday.

Selye, Hans. 1964. *From Dream to Discovery: On Being a Scientist.* New York: McGraw-Hill.

Smith, Henry P., and Emerald V. Dechant. 1961. *Psychology in Teaching Reading.* Englewood Cliffs, N.J.: Prentice-Hall.

Stace, William T. 1960. *The Teachings of the Mystics.* New York: New American Library.

*Steiner, Wendy. 1982. *The Colors of Rhetoric: Problems in the Relation between Modern Literature and Painting.* Chicago: Univ. of Chicago Press. Excellent view of linguistic principles in the visual arts. Read at least the first third of the book.

Stella, Frank. 1986. *Working Space.* Cambridge, Mass.: Harvard Univ. Press.

Strauss, Anselm. 1970. "The Art School and Its Students: A Study and an Interpretation." In *The Sociology of Art and Literature: A Reader,* edited by M. Albrecht, J. Barnett, and M. Griff,159–77. New York: Praeger.

Tillich, Paul. 1984. "Art and Ultimate Reality." In *Art, Creativity, and the Sacred: An Anthology in Religion and Art,* edited by Diane Apostolos-Cappadona, 219–35. New York: Crossroad.

Time. 1967. 90 (Nov. 17): 88–89.

Twitchell, Beverly H. 1987. *Cézanne and Formalism in Bloomsbury.* Ann Arbor, Mich.: UMI Research Press.

Walker, John A. 1975. *Art since Pop.* New York: Barron's.

Whitehead, Alfred N. 1978. *Process and Reality.* New York: Macmillan.

Whorf, Benjamin L. 1956a. "Languages and Logic" (1941). In *Language Thought* and *Reality,* 233–45. Cambridge, Mass.: The Technology Press of Massachusetts Institute of Technology.

———. 1956b. "The Relation of Habitual Thought and Behavior to Lan-guage" (1939). In *Language Thought* and *Reality,* 134–59. Cam-bridge, Mass.: Technology Press of Massachusetts Institute of Technology.

Williams, Hiram. 1963. *Notes for a Young Painter.* Englewood Cliffs, N.J.: Prentice-Hall.

Wingert, Pat. 1996. "The Sum of Mediocrity: In Math, Americans Finish Way Out of the Money." *Newsweek* 128, no. 23 (Dec. 2): 96–98.

Wolfe, Thomas. 1961. "The Story of a Novel." In *The Creative Process: A Symposium,* edited by Brewster Ghiselin, 192–205. New York: New American Library.

*Wolfflin, Heinrich. 1950. *Principles of Art History.* 1932. Translated by M.D. Hottinger. New York: Doubleday, 1950. Wolfflin is the king of the formalist art historians, and this is the most fundamental and important of his books. The formal elements as presented in this book are organized in pairs of binary opposites and should thus be useful to, and consistent with, the concerns of poststructuralism and deconstruction.

Zervos, Christian. 1961. "Conversation with Picasso." In *The Creative Process: A Symposium,* edited by Brewster Ghiselin, 48–53. New York: New American Library.

Zimmerman, E. 1985. "Art Talent and Research in the 1920s and 1930s: Norman Charles Meier's and Leta Setter Hollingsworth's Theories about Special Abilities." In *History of Art Education: Proceedings from the Penn State Conference,* edited by B. Wilson and H. Hoffa, 269–75. Reston, Va.: National Art Education Association.